# The Deborah Company

## Becoming a Woman
## Who Makes a Difference

# JANE HAMON

DESTINY IMAGE® PUBLISHERS, INC.
P.O. Box 310, Shippensburg, PA 17257-0310

*"Speaking to the Purposes of God for this Generation
and for the Generations to Come."*

This book and all other Destiny Image, Revival Press, Mercy Place, Fresh Bread, Destiny Image Fiction, and Treasure House books are available at Christian bookstores and distributors worldwide.

For a U.S. bookstore nearest you, call 1-800-722-6774.
For more information on foreign distributors, call 717-532-3040.
Or reach us on the Internet: www.destinyimage.com

ISBN 13: 978-0-7684-2426-3

For Worldwide Distribution, Printed in the U.S.A.

9 10 11 12 13 14 / 18 17 16 15 14

# Dedication

This book is dedicated to my two daughters, Crystal and Tiffany, and to the company of women whom God is raising up in this generation throughout the earth today. May each of you find your God-ordained path on your road to destiny. May you leap over every hurdle in the strength of His might and be full of the heart and mind of God. May you be bold and courageous in the face of every adversity and rise to your fullest potential in Christ. Be all that you can be!

# Acknowledgments

I have been so privileged to have two very strong, anointed men support me in my quest for fulfilling destiny as a woman in ministry. I'd like to give special thanks and appreciation to my husband, Tom, and to my father-in-law, Bishop Bill Hamon.

Thank you for all the times you have encouraged me, stood behind me, pressed me forward, and supported me. Thanks for believing in me and the call on my life, even during times when I had a hard time believing in myself. Thank you for allowing me the freedom to step into new ministry challenges with the confidence that I was not alone, and that you would be there for me if I made mistakes. Thank you for never making me feel like a second-class citizen in the Kingdom of God or in the ministry simply because I was a woman. I love you both dearly!

# Endorsements

Prophetess Jane Hamon is fully qualified to write about a Deborah Company. She has functioned as a Deborah type Prophet for more than 20 years. Her book reveals how a woman can fulfill 4 different ministries with wisdom and balance. Jane has functioned as a wife, mother, prophet and co-pastor with her husband very successfully. Every woman needs to read this book to gain wisdom and inspiration for fulfilling their calling. Every man needs to read this book to understand the woman in his life. God bless you Jane for blessing the Body of Christ with your revelation, wisdom, and experience in fulfilling the fourfold ministry of the Deborah Company.

<div align="right">

Dr. Bill Hamon
Bishop of Christian International Ministries Network
Author of Seven Major Books:
*The Eternal Church*
*Prophets and Personal Prophecy*
*Prophets and the Prophetic Movement*
*Prophets, Pitfalls and Principles*
*Apostles, Prophets and the Coming Moves of God*
*The Day of the Saints*
*Who Am I and Why Am I Here*

</div>

During God's strategic times, He raises prophetic voices calling out a fresh sound from the Lord for that season. Like a powerful trumpet, Jane Hamon issues a clarion call to women through her book, *The Deborah Company.* Women are challenged

to arise out of the mediocrity and religious bondage of old mind-sets and are encouraged to pioneer God's path for women that will affect future generations. I highly recommend *The Deborah Company* for all women who want their lives to make a difference in the world!

Barbara Wentroble
Founder, International Breakthrough Ministries
Author, *Arise to Your Destiny, Woman of God;*
*Prophetic Intercession; Praying With Authority;*
*You Are Anointed*

I have always been a great champion of women who are faithful to their call. By having a Godly grandmother and an overcoming mother, I have seen the strength of God displayed in the female gender. I know that the enemy hates women with a passion! He knows that their seed is capable of overthrowing his purposes in the earth realm. The devil knows that women will be used to stand against him and bring great victory in the earth. They will unravel Islamic religious structures. They will overcome strategies of lawlessness in inner cities. They will be positioned in major corporate roles to rule and change societal structures. Jane Hamon, one of these faith-filled, bold women, has created a book to explain who this Deborah Company is in the earth. *Deborah Company*, is a gripping reminder of the women of faith that have gone before us to establish a legacy in the earth and in the history of the Church. This book is a guide to how women will rise to their apostolic authority and secure a future for God's people. This is a must read!

Dr. Chuck D. Pierce
President, Glory of Zion International, Inc.
Vice President, Global Harvest Ministries

Using the attributes and characteristics of Deborah as a foundation, Jane outlines the identity and destiny of God's women in

this hour as He calls them forth into the fullness of His purposes. Drawing from the lives of women in the Bible as well as 21st century women who are impacting their world, you will be encouraged to embrace all God has for you as a woman of vision, wisdom, authority, courage, and passion. Take your position as part of God's Deborah Company and receive your full inheritance!

Jane Hansen, President/CEO
Aglow International

# Contents

# Foreword

As I have traveled across the face of the earth, there is a vein of the prophetic word that pops up over and over again: It is God's time for women! What does that mean? Women have always been the backbone of the nations. There are certain inherent characteristics that the Lord has placed within a woman— tenacity, strength, endurance, love of children, and a righteous indignation against injustice. Of course, I am not saying that God is not also going to use men more and more powerfully as well.

In fact, God wants to use men and women together to release His Kingdom principles in country after country.

In this new move of the Holy Spirit, there is a fresh need to look at women of the past who possessed a reformational anointing during their generation. The most outstanding example of this type of woman in Scripture is Deborah. She was a judge, prophet, valiant warrior, worshiper, and governmental leader all in one package. Amazing!

There are many such women today. One of them is Jane Hamon. Consequently, she is one of the best people I know who could write on the subject of Deborah. She embodies the attributes of this biblical leader and possesses a God-given flame of righteousness. Her prophetic word is sure and accurate, and she is a teacher of the Word, releasing revelation to the hearers.

Why is it that this book is so important at this juncture of history? While there are many women being stirred to rise up as biblical Deborahs, there are not many role models for leaders and

emerging leaders to follow. In fact, as I have looked into the eyes of young women around the world, I've noticed they are hungry to be mentored by someone who has blazed the trail before them. This book fits the needs of both those who are beginning to seek the Lord regarding where they fit in changing the nations and those who are doing so already.

Deborah was a woman who knew she could not "do it all" by herself. Hence, she teamed up with Barak to change her nation. As gifted as women are, we simply must understand that God is releasing teamwork between men and women. Of course, the major focus of this book is for women, but it wouldn't hurt for the "Barak" to take a peek inside to understand this new move of God.

While in Barcelona, Spain, in 1999, I had an amazing visitation from God. During that startling moment, the Lord showed me a vision of thousands of women mounting up on war horses and marching across the face of the earth, bringing the Gospel of the Kingdom. I saw women from Europe, Africa, Asia, Latin America, Russia, North America, Scandinavia, all riding together in a great army of the Lord. These women were in one accord and had coalesced into one voice, as they fought abortion, poverty, child slavery, prostitution, and other evils.

Many times as Christian women we have not stood together and have neglected to realize that by forming coalitions against evil we can change and reform nations. Together we can do what no lone voice can accomplish—we can shake the nations of the earth for righteousness' sake.

Sad to say, the feminists have been much better at coalescing than we Christian women. Consequently, they have formed homes for battered women, affected areas of social justice in particular, and are quoted on major news services. However, there is a shift happening in the earth. The Deborahs of God are arising! They are mounting up together to ride and say, "We will feed the poor, take care of the orphans, preach the gospel, help eradicate

poverty, and free slaves and those bound in prostitution! We will have a voice in our nations."

Deborah had been given the duty of judge, by God, at a time when her nation was in shambles. God hadn't called her to an easy task; in fact, it was a rather impossible one. Because her country was occupied, the people could not live in villages in the normal way (see Judg. 5:7), and they were afraid to travel the usual highways (see Judg. 5:6). The society had broken down.

There are women who live in such situations today. Other women, even today, are little more than a possession with few or no rights. While many of us do have complete freedom, we must hear the cries of those women who are suffering, whose children are hungry, and who have no place to turn.

Hence, this is such a critical book. We need the Deborahs to arise! For my part, I convene an incredibly gifted group of international leaders, of which Jane Hamon is one of our founders, who are committed to doing just those things. There is a group of "Young Debs" who also gather yearly. These women of merit and courage are feeding the poor, preaching, teaching school, and producing award-winning films. Iqbal Massey who writes a section in this book is one of those women. In fact, we have just inducted her into our International Christian Women's Hall of Fame as the inaugural member.

I pray that you will find yourself in the pages of this book. Whether you are a woman called to stay home and raise incredible children or a medical doctor, actress, pastor's wife, evangelist, or any one or more of a multitude of other titles—this book is for you. It will strengthen you in your calling, stir you, and help you understand your place in God's world.

Thank you, Jane, for this book. The Deborahs of the world have needed it.

Cindy Jacobs
Generals International
Dallas, Texas

# Preface

This book is written as a result of my own personal search for truth and identity as a woman called to ministry. Much of what is written is directed towards women in the Body of Christ who share my passion and zeal to be completely obedient to the will of God for our lives and to be used of the Lord in ministry in whatever way He chooses. Each of us should strive to be a person who makes a difference, impacting her sphere of influence for the Kingdom of God.

The truths of this book are not, however, in any way limited in application only to women. I will be speaking of being people of vision, manifesting godly wisdom, walking in boldness and courage, maintaining balance in our lives, team ministry, and living lives of passion before our Lord. These topics will hopefully minister to both women and men alike and hopefully encourage us all to reach our highest potential in Christ.

With the advent of the apostolic/prophetic movement in the Church, God is challenging many of our mind-sets, religious traditions, and cultural biases in order that He might bring us fully into His eternal plan.

Women have often heard sermons or teachings about being part of the "Joshua Generation"; or about having the nature of David, Elijah, or Paul; or being "sons of God." Likewise, it could be beneficial for men to learn some of the principles of the "Deborah Company" of women, just as they have learned to relate to being the Bride of Christ.

With regard to being a part of a Deborah Company, we will see in the Scriptures that a man, the General Barak, worked closely by the side of the woman/judge Deborah and was a vital part of what God was doing in and through Deborah.

Therefore, though this was written with women in mind, I would like to invite men to also catch the vision of what God is doing in the women of the Body of Christ so that we all can work together to effectively fulfill His Kingdom purposes here on earth. *God bless you all!*

# Introduction

*The Lord gives the word [of power]; **the women** who bear and publish [the news] are a great host* (Psalm 68:11 AMP, emphasis added).

Standing to speak before a crowd of thousands of Asian faces, I began to realize how faithful God had been in opening the doors to the fulfillment of my destiny. Here I was, preaching and ministering to leaders and believers in a nation, with my husband seated on the front row encouraging me on, and my grown daughter seated next to him, both ready to stand with me when the time for personal ministry began. This crowd wasn't entirely used to "women preachers" but wanted to hear what God was saying to their nation. I prayed that what I had to say wouldn't be just another nice message, but that what I imparted would really make a difference in their individual lives as well as in the life of the nation.

God had spoken to me early in my life about His plans to use me in ministry. He said that He would bring me into a "team ministry" with my husband, that we would stand side by side preaching the Word of God, and He would send us to the nations of the earth. At that juncture in the church, there weren't many examples of husband and wife teams, nor were there many models of women being used to minister God's Word. Women were pastor's wives, Sunday school teachers, or choir members. Very few preached or taught the congregation, and even fewer were positioned as leaders with authority.

But times have changed. Today, not only are women leaders in our churches, but they have stepped into leadership roles in the business and political environments as well. This is not the result of the secular women's liberation movement as many believe, but rather the timing, plan, and purpose of God to restore women to vital functioning roles in order to make a difference in the kingdoms of this world. Feminism ideology from the 1960s and 1970s was only a counterfeit of what God desired to do in and through women. It was always in God's heart to set women free to fulfill their highest potential in Christ. However, it was not His desire that this occur through rebellion or the breakdown of the family unit. What started out upside down is now being brought into proper alignment as women recognize their God-ordained destinies and pursue them with a spirit of liberty and humility in order that they might impact their environment.

From the early days of Church history, God has used women to make a difference in the earth and in society. Anna, the prophetess, was the first to proclaim that the infant Jesus was the long awaited Messiah. The lives of several women, including the Samaritan woman at the well, were touched by Jesus, who confronted the gender bias of that day. We find that women were last at the cross, first at the tomb, first to proclaim the resurrection, attended the first prayer meeting in the upper room on Pentecost, and were the first to greet Paul and Silas in Europe. The first European convert, Lydia, financially supported Paul and hosted a church in her home. In addition, women such as Phoebe, Priscilla, and Chloe were leaders in the early Church. These were a few of the first-century Christian women who made a difference and paved the way for Christianity to grow throughout the world.

Through the years, other women have made their mark through faithfulness to the call of God, purity, and persistence. We are inspired by the legacy of Vibia Perpetua, a young twenty-two-year-old martyr in the third century, who was sentenced to

death and fed to wild animals for refusing to deny her faith. She wrote many of the details leading up to this event and inspired many to stand strong for their faith. We are also encouraged when we read of young Joan of Arc, who out of her intense love relationship with the Savior, began receiving divine visitations from God. Because she was obedient to all the visions instructed her, she changed the course of kings and nations. However, at the same time, because she was a woman and was very influential during her time, she endured false accusations and was eventually burned alive as a heretic. As she died, she spoke the name of Jesus and forgave her accusers.

Another worthy role model is Florence Nightingale who is known as the founder of modern nursing. She improved sanitary conditions in hospitals and worked to advance medical care. She was eventually declared as the pioneer who inspired the Red Cross organization, which helps millions around the world in times of need.

So many other women have made a difference in their place of influence: Corrie Ten Boom, who helped multitudes of Jews escape the control of Nazi Germany and who went on to lead thousands to the Lord all over the world; Maria Woodworth Etter, a powerful preacher and revivalist in the Midwest; Amy Semple McPherson, founder of the Foursquare Gospel denomination and a great healing evangelist; Kathryn Kuhlman, a powerful miracle worker; and Henrietta Mears, author of multitudes of Sunday school curriculums and founder of Gospel Light Publications. All these women have impacted not only their generation, but also those who have followed after them. They were women who left their mark and made a difference.

As a young woman in ministry, I too wanted to impact the lives of others and bring positive change into the earth. Knowing that I had a call of God on my life, I began to search the Scriptures for that example of a woman who could do it all...be the wife, mother, business woman, anointed woman of the Spirit,

and respected leader who would characterize this new breed of women whom God was raising up and releasing in and through the Church. I found many examples of strong women in the Bible, who possessed several admirable qualities to follow, such as Sarah, Esther, and Abigail. However, when I read of Deborah, I knew that her life and ministry would be the prototype of the qualities found in this company of women of which I was to be a part.

Judges 4:4 says,

*And Deborah, a prophetess, the wife of Lapidoth, she judged Israel at that time.*

Deborah brought change to a nation in turmoil. She inspired a general, rallied the troops, and set a course of freedom for millions of people. She was a woman who made a difference! Deborah provides an excellent example of a woman who served in a leadership capacity in the nation of Israel at a time when they were oppressed by their enemies. She is described as a *prophetess, a judge, a wife,* and later when she accompanied General Barak into battle, as *a warrior* and *a worshiper*.

These aspects of Deborah's life and ministry likewise describe the characteristics of women being called by God today. They are becoming the present-day "Deborah Company," comprised of ordinary women everywhere who are answering God's prophetic call to become extraordinary and to make a difference. In this book, we will explore each of these areas of function and how we can be most effective in each one as we pursue God's call on our life.

Every woman has a calling in Christ. Some women will fulfill their calling as wives and mothers. Some will fulfill their calling in the corporate world. Some will fulfill their calling as leaders in government. Some will bring positive change into the lives of individuals. Some will challenge the world's systems of operation

to make them better. Some will even change nations by their Christ-like influence.

In all my years of ministry, I have experienced many joys and many challenges. At times, I have felt like I was bursting with vision and desired to have it all, do it all, and be it all. I wanted to be a mother and a wife, but I also wanted to fulfill the call God had placed on my life. I have had the privilege of being involved with pioneering and co-pastoring a church for over 20 years with my husband of over twenty-five years, Tom. I also have three beautiful children—Crystal, Tiffany, and Jason, all who work with us in ministry. I have been blessed to be used of the Lord as a prophet; traveled to many nations; ministered through teaching, preaching, and prophecy; and have been used with a gift of discernment over cities, churches, and nations. All aspects of my life have been a real privilege and joy, but it has also been a challenge to make everything flow together gracefully—marriage, family, friendships, and ministry.

In this book, you will hear much about my personal journey as a woman in ministry. You will also meet many other fascinating Deborahs who are impacting their spheres of influence around the world. These women are making a difference for God's Kingdom causes in many areas of the world.

If you are like me, you likewise have a burning desire to be all that God has called you to be. As we look at the example of Deborah's life, let each one of us be challenged to arise to our fullest potential in Christ, with humility and love as our guide. Let us minister the purposes of God to this generation, thereby blazing a trail for the generations of women to come. May you receive an impartation of the heart and spirit of Deborah as we more fully understand this new breed of women called *The Deborah Company.*

# SECTION ONE

# Deborah the Prophetess: Woman of Vision

*People of vision see the invisible,*
*hear the inaudible, think the*
*unthinkable, believe the incredible,*
*and do the impossible.*

Author Unknown

# Deborah—A Woman Who Made a Difference

*And of some have compassion, making a difference* (Jude 22).

Everywhere you looked people were sad and depressed. It had been 20 long years under the rule of Jabin, the Canaanite king, and things were only getting worse. The roads weren't safe to travel, and even in the villages people feared coming out of their homes. Children no longer played in the streets. What was once a fun-loving, family-oriented community had been reduced to a place of survival and sorrow, and hopelessness ruled over every home. Jabin had taken all the weapons away and forbid making more. Subsequently, because none of the young men had swords or spears, none were willing to lead in a battle for freedom. Their hearts were too full of fear. After all, didn't Jabin have nine hundred chariots of iron? And hadn't he unleashed his cruelty on the people for two decades now? *Lord, is there anyone who can deliver us from this cruel bondage?*

The people longed for the days of Ehud, when he had been the judge over the land. He had led them in a great victory and brought the land into peace. Then came the days of Shamgar. He too had been a mighty warrior and delivered Israel from the Philistines who had come to rob and destroy. These men had taught Israel the ways of the Lord and called on them to walk in righteousness. They had kept them on the straight and narrow path.

But things had changed. After years of peace, the people had forgotten their covenant with God and began to serve the idols

of the land. Soon their idolatry and sin caused God's favor to lift off of them, and they now served their enemies. They were hopeless and helpless to bring change. Only the mercy of God could save them now, so they cried out to the Lord for a deliverer.

Meanwhile, in the mountains of Ephraim, there lived a woman named Deborah, who was the wife of Lapidoth, a respected man in the community. She loved the Lord and despised the practice of idolatry. Daily she prayed that God would raise up righteous rulers in Israel once again and offered herself to the Lord to do whatever He asked of her to see His Kingdom restored.

As she continued to cry out to the Lord, He eventually began to speak to her on a regular basis. Soon her prophetic insight and wisdom caused people to be drawn to her for solutions to their problems and for judgment. Even the sons of Issachar, who were men of great wisdom and leadership abilities, came to her for counsel. Ultimately, God anointed Deborah to become the next judge over all Israel.

As Deborah sat under a certain palm tree, people would come to her seeking help. She would hear their desperate cries for change and would encourage them in their time of bondage under Jabin's cruel hand. As a mother in Israel, her heart broke for the people as they lived under judgment and dealt with the consequences of their sin; but as a prophetess, she knew that times of change were coming and that God desired to show Himself strong on behalf of His people. She knew that God had a plan to change the patterns of repression and unrighteousness and shift the nation out of bondage into freedom and life.

## Strategic Battle Plans

One day as she sought the Lord, God revealed His plan. Deborah then summoned the army general, Barak, and released the strategy God had given to bring the nation into liberty. Barak hadn't led any troops into battle for over 20 years, for Jabin had

crushed all resistance and forbade any man in Israel to own a sword or a spear. Even so, the battle plan explained by Deborah sounded foolish to his natural ears. Yet he recognized that it was not a plan dreamed up by Deborah, but rather the prophetic voice of God. But it sounded so impossible!

He was to gather troops at a certain place and wait with his unarmed men for Jabin's commander, Sisera, to come down with his army. It sounded insane. Yet the promise from Deborah the prophetess, Deborah the judge, was that God would deliver Sisera into his hands.

Barak responded to the prophetic battle plan by saying to Deborah, "If you will go with me, I will go. If you will not go with me, I will not go." He knew that he needed the anointing that Deborah carried to see the breakthrough in the battle. (I also wonder if he wasn't afraid to face his troops alone with this crazy battle strategy!) Deborah told him that she would, of course, go with him. She also informed him that he would not receive the glory for this victory, for Sisera would be sold into the hand of a woman. Then Deborah and Barak mobilized the army and saw God bring them supernatural victory over their enemies.

## Prophetic Vision for Change

Deborah was an ordinary woman called by God to make a difference during a critical season of change in her nation. She received divine revelation and insight that enabled her to effectively govern her nation and to release strategies to other leaders to bring Israel into a place of freedom. She was a woman of vision, evidenced by the fact that she was able to hear the voice of God for Israel during a time of tremendous bondage and oppression, and to release the battle plan that would secure Israel's liberty. She is an example to godly women today who desire to hear God's voice and impact their world.

Presently, we can look around the world and see that things aren't too different for us compared to the times of Deborah. We

are aware of the injustice that results when unrighteous rulers oppress the poor and weak. We see families being torn apart by the pressures of the world system. We know of cities where it is too dangerous for people to go out of their homes at night. We see people trapped in fatalism—the "this is just how it is" mentality with no hope for change. Now, more than ever, we need God to raise up prophetic people to hear His battle strategies for freedom and bring deliverance in the earth.

God is calling women all over the globe to embrace a new mandate of the Spirit to become women of vision. The strength of our families depends on this. The hope of our nations depends on this. No longer are women limited by the bands of oppression imposed by traditional, societal, and religious systems. It is a new season of breaking free from all the mind-sets of restriction that are limiting with a "you can't do it" frame of mind. God is delivering us from the strongholds of excuses and our own personally inflicted constraints that have kept us from fulfilling God's highest purpose in our lives.

Because she was a woman of vision, Deborah was able to look past the seemingly impossible situation that her nation faced, and lay hold of the hope of God's promise of deliverance. She is an example to women and men alike, who desire to look beyond their natural situations and see into the supernatural realm of possibilities with the eyes of God's Spirit, and become people of vision who see a plan to bring change.

God is raising up such a generation of people today who are willing to embrace God's vision for their lives, their circumstances, and even their nation, above and beyond that which the natural mind can see or comprehend. People of vision have a power given to them that enables them to conquer and overcome in situations that would otherwise seem unconquerable. Someone once said of people who have vision:

**People of vision see the invisible, hear the inaudible, believe the incredible, think the unthinkable, and do the impossible!** (Unknown)

If the Church is to be God's vehicle of change in the earth, then we must first undergo God's renovation and restoration process. For the Church to bring change, we must first endure change. In order to implement change, we must be full of God's vision for our future.

## My Calling as a Deborah

In 1978, as a 16-year-old young woman just recently filled with the Holy Spirit, I was seeking the Lord one day in my room regarding His plan for my life. I already had some thoughts and ideas regarding a choice of vocation to pursue, yet as I prayed and waited before the Lord (waiting, yet not really knowing what I was waiting for), I clearly heard the voice of the Lord speak to me.

This surprised me for a couple reasons. First of all, I had not been taught that God actually conversed with people, so I was a bit stunned when I sensed His Spirit unmistakably speak to me. Secondly, beyond the surprise of hearing God's voice, was my amazement at the message He spoke.

God said to me that afternoon that I was not to pursue the profession that I had chosen for myself, but rather the one He had selected for me. He said that He was calling me forth for His purposes of service, and that in the time to come I would serve Him in a "team ministry," standing side by side with my husband. Together we would preach and minister by the anointing of His Spirit, and He would send us even to the nations of the world.

## "What Do You Mean by That?"

This simply did not make any sense to my mind. My confusion was twofold. First and foremost, the concept of women in

ministry was completely foreign to my mind; and secondly, a woman standing with her husband to form a ministry team was equally incomprehensible.

In the churches I had attended, women did not participate in any active role of ministry, but rather served in hospitality and support capacities. Some would serve as Sunday school teachers, and occasionally some would even lead the choir. However, I was never exposed to any women who actually preached the Word of God or flowed with the anointing of the Holy Spirit. Even most of the women who were "pastor's wives" seemed to fill more of a decorative or administrative role in the church rather than fulfilling any area of spiritual ministry.

## God Reveals a New Thing

Because I was having a difficult time grasping what God was saying to me, I asked Him if He could show me an example of somebody who was doing what I would be doing so that I would have a living example with which to relate. His response was my third surprise of the day. I believe He said, "There is nobody now doing what you will be doing. I will be doing a new thing, and you will be a part of bringing that forth."

In the next few years, I began to look for other women in ministry as a point of reference in understanding God's personal word to me. Of those I observed, I found very few whom I wished to emulate. On the rare occasion of hearing a woman actually preach, I was left with a feeling of disappointment. It seemed the women I heard came across harsh, as though they were transferring the rising feminism philosophy from the world into the Church. Somehow I knew this was not the model of what God was calling me to be a part of.

On one occasion, after hearing a woman missionary share her experiences of ministry in far-off nations, something came alive within me. It seemed this woman had a freedom to preach and teach the Word of God and move in the supernatural

dimensions of the Spirit without the restrictions that seemed to be applied to my gender within the churches of America. I often heard the Scripture quoted, "Let a woman keep silent in church," (1 Cor. 14:34 NKJV) and wondered how God's Word to me could ever come to pass without going to some far-off country as a missionary where I could have the freedom to stand at my husband's side and preach and minister just as he did.

As is so often the case when God speaks to us of events that are yet to come, I tried to figure out in my natural mind how the Word of the Lord could be fulfilled. What I didn't understand was that God had a perfect timing to begin revealing His plan, causing it to come into focus. What I also didn't realize was that God had called me to function as a prophet, and that the time of the unveiling of the ministry of the prophet had not yet come. Thirdly, I didn't realize that until I met and married the mate God had chosen for me and began to work together with him in ministry, it would be impossible to comprehend the concept of "team ministry." This too, was an idea born in the heart of God that would be unfolded at an appointed time in the future.

## Setting the Stage for Destiny

In time, God faithfully began to set the stage to bring me into His plan. I prepared myself by giving time to the study of God's Word and prayer. I looked for opportunities to share the Gospel and to encourage others about the teachings of Christ. I started a Bible study at my high school and made preparations to attend Bible college so I could be equipped for this call God had placed on my life.

It wasn't long before I met and married my husband, Tom, and began to work in an administrative capacity for the ministry founded by his father, Dr. Bill Hamon. As my husband and I grew in ministry experience together, so also grew my hunger to press into the fullness of being used of God's Spirit in what came to be known as "the prophetic ministry." I had a burning desire

to see God's people ministered to with a personal word about their life and destiny, and before long, I realized that as we would pray and minister to them, my husband and I were standing together as a ministry team! This teamwork then carried over into our role as co-pastors of the church started in the ministry of Christian International. God was revealing the practical application to the word He had spoken to me several years earlier.

I realized that what God was doing with us was something new, but not necessarily unique, as husband/wife ministry teams seemed to be springing up everywhere. Along with this came the activation of the saints into their divine gifts and callings. I realized that God was superseding my concepts and mind-sets about what a woman could and could not do in ministry.

This caused me to stop looking for a modern day example of a woman in ministry (or even team ministry) for me to pattern my life after, and instead go to the Bible to find God's ideal. I could still glean from the lives of those who had years more experience than me in the ministry, but my heart cried out for that biblical model.

This was when I read the story of Deborah, who provided a biblical model that I could really take hold of. She was a wife (and presumably a mother). Yet she was a woman who broke out of the societal and religious molds and became one who stood in a place of great authority and power. She was a woman of vision who impacted the lives of people and a nation, and inspired other leaders to step into their God-ordained places of destiny. She encouraged the people to believe in God when all around them circumstances spoke of hopelessness and despair, and she continually stirred up faith to expect God to show up supernaturally and defeat their enemies. She literally changed the course of history!

## Deborahs in History

Today God is raising up a company of women who have the heart and vision of Deborah. Yet throughout history there have been numerous women, many of whom stood alone, who have

made a difference in great times of difficulty. Let's get to know one of them now.

## Vibia Perpetua

The year was 203. The Roman Emperor Septimus Severus had issued an edict prohibiting his subjects from converting to Christianity. As a result, a great persecution had swept Europe and northern Africa, finally reaching the city of Carthage. Many believers in Christ were being imprisoned, tried, and executed for their faith. One of these martyrs was a young noblewoman named Vibia Perpetua, who wrote and recorded much of her process leading to martyrdom, inspiring future generations by her courage.[1]

Perpetua had committed herself to Christ in her early adult life. She was a young mother with an infant son when she was captured and imprisoned. Her family begged her to renounce her faith that she might escape a cruel death in the gladiators' arena and appealed to her heart as a mother who would be leaving a nursing babe if she were to die. Yet when she stood before the Roman procurator, Hilarian, she boldly proclaimed herself to be a Christian, and with a sense of joy accepted the sentence of being thrown to the wild beasts. She thought it to be one of the highest honors to be chosen as a partaker with Christ's suffering and to die a martyr's death for her Lord and Master.

Days before her execution the Lord visited Perpetua in dreams and visions, which confirmed to her that she should suffer for Christ in death. Through these visions the Lord comforted her that in her death she would be defeating the devil and would be received into the glorious arms of the Father. In one vision she saw her victory in death; the Lord kissed her and gave her entrance through a gate called the Gate of Life. When she awoke she said, "I understood that I should fight, not with the beasts but against the devil; but I knew that mine was the victory."[2]

On the day of her death Perpetua walked into the amphitheater, with her friend and fellow martyr, Felicitas, another young

woman who had just given birth. *The Acts of Christian Martyrs* tells us the story of that day:

> Perpetua went along with a shining countenance and calm step, as the beloved of God, as a wife of Christ, putting down everyone's stare by her own intense gaze. With them also was Felicitas, glad that she had safely given birth so that now she could fight the beasts, going from one blood bath to another, from the midwife to the gladiator, ready to wash after childbirth in a second baptism.[3]

Several Christian men were then killed as they were exposed to hungry wild animals. A wild boar, a leopard, and a bear were released on them, and they died rather quickly. Yet the courageous death of Perpetua and Felicitas was a prolonged and brutal affair.

> For the young women, however, the Devil had prepared a mad heifer. This was an unusual animal, but it was chosen that their sex might be matched with that of the beast. So they were stripped naked, placed in nets and thus brought out into the arena. Even the crowd was horrified when they saw that one was a delicate young girl and the other was a woman fresh from childbirth with the milk still dripping from her breasts. And so they were brought back again and dressed in unbelted tunics.

> First the heifer tossed Perpetua and she fell on her back. Then sitting up she pulled down the tunic that was ripped along the side so that it covered her thighs, thinking more of her modesty than of her pain. Next she asked for her pin to fasten her untidy hair: for it was not right that a martyr should die with her hair in disorder, lest she might seem to be mourning in her hour of triumph. Then she got up. And seeing that Felicitas had been crushed to the ground, she went over to her, gave her her hand, and lifted her up. ...

Those who had survived till then were gathered in the usual spot for their throats to be cut. But the mob asked that their bodies be brought out into the open that their eyes might be the guilty witnesses of the sword that pierced their flesh. And so the martyrs got up and went to the spot of their own accord as the people wanted them to, and kissing one another they sealed their martyrdom with the ritual kiss of peace. The others took the sword in silence and without moving…. Perpetua, however, had yet to taste more pain. She screamed as she was struck on the bone; then she took the trembling hand of the young gladiator and guided it to her throat. It was as though so great a woman, feared as she was by the unclean spirit, could not be dispatched unless she herself were willing.[4]

Perpetua was a woman who made a difference in her day as many who witnessed her death were inspired by her faith and strength in Christ. As we read of the courage and joy with which she faced death, we understand that the same God who caused her to triumph in the midst of her trying times will sustain us and give us courage to face any circumstances that now challenge us.

As God is calling women today to stand up for the cause of Christ, He is anointing them with this same spirit of faith and courage. Most will not be asked to die the harsh death of a martyr; however, all must be willing to die the death to self and the flesh. As Deborahs are rising up throughout the nations of the earth, God is looking for those who will exemplify confidence in Christ, boldness in the battle, and a valour to win the victory for the Kingdom of God. Are you ready to answer the call to become a Deborah? Are you willing to be a woman who makes a difference?

### Endnotes

1. Terry Matz, "Perpetua and Felicity," *Catholic Online Saints*; March 7, 1996, www.catholic.org/saints/perp.htm.

2. Michal Ann Goll, *Women on the Front Lines* (Shippensburg, PA: Destiny Image Publishers, Inc., 1999) 53.

3. Franklyn J. Balasundaram, *Martys in the History of Christianity: Vibia Perpetua and Felicitas* (Delhi, India: Indian Society for Promoting Christian Knowledge, 1997) www.religion-online.org/showchapter.asp?title=1570&C=1459.

4. Balasundaram, *Martys in the History of Christianity: Vibia Perpetua and Felicitas*.

# Women Who Make a Difference Through Vision
## NANCY ALCORN

*Also I heard the voice of the Lord, saying, Whom shall I send, and who will go for us? Then said I, Here am I; send me* (Isaiah 6:8).

When I first received Christ after my senior year of high school, one of the first things I said was, "Don't ever ask me to pray out loud, don't ever ask me to speak in front of a group, and don't ever ask me to give my testimony because this is going to be a private thing with me." To me, it was unthinkable that I could stand up in public and talk about God, but He had other plans.

During and after college, I worked for the state of Tennessee. Working in a correctional facility for juvenile delinquent girls and then for the Department of Human Services investigating child abuse cases, I was touched by the broken lives I came in contact with on a daily basis. Although **those** eight years of working for the state gave me invaluable experience, they were extremely frustrating years for me. The one thing that became very clear to me during this time was that God has not anointed the government to heal broken hearts and set captives free, but He has called His people to do it (see Isa 61:1). Neither the government nor any other secular program can ever bring the lasting change that these young women need, because it is only through Jesus Christ that they can be given a new heart and a new spirit.

While I worked for the state, I volunteered many hours with the local Teen Challenge center working with troubled girls. I would go to work for the government during the day not having the freedom to share about the One I knew could change lives. But during my off hours, I was able to volunteer at Teen Challenge with the full freedom to share Christ with the girls. It was there I began to see young girls

set free from addictions through the power of Christ. In the state set-
ting, the experts called addiction a disease and said you could never
be free. However, with the freedom to share the truth of God's Word
in the Christ-centered Teen Challenge environment, I began to see
young girls set free from addictions.

Eventually, Teen Challenge offered me a full-time position, and I
was appointed Director of Women for the first girls' home where I
served for two years. During this time of working with young girls
with addictions, I received a deeper revelation of how Christ was the
answer to every problem, not just addictions. I began to be moved
with compassion toward young girls facing eating disorders,
unplanned pregnancy, sexual abuse, suicidal tendencies, and depres-
sion. What God was showing me was that if the name of Jesus is
above every name, and that Christ can set us free from anything and
make us new, then why just addictions? I truly developed a passion
for reaching hurting young women with the unconditional love and
forgiveness of Jesus Christ.

In January 1983, God directed me to move to Monroe, Louisiana
to establish the Mercy Ministries program. The vision for this pro-
gram was to establish a faith-based residential facility for girls ages
13-28 with all kinds of problems and issues. God instructed me that if
I would do three specific things, He would always see to it that our
needs would be met: 1) take girls in free of charge so they do not
think we are trying to make money off of their problems, 2) tithe at
least ten percent of all the money that comes in to other Christian
organizations and ministries, and 3) do not take state or federal
funding, or any other money with strings attached where we would
not have the freedom to share about Jesus Christ. Since 1983,
we have continued to be faithful to these three principles, and God
has been true to His word and faithful to provide for every need,
just as He promised.

*Mercy Ministries began with a small facility, and after adding on twice, we began to see the need for an additional home to make room for more unwed mothers. In 1987, we stepped out in faith, believing for God to build this home debt-free. After several months of building, the contractor told me that we would need an additional $150,000 to complete the project. It was at this point that we made the decision to sow our last $15,000 in the building fund as a seed for what we needed.*

*A few weeks later, God arranged for a divine appointment on an airplane that proved to be a major turning point. I had just spoken at a week-long evangelism conference in Las Vegas and was exhausted. The last man to board the plane sat down in the seat next to me and began a conversation by asking how much money I had lost gambling during my trip to Vegas. I explained to him my purpose for being in Vegas and of my commitment to Christ. He was so amazed that someone would come to Las Vegas and not party and gamble that he began asking questions about what I do for a living. It was at that point that I shared with him about the work of Mercy Ministries.*

*The man then began to tell me his story. He had been born to a teenage mother who had been violently raped, and he was a product of that rape. Because people were there to help his birthmother get the help she needed, she chose life and placed him for adoption when he was five days old, and he was just sure that if his mother had not had a place to go, a place like Mercy Ministries, he would have been aborted. His adoptive mother, whom he had dearly loved, had recently passed away and left him with several million dollars. As I listened intently, he told me that he had been looking for something to do in memory of his adoptive mother. He asked me how much*

*more money we would need to compete the building. When I told him that $150,000 was still needed, he simply replied, "You've got it."*

*God provided for us then, and has continued to provide for our every need over the years. He is faithful to His Word, and when we get involved in reaching hurting people with the unconditional love of Christ, it is then that Jehovah Jireh, our provider, will jump right in the middle of what we are doing to make sure that every need is met.*

*At the time of this writing, Mercy Ministries has multiple locations in America and in six other nations around the world. We currently have plans underway for many more locations both in the United States and abroad. Mercy Ministries is a testament of what He can accomplish through our obedience to His will. I never imagined that God would use me to establish a vision of hope that would reach so many people. I encourage you, in the face of fear or lack, to be obedient to what God has put in your heart to do, and follow Him fully as you take the steps of faith that will lead you into the fulfillment of your dreams. Amazing things happen and lives are changed when we are willing to seek His anointing on our lives and say Lord, "Here am I! Send me."*

**Nancy Alcorn** is President and Founder of Mercy Ministries, which brings transformation to broken, troubled young ladies throughout the world. Nancy is an author and frequently speaks at conferences in many nations. She resides in Nashville, Tennessee, which is also the home of the national headquarters of Mercy Ministries.

CHAPTER TWO

## God's Prophetic Call to Women

At the age of 13, in the small town of New Lisbon, Ohio, Maria Etter walked down a church aisle and gave her heart to the Lord. Despite great difficulties of being raised in the home of an alcoholic father, Maria greatly loved the Lord and knew as a teenager that He was calling her to serve Him in ministry. But as the hardships of life dealt her one harsh blow after the next, her dream of fulfilling a ministry calling eventually died.

She had married John Woodworth, and by the age of 35 had buried five of her six children. Now she was battling sickness herself, and was also struggling to take care of her husband, who had become mentally deranged. It was at this time that God began to remind her of His calling on her life.[1]

There were many reasons why pursuing a ministry calling seemed so distant to Maria in the year 1880. First of all, her husband had forbidden her to preach. In addition, she was uneducated, both in formal education as well as theological training,[2] and she was terrified of speaking in front of people. Furthermore, the church she was a part of didn't believe women should speak in church. Yet Maria continued to feel the call of God on her life as He visited her in visions often and confirmed that she was called to preach. Jesus would come to her in her visions and tell her, "Go, and I will be with you."[3]

In order to obey what God was so clearly speaking to her, Maria gathered some of her family members at one time and began to share from the Word of God. Suddenly, the presence of God fell in the room, causing the people to weep and fall on the

floor, and many gave their hearts to Jesus in that first meeting. Word then began to spread throughout the community, and each meeting grew in number as well as in the anointing of the Holy Spirit. Maria rarely knew what she would speak on until she stepped up to the pulpit, yet God would faithfully fill her mouth.

As she preached, God confirmed His Word with many unusual signs. Multitudes were healed of physical afflictions in her meetings. People fell into trances, had visions, shook, and rolled on the floor as the power of God was poured out. Many had demons cast out. Some were even reported to be heard speaking in unusual languages and making indistinguishable sounds that was later thought to be an early manifestation of the baptism of the Holy Spirit. These meetings were not without controversy though. Doctors came to try to discredit the healings taking place. People were paid to disrupt the meetings, and other preachers stood up in her meetings to rebuke and correct her. Yet Maria remained humble and submitted to God, and His power increased in her meetings all the more.

Although Maria had answered God's prophetic call, her life was often filled with grief and pain, and her time in ministry, while gloriously effective, was not without heartache. Yet Maria obeyed God and allowed Him to use her as He saw fit. The results were that by the age of 40, Maria was at the forefront of God's Pentecostal move. Untold thousands were saved and healed, and God's miraculous, supernatural power was displayed to a generation. Thus, she paved the way for other women, who also felt the stirring of the call of God on their lives—women like Aimee Semple McPherson, Kathryn Kuhlman, and others.

We are living in a day when God is releasing this same clarion call throughout the earth, assembling a company of women who are willing to hear His voice and obey His Word. Now is the time for women everywhere to be ready to take their place in God's army and become a great host, a company ready to do business for the King of kings. Women are taking their God-ordained

place within church leadership structures and in pulpits. They are also taking their place in the business world, establishing Kingdom businesses, affecting many lives. Women are taking their place in government as well and allowing their voices to be heard in establishing righteous legislation in nations throughout the earth. Today is an hour for the women of God to shine!

## Breaking Out of Bondage

A new day has arrived for women in the Church as well as in society. God is releasing a greater understanding of the destiny, identity, and purpose for women throughout the earth. He is shining His light of revelation upon the dark corners of religious misinterpretation and bringing women into freedom and full expression of the Christ within them.

Why is it so vital for women to discover who they have been created to be? For us to be ambassadors of God's freedom to a hurting world, we must first come into a new place of freedom for ourselves. We are living in a day when women remain severely oppressed and abused in many nations of the earth. In many cultures, domestic abuse is rampant with high percentages of women being beaten every day. Even in the United States, statistics say a woman is beaten every nine seconds with three to four million women severely beaten every year.[4] In the workforce, women account for working 67 percent of the work hours but earn only 10 percent of the income. Women own less than 1 percent of the world's property. On average, women work 12 to 16-hour days doing 70 percent of the work in most cultures. Additionally, women are the sole breadwinners in one third of today's households.

All of these statistics stem from archaic thinking where women are treated culturally and religiously as second-class citizens merely for being born female. In my early years in ministry, someone once told me, "God will use a woman only if He can't find a man to do the job." But you see, I do not believe that I,

or any woman, am God's second choice or fallback plan because of some man's disobedience. I believe that I was called from my mother's womb to fulfill a specific plan and purpose in the earth. However, sadly, much of the church world has believed this lie in the past because of misinterpreted Scriptures and religious traditions.

One such Scripture that has been misinterpreted in older translations of the Bible but has come to light in recent days is the true meaning of Psalm 68:11. The King James Version of this passage reads, *"The Lord gave the word: great was the company of those that published it."* A more thorough and accurate interpretation of this verse from the Amplified Bible would read a bit differently, highlighting the ministry of women to bring good news. *"The Lord gives the word of power, the women who bear and publish the news are a great host, (an army ready for war)."*

We must break out of the bondage of religious traditions and wrong mind-sets in order to step in to the plan and purpose of God. We must learn to hear His voice above all other voices and understand the true principles of His Word so that we can be free to answer the call with confidence and courage and to be bold in all that He has called us to do.

## Deborah and the Prophetic Ministry

*And Deborah, a prophetess, the wife of Lapidoth, she judged Israel at that time* (Judges 4:4).

Just as Deborah was called as a prophetess, women everywhere can be partakers of the same spirit and anointing that she possessed, whether they are called specifically as a prophetess or not. Although God dealt with only one prophet or prophetess here and there in the Old Testament to be His spokesperson to that nation or generation, today God is calling His new breed of people to hear the voice of God and to become an entire company of prophetic people who have sharpened gifts of revelation and vision.

In Numbers 11:29, Moses stated, "[I] *would God that all the Lord's people were prophets, and that the Lord would put His spirit upon them!*" In the New Testament we are encouraged by Paul's letter to the church at Corinth. "*...desire spiritual gifts...he who prophesies edifies the church...for you can all prophesy one by one...covet to prophesy*" (1 Cor. 14:1,4,31,39 NKJV).

To better understand the example Deborah set forth for us, let us take a look at this first aspect of her life—her calling as a prophetess—and what that means to those women who desire to fully embrace this anointing.

## The Ministry of a Prophetess

The ministry of a prophetess is more than simply having the ability to give another person a "word from the Lord," or to give a congregational prophecy. It represents more than just what we do; it encompasses, rather, who we are called to be in Christ.

The term *prophetess* is used as the female form of the term *prophet*. Deborah is actually only one of several women who are called by the name "prophetess" in Scripture.

*Miriam*, the sister of Moses, was called a prophetess as she led God's people in a song declaring Israel's victory over Pharaoh and his armies.

> *And Miriam **the prophetess**, the sister of Aaron, took a timbrel in her hand; and all the women went out after her with timbrels and with dances* (Exodus 15:20, emphasis added).

*Hannah*, though never referred to as a prophetess, prophesied in First Samuel 2:10, foretelling the founding and establishment of the dynasty of David which was to come.

The prophetess, *Huldah*, prophesied in proxy to King Josiah regarding the destruction of Jerusalem. She told him that because he had done righteously before the Lord, this destruction would not take place until after Josiah's death. Her ministry to this great

king inspired him to bring great national revival and restore true worship in the land of Israel (see 2 Chron. 34:22-33, 2 Kings 22:14-20).

*Isaiah's wife* was referred to as a prophetess (see Isa. 8:3) as was *Anna* in the New Testament who recognized the Christ child as the Redeemer of Israel. She became the first person to publicly proclaim and preach Christ after His birth (see Luke 2:36-38).

A man named *Philip* had *four virgin daughters* who were known because they prophesied (see Acts 21:9).

As Joel prophesied of the last-days Church, women are to share in the vocal and revelatory ministries of the Holy Spirit. Peter quoted this prophecy on the day of Pentecost, indicating that the Holy Spirit had indeed been poured out and that visions, dreams, and prophecy would result.

> *And it shall come to pass in the last days, saith God, I will pour out of My Spirit upon all flesh: and your **sons and your daughters shall prophesy**, and your young men shall see visions, and your old men shall dream dreams: and on My servants and on My **handmaidens** I will pour out in those days of My Spirit; **and they shall prophesy** (Acts 2:17-18, emphasis added).*

This passage encourages those upon whom the Holy Spirit has fallen, declaring that it does not matter if they are young or old, male or female, rich or poor; when the Holy Spirit is made manifest, He will be no respecter of persons. Women are to be partakers and participators of all that the Holy Spirit gives to believers.

> *There is neither Jew nor Greek, there is neither bond nor free, there is **neither male nor female: for ye are all one in Christ Jesus** (Galatians 3:28, emphasis added).*

In his Epistles, the apostle Paul emphasizes this point by declaring that we become a new creation when we put on Christ

Jesus. We all become a part of the Body of Christ where all distinction is removed between the Jew and the Greek, between the bond and the free, and between male and female. God does not look at one's gender when determining his or her membership ministry in the corporate Body of Christ (see 2 Cor. 5:17).

## The Mission of Prophetic Ministry

The words Deborah spoke as a prophet in her land sprang out of her desire to see the people of the Lord set free. The mission of the prophetic ministry is vast, encompassing several aspects of spiritual focus. *Prophets are those who have been called of God to hear His voice and speak His messages and truths to an appointed nation, generation, group, or individual person.* Different prophets, however, may have individual expressions of how that call may be fulfilled or specifically how their gift will be directed.

## Prepare the Way by Revelation

In looking at the ministry of Isaiah, we find that his particular mission as a prophet, which also may be representative of the mission of a prophetic minister, was to:

> ...*Prepare ye the way of the Lord, make straight in the desert a highway for our God. Every valley shall be exalted, and every mountain and hill shall be made low: and the crooked shall be made straight and the rough places plain* (Isaiah 40:3-4).

or as is stated in the Book of Luke:

> ...*to turn the hearts of the fathers to the children, and the disobedient to the wisdom of the just; to make ready a people prepared for the Lord* (Luke 1:17).

Prophets have been given authority to be God's spokesmen, His mouthpiece, and to proclaim that which He is doing and preparing to do on earth. Amos 3:7 says:

*Surely the Lord God will do nothing, but He revealeth His secret unto His servants the **prophets*** (emphasis added).

And again in Ephesians 3:5, the Bible tells us:

*Which in other ages was not made known unto the sons of men, as it is now revealed unto His **holy apostles and prophets** by the Spirit* (emphasis added).

As God begins to bring forth the culmination of the ages and to reveal His divine strategies and purposes for His last-days army of overcomers, prophets are arising to declare God's plans. People are being made ready, equipped, and matured through the release of God's voice through the mouth of His prophets.

## Battling and Building

Another example that characterizes the function of prophetic ministers is found in the life of Jeremiah. Chosen from his mother's womb to fulfill this ministry, we find an account of what his ministry would entail in Jeremiah 1:10:

*See, I have this day set thee **over the nations** and over the kingdoms, to **root out**, and to **pull down**, and **to destroy**, and **to throw down**, to **build**, and to **plant*** (emphasis added).

God told Jeremiah he was anointed to battle and anointed to build. He would battle by rooting out, pulling down, destroying, and throwing down. He would then be able to build and plant, establishing God's purposes. Sometimes the prophetic word is like a plow that goes deep into the soil of a human heart, of a church, or even of a geographic territory. This plow *roots out* weed seeds that will keep the harvest from coming forth. It *pulls down* strongholds that bind up freedom, salvation, families, health, and wealth. It *destroys* demonic structures and human systems that perpetuate the bondage. It *throws down* altars of idolatry and

iniquity. After this work is done, the building process can proceed, and the soil is made ready to receive seeds for harvest.

Each prophetic minister may have a specific mission to fulfill; however, many of the qualities and attributes will be the same by virtue of the anointing that comes with the calling of a prophet.

Therefore, we can look to the callings of men such as Isaiah and Jeremiah to understand that the prophetic mission upon the Church today is to pull down every stronghold, whether in the mind of man or the spirit realm; and to build, plant, and establish the Kingdom of God. God's purpose for the Church's ministry is to prepare the way and make ready a people for the second coming of Christ Jesus.

Our focus as prophets, or as women of vision called to function in this last-days Church, should be the same: to tear down every false belief and every demonic stronghold and to lay hold upon God's purposes and promises and cooperate with Him in bringing them forth in the earth. With purified minds we will be free to download the fresh vision from Heaven to bring a Kingdom-of-God impact in all we encounter.

## The Voice of the Lord Brings Power

Prophecy is a powerful tool in the hands of a well trained saint. When we prophesy, things in the heavens shift and things in the earth shake. Psalm 29 tells us the affects of the voice of the Lord:

> *The voice of the Lord is over the waters: the God of glory thunders: the Lord is over many waters. The voice of the Lord is powerful; the voice of the Lord is full of majesty. The voice of the Lord breaks the cedars.... The voice of the Lord divides the flames of fire. The voice of the Lord shakes the wilderness; the Lord shakes the Wilderness of Kadesh. The voice of the Lord makes the deer give birth, and strips the forests bare: and in His temple everyone says, "Glory!"* (Psalm 29:3-5,7-9 NKJV).

Things happen when we prophesy God's purposes into the earth! Power is released and things begin to change. As women who have a desire to make a difference, we must learn to speak God's voice against the forces of darkness and claim the promises from God's Word in the face of impossibility. When we believe, nothing is impossible to us. No demon can stand before us. Isaiah 30:31a says: "*For through the voice of the Lord shall the Assyrian be beaten down.*" In other words, when we prophesy God's Word or release God's voice, every enemy is beaten down and utterly defeated.

At times in a church service, when there seems to be an atmosphere of heaviness upon the people, I employ this principle. I prophesy against oppression, depression, or fear. I declare God's Word against every tactic of the enemy. I decree freedom over the people, because "the voice of the Lord will shatter the Assyrian [the enemy]." An anointing for breakthrough is released by prophecy, and people are then able to step in to their freedom.

## Prophesy to the Dry Bones

In Ezekiel 37, the Lord took the prophet to a valley full of dry bones. These bones were very dry. The word *dry* means "sterile, unproductive, unable to reproduce." The Lord then asked the prophet if these bones could live. Ezekiel's response was probably like yours or mine: "Oh, Lord, only You know that one." Then the Lord instructed Ezekiel to prophesy to the dry bones. When he did, life came into the dead, dry bones.

God is calling His people to be like Ezekiel. We need to recognize the "dry bones" in our lives. These bones are the promises of God that we have not seen come to pass. They are the framework of our destiny that has not been fulfilled. They are the skeletons of dead religion that have ceased to be life-giving and are now dead-dealing. The spirit of "dry bones" has taken over regions and nations where Christianity once flourished but is now only a form and a ritual. We need to see these dry bones with

eyes of faith, begin to prophesy to them, and command them to come together as an exceeding great army. It's time to prophesy to the dry bones!

## Be Prophetic—Not Pathetic!

As a prophet, as well as in my position of co-pastoring a prophetic church with my husband, Tom, I have had the opportunity to see many wonderful things accomplished as God has used men and women as instruments of His prophetic ministry. I have seen prophetic words spoken over individuals that have revealed and broken curses and bondages, brought physical or emotional healing, or have spoken new vision to hearts that have become hopeless and discouraged because of adversities in life. I have seen God use His people to prophetically discern strongholds over churches or cities, or to discern a prayer strategy that would bring breakthrough during times of hindrance, spiritual warfare, or lack. The prophetic word has brought life on so many occasions, into so many circumstances and situations, causing people to lay hold upon their God-ordained destinies.

On occasion, however, there have been individuals zealous to be used of God, yet not very spiritually mature, step into areas of presumption, which can result in being more *pathetic* than *prophetic*. These individuals may not be "false prophets or prophetesses," yet may not give a true representation of what God is really saying. Most of the time these individuals may have good intentions, but because of pride they have positioned themselves to give prophetic ministry in inappropriate settings with unsanctified intentions often motivating them.

I am not talking about people who make mistakes in the process of learning to move and flow under the direction of the Holy Spirit. Sometimes, because we are human, we may misspeak or misquote something we are ministering. On one occasion, I was delivering a congregational prophetic word regarding an anointing for healing from pain that I sensed God was releasing

to the people that day. As I prophesied, I told the people who were having pain in their bodies to step out and come forward for prayer. As they were coming, however, I declared, "God says, Because of your obedience to move out and lay hold of this anointing to release your pain, God is going to release to you a *new anointing for pain!*"

Well, people stopped in their tracks! Of course, that was not what I meant to say. I meant to declare a new anointing for *healing*, but that's not how it came out.

On another occasion, I heard a very anointed man of God praying for a woman with an inoperable brain tumor. As he prayed he said, "Lord, I just curse this *head* and command it to shrivel up and die!" Of course he was cursing the tumor, but that's not how it came out.

On yet another occasion, in one of our services, a man was prophetically preaching and declaring what he was seeing. "….and even as the four and twenty elders lay castrated before the throne…." Yikes! Of course he meant they lay prostrate before the throne, but again, that's not how it came out.

We must be prepared to face mistakes, to repent when we make them, and to be humble and submitted in the process. In many of these instances, the revelation was accurate, but the human vessel that delivered the word was not perfect. Let's be careful not to become "spooky spiritual" or "hyper prophetic" and recognize that we are human, and will at times make mistakes. Nevertheless, as we keep our hearts right before God and man, the anointing of the Holy Spirit will continue to be released in and through our lives.

## Proper Prophetic Protocol

As women of vision we must be willing to continuously sharpen our prophetic edge, yet also follow some guidelines for proper prophetic protocol. It is important for women and men of God alike, who desire to be used prophetically, to be humble, to

be submitted to those in spiritual authority, and to be teachable regarding all we say and do. If we desire to be a minister and to be used to give prophetic messages to individuals, churches, cities, or nations, we must first learn to hear the voice of the Lord upon our knees in intercession, and to *pray* His purposes before we *say* His purposes.

It is never appropriate to use a "prophetic word" to try to manipulate a situation for our own interest. I have seen people, lacking integrity in their ministry to another, by "prophesying" that the other person should give them money, invite them to their church, or even say the person should marry them! While this is horrific behavior, we certainly don't want to throw the baby out with the bath water. We need to learn the difference between what is truly the voice of God and what is our own fleshly agendas. We must constantly submit ourselves to God's purposes in every situation, especially if we think we are speaking God's heart and purposes to an individual.

As pastors of a prophetic church we encourage people to hear from God regularly; however, we do not allow people to run around prophesying to one another all the time. We have strict guidelines in place that maintain the integrity of the Word of the Lord.

We ask that people in our house do not minister "parking lot prophecies," which are prophetic words shared outside of the setting of spiritual oversight. We also ask that words be recorded, either by tape or CD recording, or by writing the word out for future reference. This protects the person giving the word, so that they are not misquoted, as well as the person receiving the word, so that they can accurately pray and relate what has been spoken.

It's also a good idea to submit a copy of any prophetic ministry you receive to those who are your spiritual leaders so that they can assist in the interpretation of the prophecy. Sometimes people hear only a part of what God is saying. Other times they hear only what they choose to hear. Wisdom is often found in

allowing others who know you and who are watching for your souls to speak in to your life.

We have also found that it is valuable to reinforce some basic biblical principles regarding the fulfillment of their prophecy. We encourage them that the word must be mixed with faith in order to see destiny unfold. We also instruct them that God has a timing for His word to come to pass, and it often conflicts with our timing. Finally, we teach that prophecy is conditional based upon our response of obedience to all God says.

Deborahs will know how to harness and release the power of the voice of God into everyday situations as well as into issues that shape nations. God's prophetic women will prophesy to the dry bones in their homes, communities, and nations and will dare to be women who make a difference!

*So the word of the Lord grew mightily and prevailed* (Acts 19:20 NKJV).

## Endnotes

1. Marilyn Hickey, *Famous Christians in History: Maria B. Woodworth-Etter*; Marilyn Hickey Online; www.mhmin.org/FC/fc-0496Maria%ZOWE.htm.

2. Hickey, *Famous Christians in History: Maria B. Woodworth-Etter*.

3. Hickey, *Famous Christians in History: Maria B. Woodworth-Etter*.

4. The Riley Center: About Domestic Abuse, Statistics; www.rileycenter.org/domestic-violence-statistics.html.

# CHAPTER THREE

# *Women in Ministry*

When I was growing up, I had three brothers with whom I was very competitive. Many of my friends were boys, and I was what some would call a tomboy. I was also a gymnast, so I was very strong and would play many of the sports they would play. My mom would jokingly say that I would never get a boyfriend if I didn't quit beating all of my brothers' friends at arm wrestling!

My mom was a great inspiration to me during my growing-up years. She was highly educated, having studied and graduated from college with a degree in science, specializing in chemistry. She had studied during a time when it was not very popular for a woman to excel in the scientific field and was often the only woman in her university classes. At that time, she faced a gender prejudice at college that most women today would never dream of facing.

When she was raising me she would say, "Jane, don't ever let someone tell you that you can't do something or be something simply because you were born a girl. If you want to be president of the United States, don't let the fact that you are a woman stop you." For the record, I have no desire to be the president; however, this encouragement built a principle in my heart from the time I was young that I could achieve anything I desired without being limited by the fact that I was a female.

Unfortunately, the first time I was told I couldn't do something, or be something because I was born a girl was after I got saved and went to church! What a sad testimony to the freedom Christ died to bring us.

After the Lord had spoken to me about a life calling into ministry, I shared this incredible experience with my pastor (who was a good man leading a traditional congregation). He very gently broke the news to me that I could not have possibly heard the call of God, and he said, "Jane, women don't preach. Sure, you can teach a Sunday school class or perhaps even marry a pastor, but you cannot preach, because you are a woman."

For many years, whenever the subject of women functioning or serving in ministry has been approached, a few Scriptures have been used to disqualify women from service in churches based on gender. These excerpts have included:

> *Let your women keep **silence** in the churches.... Let the woman learn in silence with all subjection. But I suffer not a woman to teach, nor to usurp authority over the man, but to be in **silence**"* (1 Cor. 14:34; 1 Tim. 2:11-12).

Many have used these verses to label Paul as prejudiced against women. However, Scripture interprets Scripture and must be set in context with the rest of what has been written. We will study these difficult passages in a later chapter to understand that much of Scripture which has been quoted from God's Word to keep women quiet was not the intent of either the earthly or heavenly authors.

Contrarily, throughout Paul's writings, we see many women who were actually strong co-laborers with him in ministry.

**Phebe** was a deaconess at Cenchrea whom Paul trusted to deliver the Epistle to the Romans. She is called a "succourer of many," which is the Greek word, *prostatis*, which means "to stand before (in rank), to preside" or in other words, a presiding officer or an elder (see Rom. 16:1-2).

**Lydia** was an influential businesswoman who was Paul's first convert in Philippi. She opened her home as a ministry center for Paul while he was in the region and co-labored with him to further the Gospel (see Acts 16:12-15,40).

**Priscilla** co-labored with her husband, Aquila, as a ministry team. They instructed Apollos in the Gospel and co-pastored a church in their home. Some believe that the fact that Paul mentions Priscilla's name first indicates that she was the more prominent minister of the team (see Rom. 16:3; 1 Cor. 16:19).

**Junia** and Andronicus were another husband-and-wife team whom Paul calls "notable apostles" (see Romans 16:7).[1] God is not just raising up women who are prophets to serve the Body of Christ, but also mantling women with the authority and anointing of apostles as well.

**Chloe** pastored a church in her home and reported to Paul for oversight (see 1 Cor. 1:11).

**Mary, Tryphena, Tryphosa, Euodias**, and **Syntyche** were all co-laborers with Paul in the work of the ministry (see Rom. 16:6,12; Phil. 4:1-3).

When Paul writes regarding the office of a bishop, he lists certain qualifications as to who can serve in this regard. He begins by saying:

> *If a **man** desire the office of a bishop...* (1 Tim. 3:1b, emphasis added).

The word used for "man" is the Greek word *tis*, which means "anyone."[2] Paul did not use the Greek word for man, *aner*, which would have concluded any debate regarding the ability of a woman to serve in a bishop or oversight position. Rather, he said, "*If **anyone** desires the office of a bishop....*"

Therefore, we see that Paul did not practice restricting women from service in ministry. Why then has there been so much restriction placed upon women to prevent them from acting as fully functioning members in Christ's service? Much of this restraint is caused by inaccurately applying Scriptures and because of thought patterns that have caused us to resist change.

Seth Cook Rees, President of the Pilgrim Holiness Church in 1897 said:

No church that is acquainted with the Holy Ghost will object to the public ministry of women. We know of scores of women who can preach the gospel with a clearness, a power and an efficiency seldom equaled by men. Sisters, let the Holy Ghost fill, call and anoint you to preach the glorious gospel of our Lord.[3]

## Jesus Liberated Women

In the beginning, God created man and woman to work together in their mandate to take dominion over the earth. Unfortunately though, sin and temptation entered into the picture, and Eve was deceived into partaking of forbidden fruit. Adam also partook of the fruit; however, Scripture gives no indication that he was deceived. This transaction resulted in the fall of mankind and the banishment from the Garden of Eden where Adam and Eve had lived in the presence of the Lord continually.

The results of the fall were devastating, both to mankind as well as to the entire earth realm. All creation began to groan and travail for a day of deliverance. Women in particular felt the affects of the curse and the fall. They brought forth children in pain and lived century to century in cultures where they were valued as little more than cattle.

However, when Jesus lived on earth, He started to destroy the bondage women were subjected to. He began to restore woman to her place of ruling and reigning with God on the earth and reaffirmed that she was a spiritual being with direct access to God for herself. Let's take a look at some of the women Jesus interacted with and see what lessons we can learn through His actions.

1. *The Virgin Mary.* Prior to the Spirit of God overshadowing Mary and impregnating her with the Son of God, God did not first ask her father's permission or even inform him. Neither did He first consult her fiancé. He didn't deal with any man before allowing the Holy Spirit

to come upon her. He spoke directly to Mary through the angel, Gabriel.

2. God allowed Jesus to first be proclaimed as the Redeemer to the Jews by a woman, the *Prophetess Anna*. See Luke 2.

3. Jesus revealed Himself as the Messiah to a *Samaritan woman* before He revealed Himself to any of His disciples. In John 4, when Jesus discussed theology with the Samaritan woman at the well, He broke two cultural rules. He spoke to a Samaritan, breaching the racial code, and He spoke to a woman, breaking the gender bias. Through a word of knowledge regarding her life, she recognized who Jesus really was. Then she went and evangelized a city. Jesus launched a woman in ministry!

4. Jesus approved of *women learning spiritual matters*. In Luke 10:38-42, we find the story of Mary and Martha. Martha was busy running around caring for the house and serving food while Mary sat at the feet of Jesus. When Martha complained, Jesus explained that Mary had chosen the better part. We've all heard messages from this passage about how it is better to sit at the feet of the Master rather than running around serving; however, Jesus was making a social statement, not just saying that He is delighted when we sit at His feet. He was saying that He approved of Mary's desire to learn during a time when it was forbidden for women to learn spiritual things. He was reaffirming that Mary was a spirit-being first, with a heart after God, and a servant of people second. This was a radical statement in the religious climate of that day. As a matter of fact, Rabbi Eliezer, a first-century teacher said, "Rather should the words of the Torah be burned than entrusted to a woman...Whoever teaches his daughter is like one who teaches her obscenity."[4]

5. Jesus received *financial support from women*. In Luke 8:2-3, Mary Magdalene, Joanna, and Susanna are called by name for their financial support of Jesus' ministry. Women were created to be financially prosperous so that they might aid in the work of the spreading of the message of the good news. Notice that Jesus had women in His entourage and that they were also His disciples.

6. God chose a *woman* to be the *first to proclaim Jesus' resurrection*. This is important in a time when a woman's testimony was thought not to be reliable merely because it came from the lips of a woman. Jesus chose to allow His resurrection to be proclaimed by women first, validating that they can speak the truth as well.[5]

7. *Women were present at the birth of the Church on the day of Pentecost and were partakers of the outpouring of the Holy Spirit*. See Acts 1–2.

8. Concerning the woman caught in adultery, Jesus confronted the double standard of that day. What about the man?

9. Jesus identified with *women when He stooped to wash His disciples' feet*. This was considered the work of slaves and women.

10. *Women were pioneers in spiritual endeavors and discoveries*. Women were last at the cross, first at the tomb, first to proclaim the resurrection, attended the first prayer meeting in the upper room, first to greet Paul and Silas in Europe, and included the first European convert (Lydia) who financially supported Paul and had a church in her home.

These are but a few examples of how Jesus came to interact with women as well as men and to bring complete restoration in our ability to relate directly to the Lord of the universe. This is vital if we are to hear His voice and understand His strategies for change, which He longs to impart to those who have ears to hear.

## Endnotes

1. Kelly Varner, *The Three Prejudices* (Shippensburg, PA: Destiny Image Publishers, Inc., 1997), 61-63.

2. Varner, *The Three Prejudices*, 63.

3. Seth Cook Rees, *The Ideal Pentecostal Church* (Cincinatti, OH: Knapp, 1897), as quoted by J. Lee Grady, *10 Lies the Church Tells Women* (Lake Mary, FL: Charisma House, 2000), 1.

4. Mishnah, Sotah, quoted by Frank Daniels, *The Role of Women in the Church*, 1999, www.frikteck.com/rel/women.htm.

5. Baba Kamma, as quoted by Let Us Reason Ministries, *Women in the Church*, www.letusreason.org/Pent45.htm.

CHAPTER FOUR

# Women of Vision

The word *vision* is related to our ability to see. At times it is used to refer to things seen with the natural eye that are within the natural realm. Spiritually speaking, however, vision can refer to seeing things with our spiritual eye that are within the realm of the spirit.

At times, spiritual sight will refer to the ability to see things prophetically, or in other words, things that are yet to happen. In other instances, spiritual sight refers to a clarity that comes into our natural understanding as a result of comprehending that which is occurring in the spiritual realm at the time.

## Vision Brings Breakthrough

"Having vision" also refers to the ability to grasp the mind and will of God for a given situation, or even for one's life, which will help to develop focus and priority along life's journey. Vision penetrates the clouds of darkness, confusion, and fear, and releases the light of revelation, which illuminates the path that leads to destiny. Vision will bring breakthrough!

Vision enables individuals to see "the big picture" rather than getting stuck focusing on something that seems vital and important at the time, but which is, in reality, quite trivial in the grand scope of one's life.

Think of vision as though it is a jigsaw puzzle that has been dumped out of a box onto the table. Each piece is vital to the completion of the whole; however, on its own, it communicates very little. Our goals, dreams, plans, and desires combined with

the personal words God has spoken to us, as well as our natural and spiritual gifts and abilities He has deposited within us, comprise the puzzle pieces. But it is only as we yield to the Lordship of Jesus Christ, and His divine call and purpose for our lives, that those puzzle pieces can be arranged to bring forth the whole picture of the vision and destiny God has called us to.

Proverbs 29:18 tells us, "*Where there is no vision, the people perish.*" *In another translation it reads: "Where there is no revelation, the people cast off restraint*" (NIV). And in yet another translation, it admonishes us: "*Where there is no vision, people run wild*" (Modern Language Translation).

If ever there was a picture of the state of our society today, this is it! This generation has been confronted by the belief system that says there are no absolute truths, no absolute standards. We are living in a day where every man does what is right in his own eyes with no regard for the laws of God or for His purpose and plan for his life. Many people struggle with the feeling that their lives have little or no value. In short, they lack a godly vision!

## Vision for This Generation

It's no wonder this generation feels this way. Our children have been taught that we exist merely as a result of some cosmic accident that occurred millions of years ago, which somehow caused the creation of life! This microscopic life form then, somehow, accidentally evolved through time into fish, birds, animals, and eventually human beings.

The preciousness of life seems to be treated with very little regard as violent crime, abuse, and abortion run rampant in our society.

With this vision of where we have come from and the constant devaluing of human life incessantly pounded into our minds, no wonder we have difficulty grasping the fact that we were created in God's image and likeness to fulfill His divine

purposes on earth. We were created to have dominion, to rule and to reign with our Creator, as joint-heirs with Jesus Christ.

It is imperative that we rise up as women of vision and begin to speak life to this generation who seem to be wandering aimlessly. As we give them vision and a sense of destiny and purpose, we will confront hopelessness, discouragement, and fear. We will take them from a place of perishing to a place of flourishing, from a place of death to life!

We must first, however, lay hold of God's vision for our own lives and understand the significant part that each of us has to play in the plan of God. It is time for us to understand that, as women, we are not second-class citizens in the Kingdom of God, but rather, we have a vital responsibility to fulfill.

It will require us to become women like Deborah, who was able to rise above the oppression, hopelessness, prejudice, and darkness of her day, to bring forth deliverance, vision, life, and light to her generation.

## Vision for True Identity

While watching a news program regarding women in the Middle Eastern countries today, I was grieved by the images of these women dressed in black burkas, the cultural dress in many Islamic nations. The burkas completely cover the women from head to toe leaving only a small slit for their eyes to see through, thus stripping them of any expression of beauty or any identity. Except for the eyes, you know very little about these women because their bodies, and I have to wonder if their souls as well, are shrouded in secrecy.

As I thought about this in relation to Christian women in the church, I realized that many are wearing spiritual burkas, with masked identities, motivated by wrong concepts of religious traditions. As a result, women are living with an overarching sense of false identity, anchored in shame, fear, and spiritual bondage. In order for women to strip off this burka, we must

expose ourselves to the light and freedom of God's Word so that we can be who God designed us to be.

To fully embrace all that God has purposed for women in the 21st century, we must go all the way back to creation to understand God's biblical order and intent. Having this understanding will negate some of the religiously promoted concepts that have limited women in their individual functions in the church and in the earth.

## Created in God's Image and Likeness

*And God said, Let Us make man [mankind] in Our image, after Our likeness: and let them have dominion over the fish of the sea, and over the fowl of the air, and over the cattle, and over all the earth, and over every creeping thing that creepeth upon the earth. So God created man in His own image, in the image of God created He him [them]; male and female created He them. And God blessed them, and God said unto them, Be fruitful, and multiply, and replenish the earth, and subdue it: and have dominion over the fish of the sea, and over the fowl of the air, and over every living thing that moveth upon the earth* (Genesis 1:26-28).

As we look at this familiar passage of Scripture, we find that first of all God said, "*Let Us make man in Our image.*" Even here in Genesis chapter 1, we see that God is revealing His triune nature, as God the Father, the Word, and the Holy Spirit. John 1:1-3 tells us, "*In the beginning was the Word, and the Word was with God, and the Word was God. [He] was in the beginning with God. All things were made by Him; and without Him was not anything made that was made.*" This multifaceted nature of God would be reproduced in this new creation He was about to form.

God went on to say that He would make man in His image and likeness. This word "man" is the Hebrew word *adam*,[1] which means "a human being, the species, mankind." So we could read this passage as saying, "God said, Let Us make mankind in Our

image...and let *them* have dominion." Clearly God was not just referring to the male of the species but to the entire human race.

This word "man" is also used in Genesis to refer to Adam, the first male, but we find that in Genesis 2:23 when God separated woman out from the man, a different Hebrew word is used. In this case the word *iysh*[2] is used, which indicates "a man as an individual, a male person."

What does all this mean? When God created the first mankind being, He took the dust of the earth and formed "adam"—a human being. This being was created to be a direct reflection of its Creator, a replication of all He is. Everything that is in His nature and character was formed in this original being. It was a single being, yet God referred to this mankind creation as "them." "Let *them* have dominion...."

"*So God created man in His own image, in the image of God created He him; male and female created He them*" So, did God originally create "him," or did He create "them"? To answer this question, we must return to a basic understanding of the triune nature of God. God is one God with three different, separate, and unique expressions. We do not serve three gods—Father, Son, and Holy Spirit. So how can three be One? This is a mystery to our human understanding, yet one thoroughly supported with the entirety of the Scripture. Inside of one God are three. Therefore, we see that in this single mankind being, "him," whom God originally created was "them." God placed both a male and female expression within one original being. Together they formed the fullness of the image, nature, and character of God.

Later, God declared that it was not good for man to be alone, solitary, isolated, sufficient in himself, but that He would make for Adam a helpmeet. This word "helpmeet" (*neged*) means "one that aids, surrounds and protects; a counterpart, opposite, another point of view."[3] When God formed woman, He did not take another lump of dirt. He did not speak her into existence as

He did the animals. Rather, He caused a deep sleep to fall upon Adam and separated out woman from man. In spirit, she already existed, created at the same moment as her male counterpart. With the rib from man's side, God gave her a body, and the distinctions of male and female were born. Both were created in the image of God, and together they revealed the fullness of His character, nature, and likeness.

## Created for Dominion

*And God blessed them, and God said unto them, Be fruitful, and multiply, and replenish the earth, and subdue it: and have dominion over the fish of the sea, and over the fowl of the air, and over every living thing that moveth upon the earth* (Genesis 1:28).

If God gave this command to male and female, He knew it would take both to cause it to come to pass. Being fruitful and multiplying—reproducing themselves—would happen only as they worked together. He did not create us to propagate our species without needing someone else. Nor did He intend for any of the rest of this mandate to be fulfilled by only one part of the team. God intended for male and female to work together to have dominion over the earth.

*Dominion* is defined as having "the power or right of governing and controlling; having sovereign authority; rule, control, domination."[4] God saw, in His infinite wisdom, that this would be accomplished only as they worked together. We were not to be engaged in a struggle for dominion over one another, but rather exercise our rulership over the earth. We were created to do this. We were created with divine attributes. We were created to be purposeful, productive, prosperous, and powerful!

In understanding God's creation purpose for man and woman, we see that woman was created in God's image just as man was. We find that woman is not a spiritual second-class citizen because her body was formed second. She was given the

same mandate that man was given to be fruitful, multiply, sub-due, and have dominion. Woman was created to be man's oppo-site, his counterpart, his partner for the purpose of aiding him, surrounding him, and protecting him. Sometimes this protection comes as she is "*neged*," holding an opposite point of view. But the goal is for the two to work together and thus reflect to the world the image and nature of their Creator.

## They All Fall Down!

Of course, we realize that this wonderful plan for dominion and communion with God was messed up when Adam and Eve fell into sin in the garden. As the story goes, satan came to Eve and tempted her to eat of the fruit of the tree of knowledge of good and evil, which had been forbidden by God. He came with the oldest trick in the book (literally) when he caused Eve to question God's directives by saying, "Hath God said…?" Indeed, satan's tactics are no different today when he comes to the people of God who are full of zeal and passion for the purposes of God. If he can cause us to question God's Word to us, we will begin to align with his plan rather than the plan of God.

In stirring up the question of what God had said to Adam and Eve, satan took it one step further. He told Eve that God was holding out on her. He told her that God knew that once they ate of the fruit of the tree, they would "be like God," as though somehow that threatened God's place in the universe. What Eve forgot is that they were already like God, created in His image and likeness. In other words, satan stole her identity! This is why women throughout the earth continue to suffer from an identity crisis today. It all goes back to the garden.

The story continues on that in her state of deception, Eve partook of the fruit of the forbidden tree, then ran to her hus-band, and gave it to him to eat. Scripture tells us that Eve was deceived, but that Adam willingly entered into sin. Together,

Adam and Eve found themselves separated from God and brought a curse of death on all mankind.

## Jesus—The Last Adam

Scriptures tell us that Jesus was slain from the foundation of the earth (see Rev. 13:8). This means that God knew man would sin and that He, in His infinite wisdom and knowledge, had a plan in place to redeem mankind from the fall. After thousands of years of dealing with fallen humanity, God sent His Son, Jesus, to redeem us from the curse of separation and death that came at the fall. The Bible calls Jesus the "last Adam," contrasting Him with the first man, Adam, who disobeyed God and led all captivity captive.

> *And so it is written, "The first man Adam became a living being." The last Adam became a life-giving spirit. However, the spiritual is not first, but the natural, and afterward the spiritual. The first man was of the earth, made of dust; the second Man is the Lord from heaven. As was the man of dust, so also are those who are made of dust; and as is the heavenly Man, so also are those who are heavenly. And as we have borne the image of the man of dust, we shall also bear the image of the heavenly Man* (1 Corinthians 15:45-49 NKJV).

> *Therefore, just as through one man sin entered the world, and death through sin, and thus death spread to all men, because all sinned.... For as by one man's disobedience many were made sinners, so also by one Man's obedience many will be made righteous* (Romans 5:12,19 NKJV).

> *For since by man came death, by Man also came the resurrection of the dead. For as in Adam all die, even so in Christ all shall be made alive* (1 Corinthians 15:21-22 NKJV).

## Last Adam, Last Eve?

There was a first Adam as well as a first Eve who failed. Jesus came as the "last Adam" to set right all that the first Adam had messed up. So, if there was a last Adam who did it right, doesn't it make sense that there will also be a last Eve who will do it right as well?

I believe the "last Eve" is the last-days Church who is rising up in victory. Just as the first Eve was taken from the side of the first Adam to co-labor with him in taking dominion, so the last Eve was taken from the side of Christ when His blood poured out, having been pierced as He hung on the cross. We are called to co-labor with Him and to fulfill our original mandate of taking dominion in the earth.

After the fall, God released a decree to the serpent saying:

*From now on you and the woman will be enemies, as will your offspring and hers. You will strike His heal but He will crush your head* (Genesis 3:15 TLB).

The woman and her seed will crush the head of the serpent! This is referring to Christ who was to come and restore all that the serpent had stolen from mankind. It also refers to the seed that is within the woman—that what she does will render defeat to satan and all his plans. The seed of the woman has the power to destroy demonic strongholds and set captives free.

In his book, *Woman, God's Secret Weapon*, Ed Silvoso tells us of how important it is for women to understand the threat we represent to the kingdom of darkness. He writes:

Women need to discover this truth. The devil knows that God does not lie—what God promises always comes to pass. This is why Satan has spent centuries belittling women and weaving a web of lies into a formidable worldwide network of oppression to hold them down. He knows that when women find out who they really

are, his evil kingdom will come to an abrupt end. He cannot afford to have women walking upright. He desperately needs to keep them down.[5]

The devil is terrified of the day that women take back their stolen identities and realize they were created for dominion in the very image of God. As women become full participating members of the Body of Christ, the devil trembles in fear as he watches the Church, the second Eve, rise to her calling and destiny. This is why he has worked for thousands of years to oppress women, keeping them shrouded in false identity and shame.

## Overcoming Religious Confusion

Because of this "burka" of false identity, not understanding who God formed them to be, women have had to face much opposition, not only in society according to cultural dictates, but also within the church as well. Florence Nightingale said, "I would have given the church my head, my hands and my heart, but she would not have them."[6]

Jesus came to restore women to a place of functioning in His Kingdom. In this important season of the Spirit, God is once again making a place for women within the church and bringing them forth to give their all for Him. Unfortunately, this was not always the case. In looking back through church history, we notice the mind-sets, concepts, and attitudes of some of our church fathers, which returned women to their place of immobilization and dysfunction in the church. Understanding their perspectives may shed some light on things we are dealing with today. These perspectives are opinions of man, and not in any way derived from the Scriptures by which we are to live and form our views.

**Apocryphal Teachings**. Ecclesiasticus 25:19,24. "No wickedness comes anywhere near the wickedness of a woman... Sin began with a woman and thanks to her all must die."

**Tertullian (160-225).** "Do you not know you are each an Eve?...You are the devil's gateway: you are the unsealer of the forbidden tree: you are the first deserter of divine law...you destroyed so easily God's image, man. On account of your guilt...even the son of God had to die."[7]

**Clement (150-215).** "Man is stronger and purer since he is uncastrated and has a beard. Women are weak, passive, castrated and immature...."[8]

**Origen (185-254).** "It is not proper for a woman to speak in church, however admirable or holy what she says maybe, merely because it comes from female lips."[9]

**Ambrose (340-397).** "They should go in rags and mourning because all the evils had come in the world through them."[10]

**St. Augustine of Hippo (354-430).** "What is the difference whether it is in a wife or a mother, it is still Eve the temptress that we must be aware of in any woman....I fail to see what use women can be to man if one excludes the function of bearing children."[11]

**Jerome—4th Century Monk.** "As long as woman is for birth and children, she is different from man as body is from soul. But if she wishes to serve Christ more than the world, then she will cease to be a woman and will be called man."[12]

**Salimbene, 13th Century Franciscan Monk (1221-1288).** "Woman was evil from the beginnings, a gate of death, a disciple of the servant, the devil's accomplice, a fount of deception, a dogstart to godly labours, rust corrupting the saints....Lo, woman is the head of sin, a weapon of the devil, expulsion from Paradise, mother of guilt, corruption of the ancient law."[13]

**Calvin (1556).** "Woman was created later to be a kind of appendage to the man on the express condition that she should be ready to obey him, thus...God did not create two heads of equal standing but added to the man a lesser helpmeet."

**Martin Luther.** "Men have broad shoulders and narrow hips, and accordingly they possess intelligence. Women have narrow

shoulders and broad hips. Women ought to stay at home; the way they were created indicates this, for they have broad hips and a wide fundament to sit upon, keep house and bear and raise children." He also said, "If women get tired and die of childbearing, there is no harm in that; let them die as long as they bear; they are made for that."[14]

In understanding some of the prejudices and mind-sets that these men of faith held, we can see that God has already done a tremendous work of liberating women from such bondage. We must, however, shake off every last chain of the philosophies and the mind-sets that would shackle us and hold us back from fulfilling destiny within the Body of Christ.

We must lay hold of the image of our God-designed destiny and not allow an inferior, weak, selfish, substandard concept within our limited human understanding to take its place. We must be women of vision!

### Endnotes

1. Biblesoft's *New Exhaustive Strong's Numbers and Concordance with Expanded Greek-Hebrew Dictionary*. Copyright (c) 1994, Biblesoft and International Bible Translators, Inc.), 120.

2. Strong's Concordance, 376.

3. Strong's Concordance, 5048.

4. *Webster's Encyclopedic Unabridged Dictionary of the English Language*, Value Publishing, Inc., 1997.

5. Ed Silvoso, *Woman God's Secret Weapon* (Ventura, CA: Regal Books, 2001), 17.

6. Henry Ramaya, *Arise, Daughters of Zion, Arise* (Malaysia, Firstfruits Sdn. Bhd 1991), 1.

7. Tertullian, *On the Apparel of Women*, 1.1 quoted in J. Lee Grady, *10 Lies the Church Tells Women*, 118.

8. Kelly Varner, *The Three Prejudices* (Shippensburg, PA: Destiny Image Publishers, Inc., 1997), 61-63.

9. Katherine Bushnell, *God's Word to Women* (Mossville, IL: God's Word to Women Publishers, 1983), 316.

10. Varner, *The Three Prejudices*, 70-71.

11. Augustine, *Literal Commentary on Genesis IX.5*, as quoted in Grady, *10 Lies the Church Tells Women*, 18.

12. Vern Bullough, "*Medieval Medical and Scientific Views on Women,*" Viator 4 (1973) quoted by Grady, *10 Lies the Church Tells Women*, 136.

13. Salimbene, as quoted by Grady, *10 Lies the Church Tells Women*, 118.

14. John Calvin, Commentary on the First and Second Epistles of Paul the Apostle to Timothy, (1556; Oliver and Boyd, 1964), as quoted by Davis/Johnson, *Redefining the Role of Women in the Church* (Santa Rosa Beach, FL: Christian International Publishers, 1997), 25.

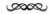

## Women Who Make a Difference
## Through the Prophetic Voice
### DR. BONNIE CHAVDA

*The ancient Jewish sages called the spirit of prophecy **bat kol**, the daughter's voice. In story after story from Scripture, the voice and instruction of a woman plays a pivotal role in the destiny of those around her. The Jews have a saying, "God gave ten measures of speech to mankind and women got nine of them!"*

*Beyond the prophetic voice there was an accompanying witness testifying to God's apostolic authority upon His vessels of old. That witness was the power to call elemental forces into subjectivity to the divine will of God through miracles, signs, and wonders. Such witness was with Moses before Pharaoh. Moses' rod of miracles ate up that of the sorcerers in testimony to the prophetic word he delivered. Jesus came as the Apostle of our faith, the final Messenger, declaring that even if people rejected His words, the miracles He performed testified to His Kingdom power. Such was the ministry of Deborah in a day of war. The stars and angels of Heaven were moved together with the waters and armies of earth to perform the desire of God as she fulfilled her prophetic destiny in a generation.*

*By design and equipping, women are communicators. The unique combination of intuition and communication make women especially powerful as teachers, negotiators, representatives, nurturers, and leaders. Such vessels being filled and anointed by the Holy Spirit are no longer kept as "secret" weapons. What Eve lost at the tree in Eden was restored on the Tree of Calvary and empowered on the day of Pentecost. This is a truth whose set time has come.*

*Mahesh and I are witness to the fact that we are living in a new era concerning the destiny and power of women who know their God.*

*The sound of woman's voice, her power, insight, and influence with signs following is being displayed across the globe. This is God's doing, and it is marvelous in our eyes. We cannot deny the significance of Jesus commissioning the women who ministered to Him as the first witnesses of His resurrection. From that moment the whole of creation quivered under the anxious press for release from the bondage of sin and death. Every day that passes, the image and form of the Bride He is molding to take up this mantle is emerging out of the shadows to take her place in His name. Significantly, like every move of the Spirit in history, this emergent company includes many women at the forefront.*

*God is restoring the voice and presence of His daughters to the fivefold ministry of the Church. In the early church, women were commonly church leaders as believers met from house to house. Even in the birth of His Son, God depended on a woman! The Fatherhood of God gives security, identity, vision, and empowerment to His family, and as in the natural so in the spiritual. It is plain to see that there is no fatherhood without a woman intimately involved. Jesus told His disciples, "As the Father sent Me, so send I you." The mission, including the anointing for signs and wonders in the manner of the greater works He prophesied, will require the full participation of men and women as co-laborers together contributing their unique characteristics to the mission.*

*For God to be fully revealed in the Church as Father, and for His children to be brought forth and molded, the influence of godly women is critical. We find ourselves living in a day like that of Deborah and the judges of Israel. The nations languish for lack of knowledge of the true God. At the same time the birth pangs of His coming are manifest in war in the natural and spiritual realms. Crucial to this generation and the next are ministers of this great*

Gospel of the Kingdom in power to heal and deliver in the face of false philosophies and the demonic flood being poured out of the serpent's mouth. But God is pouring out His Spirit.

We are encouraging leaders everywhere to train up women as pastors, teachers, evangelists, prophets, and apostles. Mahesh and I have founded and pastor our church together. Our joint leadership tends to reproduce in kind. The unique combining of both male and female in equal partnership, whether single or married, and committed to the purpose and will of God is unstoppable. Faithfulness, loyalty, equipping, and fervor (not a person's gender) are the qualities that make up our "mighty men of valor." Authority in God's Kingdom, beginning with the working of miracles, is delegated from the throne. Therefore, everyone who comes under that authority will do the works of Jesus.

This equipping demands we be emissaries of God's prophetic rhema. Standing firm on His written revelation and promise of Scripture, it is time for action. As we train up leaders to take this generation into full possession of the promise of God, we will call, teach, mold, exhort, and impart to women in full. Deborah remains the prototype of the renaissance woman called for today. Rightly related to Heaven and earth in God and in her community, this woman comes up out of the wilderness leaning upon her Beloved. When Deborah was invited in to the war counsel of the nation's commanders, God anointed her with power to release the breakthrough for Israel.

"Who is she who looks forth as the morning, fair as the moon, clear as the sun, awesome as an army with banners?" We are looking for her rising. We are listening for her voice in this hour.

**Dr. Bonnie Chavda** and her husband, Dr. Mahesh Chavda, are founders and senior pastors of All Nations Church and head up a global prayer movement called the Watch of the Lord. Bonnie has served with her international evangelist husband in global mission work since 1980. She has a prophetic anointing and has authored numerous books. The Chavdas maintain ministry bases in North Carolina, Central Africa, and the United Kingdom, while conducting evangelistic crusades and training seminars around the world. Bonnie and Mahesh have four grown children and live at their home in Charlotte, North Carolina.

# CHAPTER FIVE

## *Interpreting the Hard Passages*

In my early years as a woman in ministry, I was occasionally the brunt of comments or attacks leveled against me for simply obeying God and stepping forward to speak His Word. One might think that these comments would have come from over-protective men who were threatened by a woman who could minister under the anointing. Actually, it was other women, more often than not, who gave me problems. One particular woman would turn her head away from me every time I got up to preach. I'm not sure how she stayed in that position for an hour, but I'm sure her religious reaction to a woman preacher was responsible for her stiff neck!

But it wasn't *always* women who challenged my position of ministry. On one early occasion in my ministry, my husband and I were operating as a team as visiting ministers in a church. My husband brought the message; then we both began to minister prophetically to the people. After the service, a man came up to me and stood in front of me with a look of anger on his face. I asked him if I could help him and he just continued to stare. So I asked him if he enjoyed the service. He said that he did, right up until the moment the Holy Spirit was grieved. I asked him at what point that may have been, and he said, "The minute you opened your mouth."

Whether it is in a man or a woman, a religious spirit will always attempt to stop the flow of ministry, often trying to put situations or circumstances in neat little boxes that fit its paradigm. When anything occurs outside of that box, it loves to

quote the Scripture, "*Let all things be done decently and in order*" (1 Cor. 14:40). It obviously is more focused on the part about decency and order rather than on the part that says "*Let all things be done.*"

As previously stated, often the role of a prophetic minister is to root up, pull down, destroy, throw down, and then to build and plant (see Jer. 1:10). No wonder it is very difficult to truly become women who make a difference if we are bound by dead religious patterns and mistranslated Scriptures. Consequently, it may be of benefit to take a look at some of the more difficult passages that have often been used to relegate women to a second-class citizen status in the Body of Christ.

Consider the words of Catherine Booth, co-founder with her husband, William, of the Salvation Army organization:

> Oh, that the ministers of religion would search the original records of God's Word in order to discover whether the general notions of society are not wrong on this subject, and whether God really intended woman to bury her gifts and talents as she does now.[1]

As a matter of fact, her husband, William Booth said, "Some of my best men are women!"

Much of the fuel that fires up a religious spirit that wants to hold women back comes as a result of difficult-to-understand Scriptures regarding women. Of course, all that we do must have a basis in Scripture and be founded on the Word of God. However, many of these passages have been mistranslated or misunderstood. Therefore, it is time to seek clarity on these issues that we may move forward and not become entangled again with bondage.

## The Rules of Proper Interpretation

According to Cindy Jacobs in *Women of Destiny*, there are four rules for properly interpreting the Scripture, especially those

hard passages that often stir controversy or seem incongruent with other passages. These rules are:

1) Determine the author's intent.
2) Determine the context within the chapter, the book, and the rest of the Bible.
3) Determine the historical or cultural setting at the time it was written.
4) Interpret unclear passages in light of passages that are clear.[2]

Let's look at some of these passages regarding women in light of these four rules.

## Question #1 — Are Women to Keep Silent?

*Let your women keep silent in the churches, for they are not permitted to speak; but they are to be submissive, as the law also says. And if they want to learn something, let them ask their own husbands at home; for it is shameful for women to speak in church* (1 Corinthians 14:34-35 NKJV).

1. *Author's intent.* Does the author intend for women not to speak in public worship services? If the author's intent was for women not to speak or to "keep silent," this would mean that there would be no place for a woman to teach Sunday school or to even sing in a choir. This "silence" cannot be the author's intent because in other passages of Paul's writings, women are clearly taught about their public praying and prophesying, which would obviously violate this silence (see 1 Cor. 11:3,5,10 NKJV). In the same Book of First Corinthians, Paul encourages the saints, "…you can all prophesy one by one" (14:31 NKJV). When the apostle Paul says "all," does he mean "all," or is he referring to only the men? If women were to keep silent, they could not participate in "all can prophesy."[3] Therefore, he cannot mean a literal silence as so many have concluded.

2. *Context within the chapter, the book, and the rest of the Bible.* In discussing the supposed "sentence of silence" upon women in

the early church, it is important to look at the context in the New
Testament as to whether women were in fact expected not to
speak. In Acts 2, we are told that after the outpouring of the Holy
Spirit, *"your sons and your daughters shall prophesy...and on My
menservants and on My maidservants I will pour out My
Spirit...and they shall prophesy."* Philip's daughters were recog-
nized prophetesses, so presumably they prophesied in a public
worship setting (see Acts 21:9).

3. *The historical or cultural setting at the time of writing.*

a) The word "speak" in the phrase, "not permitted to speak"
is from a word meaning continually speaking up. The same
word is used earlier in the same chapter referring to those
who speak in tongues without an interpreter.[4] In First Corin-
thians 14, Paul is addressing order in public worship, not set-
ting a "silencer" on saints, male or female. He is addressing
disruptive speech and asking that women not interrupt the
meetings with continual questions, but to learn quietly and
ask their husbands questions when they get home so as not
to disrupt the meeting for all.

b) Scholars also think that these two verses are Paul quoting
from another letter (see 1 Cor. 7:1— *"Now concerning the
things of which you wrote to me..."*) written from church lead-
ers. In Corinth, the Judaizers—having strong anti-woman
Jewish roots—were trying to press the church back into
legalism by restricting participation of women. A specific
Greek symbol is used at the beginning of verse 36 to indicate
the previous statement was a quotation (the equivalent to our
quotation marks).[5] When he speaks of women keeping silent,
and says that it is shameful for a woman to speak in church,
he is actually quoting the words written to him in their let-
ter, which emphasize, not biblical or Jewish law, but rather
the Jewish tradition.[6] "As says the Law" does not refer to any-
thing found in the Old Testament law, but rather to the tal-
mudic writings which out of Jewish tradition says it is

"shameful for a woman to speak." Paul is actually addressing and contradicting the introduction of anti-woman doctrine in the church.

c) The following verses, First Corinthiains 14:36-37 (NKJV) says, "*Or did the Word of God come originally from you? Or was it you only that it reached? If anyone thinks himself to be a prophet or spiritual, let him acknowledge that the things which I write to you are the commandments of the Lord.*"

Paul is saying, "Do you really believe the Gospel was written only for you Corinthian men? Are you going to silence women who were actually the first ones to preach the resurrection from the tomb? Paul's entire chapter 14 is all about being activated and involved yet using order in the public worship services.

4. *Interpret unclear passages in light of clear passages.* Are women entitled to less of an inheritance in Christ? Are we relegated to a second-class position? Are we somehow still under the bondage of the law or traditions? The author of First Corinthians 14:34, Paul, addresses this gender prejudice in Galatians 3:23-25:

> *Before this faith came, we were held prisoners by the law, locked up until faith should be revealed. So the law was put in charge to lead us to Christ that we might be justified by faith. Now that faith has come, we are no longer under the supervision of the law. You are all sons of God through faith in Christ Jesus, for all of you who were baptized into Christ have clothed yourselves with Christ. There is neither Jew nor Greek, slave nor free, male nor female, for you are all one in Christ Jesus. If you belong to Christ, then you are Abraham's seed, and heirs according to the promise* (NIV).

## God Is Releasing Esthers and Dealing With the Spirit of Ahasuerus in the Earth

> *For if you remain completely silent at this time, relief and deliverance will arise for the Jews from another place, but*

*you and your father's house will perish. Yet who knows whether you have come to the kingdom for such a time as this?* (Esther 4:14 NKJV).

At the time of Esther, King Ahasuerus signed a petition presented by the evil Haman requiring that all the Jews be destroyed. Esther had just become queen, but had not revealed her own Jewish heritage. If she was discovered, she would also be put to death for she would be counted among those marked for annihilation by Haman's plot. She was faced with the intimidation of the enemy and the choice to keep silent and protect herself. If she decided to speak up, she would risk everything.

This word *Ahasuerus* is defined in the Hebrew Lexicon as "*I will be silent and poor.*"[7]

The devil delights when women capitulate and remain silent and poor, without a voice and without influence. The enemy has worked overtime through the ages trying to keep women silent. But as Esther spoke up, she saved her nation and her generation. Promotion came to her house, and the blessings and favor of the Lord were her continual portion.

## Question #2 — Are Women Allowed to Teach? To Teach Men?

*Let a woman learn in silence with all submission. And I do not permit a woman to teach or to have authority over a man, but to be in silence. For Adam was formed first, then Eve. And Adam was not deceived, but the woman being deceived, fell into transgression. Nevertheless she will be saved in childbearing if they continue in faith, love, and holiness, with self-control* (1 Timothy 2:11-15 NKJV).

The silence issue again!

"*Let a woman learn in silence.*" In this case, many people miss the forest for the trees! The first part of the verse is "Let a woman learn!" This was not a restriction but rather liberation! Previously,

under the Jewish culture, it was forbidden for women to learn.[8] They were thought to be unworthy of instruction. Thus, Paul actually begins by releasing women from that restriction.

It is interesting to note, though, the incongruity in the translation of this word. The word "silence" is the Greek word *hesuchia*.[9] When it referred to women, the translators wrote, "*be silent.*" Yet, when it referred to men, the translators wrote "quietness."[10] (see 1 Tim 2:11, 2 Thess. 3:12). This verse should say, "Let women learn in quietness."

1. *Author's intent.* So was Paul saying again that women should just be quiet and never find themselves in a position of giving instruction or teaching men? Would this usurp their authority? We clearly see in the following Scriptures that certain women did, in fact, teach men; therefore, this couldn't be the full meaning of what Paul was trying to say.

Acts 18:24-26—Priscilla and Aquilla taught and corrected Apollos.

Second Timothy 1:5—Paul commended Lois and Eunice for teaching Timothy.[11]

2. *Context in Scripture.* First Timothy is a Book that addresses some who were teaching heresy. In First Timothy 1:20 and Second Timothy 2:17 and 4:14, he deals with Hymenaeus, Alexander, and Philetus who opposed sound doctrine. Some theologians believe one of these may have been a woman.[12] In the original language, "women" is plural in First Timothy 2:11, while in verse 12 it is singular, which could mean it is referring to a specific woman. Instead of "a" woman, it could mean "that" woman.

*And I do not permit a [that] woman to teach or to have [usurp] authority over a man, but to be in silence* (1 Timothy 2:12 NKJV).

Is Paul saying women can't teach at all in any setting? No, because this would be inconsistent with other Scriptures some of which he wrote:

Titus 2:4—Older women are to teach the younger ones.

Proverbs 31:26—She should have the law of kindness on her tongue.

Matthew 28:19-20—The Great Commission is given to men and women alike.

But what about the passage, "...*or to have authority over a man*"? The word used here for "authority" may shed some light on the matter. The Greek word *authentein* is used here instead of the more common term for authority, *exousia*, which is used everywhere else. This word *authentein* means "to dominate, usurp, to take control; associated with violence or even murder."

Cindy Jacobs, in her book, *Women of Destiny*, says, "Studies of the use of *authentien* in the literature of that day show that originally the word meant murder....*Authentien* was also used in connection with sex and murder."[13]

Paul was admonishing the saints and insisting that he did not want to see "that" woman spread false doctrine or dominate the meeting times with her foolishness. To understand this false doctrine, we must look to the next principle of sound interpretation and study the culture of the day.

3. *Cultural setting.*

*For Adam was formed first, then Eve. And Adam was not deceived, but the woman being deceived, fell into transgression* (1 Timothy 2:13-14 NKJV).

Understanding the cultural setting of First Timothy may aid in understanding what Paul was trying to communicate in this Scripture. At the time of his writing, there was false doctrine in Ephesus spread in part by women. Timothy's first Book was in response to the false doctrines seeping into the church in that day.

As previously stated, these heresies were not just being perpetuated by women, but men as well. However, there was one false doctrine in particular that was being spread by liberated yet unlearned Ephesian women. They were mixing Jewish tradition,

Christian and pagan doctrines. Even some teaching of the false goddess, Diana, (also known as Artemis) began to creep into the church. It sounded good, especially to those brought up in paganism, but was a deadly virus that had begun to spread, corrupting new believers with a lie. This is why Timothy wrote in such strong terms.

In Ephesus, the doctrine of the Gnostics began to appear. Gnosticism taught that Eve was created first, and she was called "The Originator" in the Gnostics version of creation. They taught that Eve was Adam's mother, not his wife, and was called "the progenitor of mankind." She is also said to have illuminated the earth as "The Illuminator" when she listened to the serpent.[14] This particular act of Eve's, which true believers view as disobedience to God, was viewed by Gnostics as enlightenment because Eve partook of the tree of the knowledge of good and evil and her eyes were opened. They also claimed that Adam was more or less the bad guy because he tried to stand in Eve's way from partaking of the fruit.

These false teachers who bought into the pagan lies disrupted the church services to teach their false doctrines and perform pagan rituals. Subsequently, Paul's command was for all women to learn quietly in submission. Remember, it had been forbidden for women to even be educated, so this occasion was probably their first learning opportunity. Paul was concerned and wanted them to learn true doctrine, not be infected by the false.

In this Scripture, Paul is setting the record straight according to Genesis. Adam was created first, not Eve. Adam was not deceived, but the woman was deceived—not enlightened— deceived![15]

Again, Paul was not just coming against the women teaching false doctrine. First Timothy 1:20 says he delivered two men to satan, Hymenaeus and Alexander. Also, Titus 1:10-11 says there were many rebellious men who were to be silenced. First Timothy 1:3 says that certain men were to be instructed not to teach strange

doctrine. Second Timothy 3:8,13 challenges *"men of depraved mind and imposters that take advantage of weak women."* So, this issue of false doctrine was infecting both genders.

These Scriptures are not meant to reinforce the macho positioning designed to keep women out of leadership roles in the church, or to support the thinking of biased individuals who say, "Women are to show up and then shut up!" Rather, in Proverbs 8:1-11, we see godly wisdom personified as a woman who cries out publicly. Women have a role and function in the Body of Christ and are even now being given that place.

## Saved Through Childbearing

*Nevertheless she will be saved in childbearing if they continue in faith, love, and holiness, with self-control* (1 Timothy 2:15 NKJV).

This is, once again, a misleading part of the verse. We must know that a woman's spiritual worth or salvation is not determined by being a baby-making machine. Women are saved the same way men are—by the blood of Jesus. Some scholars believe this verse should have been translated, "She shall be saved by the bearing of the Child (the Redeemer)."

In her book, *God's Word to Women*, Katherine Bushnell says, "Women are saved from their sins, and are saved for heaven, precisely on the same terms as men, and on no additional terms, for God is no respecter of persons. What Paul says here, as literally interpreted from the Greek is, 'She (woman) shall be saved by the childbearing' that is, by the birth of a Redeemer into the world."[16] We are after all told in Genesis that God would put enmity between the woman's seed, her Offspring, and the devil. The devil would bruise her Offspring's heal, but He would crush his head!

## Henrietta Mears—A Woman Who Did Not Keep Silent

Because this section's main topic is whether or not a woman should keep silent in the church or whether it is scriptural for a

woman to teach, let us now look at a woman who did both and changed the world.

In 1928, Henrietta Mears was hired to be the Christian Education Director at the First Presbyterian Church in Hollywood, California. Dissatisfied with the lessons she was provided with, she developed a passion to see quality materials for Sunday schools that would equip children and families in their understanding of the Word of God. She undertook the task of writing, developing, and teaching new curriculum that became an instant hit. In three years, the Sunday school attendance went from 450 to 4500.

Not only was Henrietta a teacher in the classroom on Sundays, but with a heart to mentor some of her students who showed promise, she worked with several young men to lay strong biblical foundations in their lives. Three of her star pupils were Bill Bright, founder of Campus Crusade for Christ; Richard Halverson, who later became chaplain of the US Senate; and a young man named Billy Graham.

Henrietta's passion continued as she founded a new publishing house to make her Sunday school materials available to the masses. Gospel Light Publications continues to be on the cutting edge of all that God is doing in Christian publishing. Henrietta Mears' book, *What the Bible Is All About*, has become one of the most popular Christian books and has been translated into 22 languages.

Henrietta was a woman who would not keep silent. She was truly a woman who made a difference.

### Endnotes

1. Grady, *10 Lies the Church Tells Women*, 189.
2. Cindy Jacobs, *Women of Destiny* (Ventura, CA: Regal Books, 1998), 228.
3. Grady, *10 Lies the Church Tells Women*, 56.
4. Grady, *10 Lies the Church Tells Women*, 60-61.

5. Grady, *10 Lies the Church Tells Women*, 63.

6. Grady, *10 Lies the Church Tells Women*, 64.

7. The Online Bible Thayer's Greek Lexicon and Brown Driver & Briggs Hebrew Lexicon, Copyright (c)1993, Woodside Bible Fellowship, Ontario, Canada. Licensed from the Institute for Creation Research.

8. Grady, *10 Lies the Church Tells Women*, 60.

9. Strong's Concordance, 2271.

10. Jacobs, *Women of Destiny*, 237.

11. Grady, *10 Lies the Church Tells Women*, 55.

12. Don Rousu, *Spread the Fire: The Truth About Women in Public Ministry* (Oct. 1997), 5; as quoted by Jacobs, *Women of Destiny*, 235.

13. Jacobs, *Women of Destiny*, 240.

14. Jacobs, *Women of Destiny*, 236.

15. Grady, *10 Lies the Church Tells Women*, 30.

16. Katherine Bushnell, *God's Word to Women* (Mossville, IL: God's Word to Women Publishers, 1983), 160.

❧❧❧

# Women Who Make a Difference Through Reformation
## Dr. Sharon Stone

*When Jane asked if I would write a segment in this book, I considered it an honor because of the caliber of woman Jane is in her personal life and her ministry.*

*I have been in the ministry for over 30 years now. When I look at women in ministry today, I think what a different world it is than that which I was raised in! We had few to no women role models. Then I look at many women's roles in traditional denominations and church structures today and I think, My God, things have not changed at all. As a teenager and in my early 20's, I struggled with God's call on my life. The precious loving church I was raised in believed women could be anointed and gifted but not called to a governmental position in the church. The statements by Katherine Kulhman when she said that she was being used by God only because some man somewhere wouldn't be obedient to his call, caused me and many others to feel like substitute teachers in the Body of Christ. Or worse yet, there were rebellious ones who took on masculine characteristics to fortify themselves in this priestly society.*

*This put me in a difficult position. I did not want to change or rationalize Scripture, but I was confused when I read verses like First Timothy 2:11-13 (NKJV), "Let a woman learn in silence with all submission. And I do not permit a woman to teach or to have authority over a man, but to be in silence. For Adam was formed first, then Eve"; and First Corinthians 14:34 (NKJV): "Let your women keep silent in the churches, for they are not permitted to speak; but they are to be submissive, as the law also says."*

*The question, "Should women be allowed to teach in the church?" followed me through the first ten years of pastoring, church planting,*

*and eventually even divorce. I was convinced that even though I divorced for scriptural reasons, God would no longer use me in any forefront arena. I told myself I would spend the rest of my life investing ministry in my children and then one day, when they were raised and fulfilling the ministry call on their lives, I would go along and carry their bags and care for their children.*

*Previous to this time, I had come into networking relationship with Dr. Bill Hamon of Christian International Ministries in Florida. So when I showed up literally on his doorstep during my marriage breakdown, I was surprised and amazed at the support offered to me as a woman, as a mother, and as a minister. Those Scriptures that already seemed so straightforward suddenly became clear to me. I learned that these Scriptures were inconsistent with other Scriptures and to apostle Paul's own routine and practice because of mistranslation. I found that this gender bias was not stated anywhere in the law and that the fruit of this misinterpretation had produced defective quality in the Body of Christ. I learned to rightly divide God's Word concerning gender. Psalm 119:160 says, "The entirety [sum] of Your word is truth." If one Scripture seems to stick out against the rest, don't base your beliefs on that particular Scripture alone. There is often a reason for what looks like contradiction in Scripture. Always go with the sum of God's Word. I was no longer under the limiting confusion, trying to decide whether a woman could teach or pastor in the church.*

*My next question was: "Because the Bible mentions prophets and prophetesses, is there a difference in authority or only gender?" With the support of my father in the Lord, Dr. Bill Hamon, it took me only a few months rather than another ten years to wrestle this one through. I saw where women were named prophetesses in both*

*the Old Testament and New Testament. I also saw that Paul, in the same letter where it says women are not to speak, gave directions for protocol when women prophesy. During this time God was restoring prophets back to the church. People were so hungry for the prophetic they did not care whether it came from a man, woman, rooster, or donkey. I traveled the nations and spoke to over seven heads of nations (mostly European and Third World), two parliaments, and a U.N. gathering.*

*Hallelujah, I thought the point of contention concerning women and ministry was finally over for me. Then I started receiving prophecies calling me to the office of an apostle. Shortly afterwards, God asked me to move to Europe, plant churches, establish schools, and build an apostolic network. That was ten years ago. Today I live in England. With the graces of God, I have planted and net-worked 50 churches/ministries and over 70 ministers. There are six schools established in Europe. God is faithful to fulfill what He has begun in us.*

*But still I erred in one main area. Yes, I had demonstrated that a woman could maintain a governmental position in the church and in the nations, and I gave opportunity and platforms to many indigenous women who otherwise would have had to break through by themselves. But I did not teach others concerning the Word of God and the authority through which I functioned. I did not put myself in the precarious position of teaching on women in govern-mental roles or the fivefold ministry. I mistakenly thought if I carried the banner of this emancipation, it would restrict the apostolic/prophetic message I was carrying. I was wrong! I now have purposed to mentor young women who are making a difference in their nations. Where I used to hide from women's gatherings, I now*

*include them in my itinerary. I have learned that true liberty affects future generations and that I can work with God in establishing it.*

**Dr. Sharon Stone** has been in ministry over 30 years. She has served as the Apostle over Christian International Europe since its inception in 1996. She has a powerful prophetic mantle and has ministered God's prophetic word to many heads of nations. She has three grown children who have also worked with her in ministry. Sharon and her husband, Greg, live in England.

# CHAPTER SIX

# *The Deborah Anointing Versus the Jezebel Spirit*

*Notwithstanding I have a few things against thee, because thou sufferest that woman Jezebel, which calleth herself a prophetess, to teach and to seduce my servants to commit fornication, and to eat things sacrificed unto idols* (Revelation 2:20, emphasis added).

For everything real that God brings forth, the enemy attempts to establish a counterfeit work to lead the people of God astray. When a money counterfeiter prints false, illegal bills, the illegitimate product looks and feels a lot like the real; and usually, only those who are trained in detecting the difference can distinguish between the two.

Similarly, as God is bringing forth a new breed of prophetic women in the earth, so a counterfeit group is also coming forth. The true, legitimate group is comprised of strong women who know who they are in Christ, and understand what they are called to do. The false representation is also made up of strong women; however, they operate out of a wrong spirit and a false philosophy. This false philosophy comes from both inside and outside the Church and is affected by the influence of what I will term the "Jezebel spirit." As God is restoring women to a place of proper function, many have mistakenly labeled these strong women as "Jezebels." The difference between a woman rising up as a Deborah and a woman who lives under a Jezebel spirit is in how they operate.

Jezebel is mentioned in two different places in Scripture—once as the wife of the wicked king, Ahab, in the Old Testament, and again in the New Testament in the message to the Church at Thyatira. One had influence from outside the circle of God's chosen people, and one had influence from within, leading people astray. Both scriptural examples give a description of one who opposes God's true work and of the enticing nature to thwart men and women's true destinies from coming forth.

Jezebel represents a demonic spirit that wants to kill the true purposes and plans of God. As God is raising up true prophets and prophetesses, so the enemy is raising up the false or counterfeit ones. Though it is spoken of as a female form, this spirit can affect both men and women alike. The Jezebel spirit is an enemy of the prophetic move of God's Spirit and of all who are pressing into His purposes. In short, she hates prophets and has an obsession with stopping God's prophetic voice from coming forth. She killed the prophets of God in the Old Testament and replaced them with the prophets of Baal. In these days she continues to lay siege to the prophetic word and choke out the ability for God's prophetic people to fulfill their purpose.

## The Nature of Jezebel

*And it came to pass, when Joram saw Jehu, that he said, Is it peace, Jehu? And he answered, What peace, so long as the **whoredoms** of thy mother **Jezebel and her witchcrafts** are so many?* (2 Kings 9:22, emphasis added).

Jezebel called herself a prophetess, but she actually practiced idolatry, divination, and witchcraft. She used seduction, both sexually and of the mind, to draw her subject in towards destruction. She moved with authority, but it was not an authority given by God, or even by her husband, the king. She was controlling through the force of her personality, manipulating towards her own agenda, and very intimidating to all who came in her path.

The name, *Jezebel,* means "without co-habitation."[1] Those controlled by this spirit are very difficult to live with or to be with. Those who give place to this spirit to operate refuse to live with others peacefully, unless they are in control and dominating. The Jezebel spirit is an independent spirit. She needs no one unless that person will bring her an advantage in gaining power, position, or preeminence. Even then, she normally will use the relationship only for her own selfish agendas.

Jezebel was also a man-hater and responded with violence whenever someone else was in control. She surrounded herself with eunuchs, men whom she had emasculated. The Jezebel spirit will seek to control men by manipulating their sexual desires through seduction, fantasy, sensuality, and lust. Sex isn't usually the issue, control is![2] Much of the adult entertainment industry has fallen under Jezebel's control, as has the leadership of our nation. Pornography, adultery, fornication, and lust have taken down many great men, both in the church and in the government of nations.

Jezebel influences her victims through a strong spirit of seduction, but this seduction is not limited to the sexual arena. Revelation chapter 2 says that she not only tries to seduce people into fornication, but also into eating things sacrificed to idols. This was a forbidden practice. She will entice even sincere members of the church to do and say things that they know are wrong, but seem acceptable at the time. Then she becomes the master of manipulation and shame using self-pity, guilt, and condemnation to control.

Jezebel is largely responsible for the booming abortion industry throughout the world. She says to women, "You have to be in control." She has no regard for life, even if it is the life of an unborn child. She has no mercy. Anything and everything is sacrificed to gain the prize of domination and control.

## Jezebel's Partners

Jezebel, the queen, was certainly a force to be reckoned with. She killed the true prophets of God and formed a partnership with the prophets of Baal and Ashtoreth. She was strong in personality as well as intimidation, using her witchcraft. She even had the mighty prophet, Elijah, running for his life in fear and discouragement, hiding out in a cave.

Where Jezebel was present, death and destruction abounded. She not only killed the prophets, but also had the righteous man Naboth executed in order to steal his vineyard for her husband, Ahab. To do so, she forged an agreement with the sons of Belial to make false accusation against this righteous man. Belial comes from a root word which means "destruction, failure, to wear out."[3]

The Jezebel spirit joins forces with whatever means necessary to bring accusation and destruction to God's people. She will resort to any means to wear out the saints of God, especially leaders, so that once again, she will be in control. Whenever there is a spirit of extreme weariness present, it can be an indication of Jezebel and Belial's teamwork to wear out the saints.

Wherever the Jezebel spirit is in operation, you will normally find strife, division, and people being stirred up in anger and confusion. Jezebel stirred her own husband up to do wickedness.

> *But there was none like unto Ahab, which did sell himself to work wickedness in the sight of the Lord, **whom Jezebel his wife stirred up*** (1 Kings 21:25, emphasis added).

Though Ahab was responsible for his own actions and decisions, it is clear that Jezebel had a large effect upon him.

If one does not stand up against the Jezebel spirit, she will rule the day. Passivity, lethargy, and hopelessness will set in and cause one to feel powerless to change. This sense of powerlessness will cause people to either completely shut down and give free reign to Jezebel or will cause frustration and anger to manifest.

I recall a time when we were dealing with a woman under the influence of a Jezebel spirit. She knew how to say all the right things to appear sincere and submissive; however, she constantly maneuvered situations with various leaders and proceeded to latch on to them and wear them out. She was demanding and controlling, and had learned to manipulate those who were merciful and tenderhearted through her "poor-me" syndrome. She would stir things up whenever she was on the scene. She had even managed to anger and frustrate one of the most gentle men in our church in his struggle to ward off her control.

## The Open Door to Jezebel

As previously stated, the Jezebel spirit is no respecter of persons. She will spin her evil web around men and women alike. However, because she is scripturally personified as a woman, we must understand that women are especially susceptible to the influence of her power.

Women who have been victimized by men are usually good targets for this spirit.[4] There is often a generational curse (or predisposition) towards allowing this spirit to rule in their lives. Once this spirit takes root, the individual becomes dangerous, as the spirit proceeds to wrap itself around her personality and become a part of her identity.

In the church, I have heard certain women referred to as a "Jezebel." I don't believe that people are "Jezebels," but rather may be operating under the influence of a Jezebel spirit. We must understand that "Jezebel" is not the identity that God has spoken or written over these women's lives. God has a call and destiny over each individual. It is important that we identify ourselves and one another according to God's call and identity, rather than what the enemy tries to speak as identity over our lives.

Any one of us is capable of controlling or manipulating a situation to our advantage. This is part of our unredeemed human nature and does not necessarily mean we are being controlled by

a Jezebel spirit. Rather, the Jezebel spirit becomes so entwined with a person's personality and identity that it becomes difficult to determine where the personality stops and demonic control begins.

On one occasion, my husband and I ministered to a woman who seemed to be sincerely seeking deliverance from a Jezebel spirit. We had heard prophetic words come over her life in regards to her call from God as a prophetess; however, her ministry always made many feel uneasy. Many whom she had prayed with immediately got sick or had accidents. She considered herself an intercessor and would often control the flow of corporate prayer times.

Eventually, we discerned a spirit of Jezebel that had apparently come through generational curses as well as through a sexual relationship with a warlock prior to her coming to Christ. We began to fast and pray with her and ministered deliverance. She was wonderfully delivered and had a completely new countenance when you looked at her.

Yet, within a week, when she walked into a room, we noticed that the old countenance was back, and that she had obviously once again opened herself up to this spirit's control. It had become so much a part of her that until her mind was renewed and she learned to refuse to give place for this spirit to operate, her deliverance could not be complete. She eventually received a good measure of freedom, but it was not an easy process for her or for us.

Regardless of how intimidating this spirit is, we must remember that the power of the blood of Jesus is more powerful than anything this spirit can bring. The Jezebel spirit must bow its knee at the name of Jesus. We must not allow ourselves to lose this focus, or we will permit her to become more powerful in our minds than God.

Elijah made this mistake. Even after he witnessed great miracles and signs wrought by the hand of God, including the fire

that had rained down on the altar of sacrifice, he became so intimidated by Jezebel that she seemed to have more power over his life than God. This forced him to run and hide out in a cave in fear for his life. Elijah was deceived by her intimidation and completely lost focus and perspective until God directly confronted him.

## Jezebel in the Church

Because the Jezebel spirit promotes a strong personality and operates out of manipulative control, many who are under the influence of this spirit will press themselves into places of leadership and influence in the church. It is not unusual for these individuals to control others through prophecy, saying such statements as, "The Lord showed me something about you...." This person may even have accurate information, but will be motivated out of the wrong spirit or operate out of an illegitimate source. In returning to the example of the counterfeit dollar bills, someone may determine that this money is fake because it doesn't look right or feel right. But in fact, a good counterfeit looks so much like the real thing that only an expert can distinguish the true from the false. What actually makes the bills counterfeit is their source. Is the source of the bill the US Treasury Department or not? If not, it is counterfeit regardless of how real it looks.

The Jezebel spirit will attempt to access illegitimate spiritual information. Through this, she will draw on the spirit of divination, which is defined in Acts chapter 9 as the spirit of Python.[5] The attack method is actually similar to that of the python snake in the jungle. It attempts to lull its victim into a place of unpreparedness, perhaps even waiting for its prey to fall asleep. It will then proceed to slowly squeeze the life out of you. It cuts off life, it cuts off joy, it cuts off provision. It cuts off anything and everything one needs to accomplish God's plan. The Python spirit is subtle but deadly, and comes as divination, witchcraft, or false prophecy is used to manipulate people for its agenda.

(Remember, as a protection against receiving false prophecy, we encourage people not to give or receive prophetic ministry of any type without proper oversight of a church leader.)

Those influenced by the Jezebel spirit will often target certain areas for involvement within the church. It seems that many of these individuals are drawn towards the areas of intercession, counseling, worship, and the arts. These are apparently the areas in which Jezebel can exercise the most control. These are also places of great power when God and godly people are working together. These areas of function can be the very places where spiritual battles are taking place, and where Jezebel can stir up strife and division to keep the army of the Lord from accomplishing its mission.

The Jezebel spirit's goal is not only to destroy, but more subtly, to take the focus off the vision of the Lord for a particular church and draw it towards herself. She hates the prophets, and therefore, hates vision. She will be critical, judgmental, and subversive, but not always in an overt manner. She gives prayer and counsel to needy members, then uses her influence to discredit the leaders and the vision, ultimately resulting in the separation of her counselee from the vision, trust, and love of the Body.

## The Strength of Deborah Versus the Control of Jezebel

The Deborah Company of women will be those who are firmly rooted and grounded in their God-ordained identities. They will not have to resort to soulish, manipulative, fleshly ways to fulfill their destinies, but will have hearts of humility and a trust in God that leads them in every endeavor. Following is a comparison between the two women and the heart attitude and spirit in which each operates.

### While Deborah is...Jezebel is...

Bold...brazen.
Humble...proud.

Teachable...unteachable.

Mighty through God...manipulative.

Submitted...controlling.

Focused on God's agenda...focused on self.

A team player...independent.

Pure...seductive.

Secure in her call...insecure and jealous.

While Deborah used godly wisdom and courage to achieve her goal, Jezebel used witchcraft, fear, and intimidation to achieve her agenda. Deborah was a friend of God and His people and desired to see them brought into fullness of freedom. Jezebel was an enemy of God and His prophets and did all she could to put them under bondage. Deborah worked with other leaders, while Jezebel sought to destroy everyone who would not allow her to have ultimate control. Deborah led others to submit to God and arise in faith, while Jezebel led others to serve self and ultimately arise in rebellion against God and godly authority.

But the story has a happy ending! Deborah led the armies of Israel to victory and brought the land into rest for 40 years. Jezebel, though she had her moments of triumph, was ultimately destroyed. She was thrown from her high place by the eunuchs, whom she had controlled, and was eaten by the dogs until the only thing left of her was the palms of her hands! In Revelation chapter 2, Jezebel and all her descendants are completely and utterly destroyed! Her end is always destruction.

## Renouncing Jezebel

It is important to renounce the Jezebel spirit and all her works. Godly women must not resort to using charm, deceit, seduction, control, or manipulation to fulfill their destinies. We must draw on the strength and grace of the Lord and remain humble, even in the midst of accusation or controversy.

Jezebel hates repentance. She hates humility. She hates people who pray. She hates the prophets. Ultimately, Jezebel hates

God.[6] We must love what Jezebel hates in order to renounce the works of darkness and embrace our freedom.

While godly women need not yield to Jezebel's powers in order to be strong, it is also important to recognize that at times, the fear of being labeled "a Jezebel" may keep many women from rising to their fullest potential in Christ. As we take on God's identity for our lives, we can receive His strength and wisdom, learning how to press forward without being pushy, how to walk in dominion without being dominating, and how to be strategic without being manipulative.

## A Charge to Women of Vision

Rise up, Deborah Company, and stir up the gift of God that is in you! It is the appointed time and season for you to break the bands of darkness and to release the light of vision to this generation! Rise up, and break through every cloud of confusion and despair, and speak forth the plan and purpose of God. Stir yourself out of complacency. Submit yourself to God. Resist the devil. Open your eyes, ears, and hearts to the things of the Spirit. Lay hold of divine strategies. Lay hold of revelation. Lay hold on your destiny. Now is the time for you to come forth!

### Endnotes

1. Strong's Concordance, 336 and 2083.
2. Francis Frangipane, *The Three Battlegrounds* (Cedar Rapids, IA: Arrow Publications, 2002), 99.
3. Strong's Concordance, 1100, from the root words of 1097 and 3276.
4. Frangipane, *The Three Battlegrounds*, 101-102.
5. Strong's Concordance, 4436.
6. Frangipane, *The Three Battlegrounds*, 102–103.

## SECTION ONE

# *Questions for Consideration*

1. List three gifts that you feel God has given you.

2. What are you currently doing to use these gifts?

3. Write a statement that sums up what you feel is your vision for your life.

4. List several actions you are currently taking, or plan to do that will fulfill that vision.

5. Evaluate and repent of any unredeemed methods or open doors to the Jezebel spirit that you may be employing along your road to fulfilling your destiny.

6. Evaluate which of the following four levels of prophetic ministry you are able to minister in, with faith, accuracy, and anointing?

    a.  *Spirit of prophecy* (song of the Lord or general congregational prophecies). Revelation 19:10, Zephaniah 3:16.

    b.  *Prophetic intercessory prayer* (revelation gifts and prophetic declarations). Romans 8:26-27.

    c.  *Gift of prophecy* (an abiding ability to hear and minister the heart, will, and mind of the Lord; ministering prophetic words to people). First Corinthians 12:10; Romans 12:6.

    d.  *Prophet* (able to function with the same anointing, authority, and wisdom as a fivefold prophet minister). Ephesians 4:12.

# SECTION TWO

# Deborah the Judge: Woman of Wisdom and Authority

*Reconciliation should be accompanied by justice, otherwise it will not last. While we all hope for peace it shouldn't be peace at any cost but peace based on principle, or justice.*

Corazon Aquino
First Woman President of the Philippines

# CHAPTER SEVEN

# *Deborah the Judge*

*And Deborah...**judged Israel** at that time* (Judges 4:4, emphasis added).

Deborah served as judge in Israel during a very difficult period of time. Israel had been living under the tyranny of an enemy king for 20 years when we first learn of her. We find Deborah sitting under "the palm tree of Deborah," which was her seat of government and where the children of Israel came to her for righteous judgment. She was not only a prophetess who could receive revelation from God, but she was also a woman of great wisdom, promoting her to a position of prominence and honor in the land. This governmental anointing caused Deborah to wear not only the mantle of a prophetess, but also that of an apostle.

## The Role of Judge

Deborah is the fourth in a list of 12 judges who ruled in Israel during this period of history. She is also the only judge to be called a prophet before the time of the great prophet/judge Samuel. These men and women were raised up or appointed by God to lead His people out of their cycle of sin and idolatry that they constantly fell into.

Time and time again, we see Israel forsake the law of God and begin to follow after the idols and gods of the land of Canaan, which God had sent them in to possess. Once they fell into the entrapment of idolatry, God allowed them to become

oppressed by heathen rulers until their burden became so heavy that in desperation they cried out to their one true God for deliverance.

God was always faithful to His people, and would eventually raise up a judge who would lead Israel in throwing off the enemy's oppressive yoke and bring them into rest and freedom. The judge would then continue as a supervisor of God's people and was normally successful in preventing them from falling back into the evil and wickedness of idolatry.

The word "judge" is the Hebrew word *shapat*, meaning, "one who judges, governs, passes down divine judgment, pronounces sentence, and decides matters."[1] This word would include every aspect of the function of government.[2] This position was much more than simply settling disputes. Judges were basically the governors of the land and would rule in all judicial, legislative, and military matters. They were the executive, military, and religious leaders of the land, and because of their divine appointment by God, were the ultimate authority in ruling the people. They were respected and honored for their wisdom in judgment and ability to bring the people of God from a place of oppression and cursing to a place of rest and blessing.

## Deborah's Domain

In Judges 3:30, we find that Israel had been delivered from their enemy oppressors, the Moabites, by the judge Ehud, and had been given rest for 80 years. But as so often was the case, they used their liberty as an occasion for the flesh, fell back into idolatry, and did evil in the sight of the Lord (see Judg 4:1; Gal. 5:13).

Deborah's victory song in Judges chapter 5 tells us of the condition of the land when God placed her in power and of her heart towards those she had been called to lead:

*In the days of Shamgar son of Anath, in the days of Jael, the roads were abandoned; travelers took to winding paths.*

*Village life in Israel **ceased**, ceased **until I, Deborah, arose,** arose **a mother in Israel**. When they chose new gods, **war came to the city gates**, and not a shield or spear was seen among forty thousand in Israel. My heart is with Israel's princes* [governors], *with the willing volunteers among the people Praise the Lord!* (Judges 5:6-9 NIV, emphasis added).

The land was in distress and turmoil. Normal living had ceased, and people hid in fear. Men had become so complacent in their bondage that they didn't even own a spear or shield! Instead, they had resigned themselves to the overpowering rule of the Canaanite king. This is typical of today's Laodicean church people who are lukewarm, apathetic, and without weapons of spiritual warfare honed and ready (see Rev. 3:14-16).

Into this setting God raised up a woman, Deborah, to bring the strategy for freedom. Her heart was towards the ones who were to be leaders in the land, the governors and princes, who had become overwhelmed by the wickedness of the people and had lost their effectiveness and ability to lead. She was bold enough to take on the leadership mantle that others had cast off due to fear and intimidation. She arose as a leader who would inspire others to once again take their God-ordained positions to lead.

## Confronting the Worldview of Women

Israel, as well as many ancient cultures, was patriarchal in structure, meaning that the chief authorities in that society were men. In many eastern societies, women were regarded as little more than property, having no rights to own land or to even inherit the possessions of their husbands. The following is an account of how women were treated in many of the cultures of the far east.

Hindu widows were burnt alive with their husbands' corpses. Japanese men introduced their wives as "My

stupid wife." Chinese men said, "It is better to see my son's backside than to see my daughter's face." Believers in reincarnation hold that it is a curse and punishment to be born a woman. A major world religion looks upon women as sex-objects without souls, only to be enjoyed then discarded.[3]

The Jewish traditional teachings from the Talmud regarding women were similar. The daily prayer of the Pharisees was, "I thank you, God, that I am not a Gentile, a slave, or a woman."

The writings of the Talmud did not come until long after Deborah's day; however, much of the same prejudice existed. Though women in Israel were not as oppressed as women from other lands of that day, it was nonetheless, highly irregular for a woman to hold such a position of power.

Yet God chose such a woman—a woman gifted not only with prophetic abilities of revelation, but also with great wisdom that would enable her to be an effective and respected leader. Because of her tremendous reputation for having an anointing in *revelation and wisdom*, Deborah called for the great general, Barak, and he responded to her summons. She would be one who could work with those who had submitted themselves to God and bring them forth into their divine gifting to fulfill their God-ordained purpose.

## Women of Influence

Deborah was a woman of great wisdom and revelation, which caused her to have influence in her nation at a critical hour. Today God is looking for women who are also willing to pay the price to allow God to develop these gifts within them so that they can have influence in communities, the marketplace, and in churches and make a difference in the earth. In choosing a woman to bring change, God does not look at educational background or social or economic status. Rather, God looks for a woman who is willing to sacrifice her own comfort in order to

engage the battle against oppression to lead people to freedom. A modern day Deborah named Sojourner Truth was just such a woman.

## The Legacy of Sojourner Truth

Sojourner Truth was one of the most prominent women freedom fighters in United States history. She was born into slavery in upstate New York in 1797 and was originally known as Isabelle Baumfree. She was one of 13 children, and through all the hardships of her upbringing her mother taught her to pray. But it wasn't until much later in her life, after being sold to four other masters, after being repeatedly beaten for little reason, after being forced to marry another slave and bare children, and after escaping from slavery and winning her freedom that she was introduced to her Savior, Jesus Christ.[4]

After her conversion, she heard the voice of the Lord calling her to become an itinerant preacher, to travel wherever He would lead, and tell people of His love. As she embraced this calling, she asked God for a new name. He led her to a passage in Psalm 39:12 that says, *"Hear my prayer, O Lord, and give ear unto my cry; hold not Thy peace at my tears: for I am a stranger with Thee, and a sojourner, as all my fathers were."* The word "sojourner" meant "traveler," and she knew she was called to travel and spread God's mercy and truth and stand against injustice.

Curiosity seekers were initially drawn to Sojourner's meetings. Standing six feet tall, this illiterate ex-slave would preach of God's mercy and of the injustices committed against slaves and women with a power and persuasiveness that stirred the hearts of the people. Her most famous speech given in Akron, Ohio, in 1851, entitled "Ain't I a Woman?" challenged even many of the ministers of that time. Some had been preaching against the rights of women when Sojourner took the podium and with her bold, resonant voice gave this response:

Well, children, where there is so much racket there must be something out of kilter. I think that 'twixt the negroes of the South and the women at the North, all talking about rights, the white men will be in a fix pretty soon. But what's all this here talking about? That man over there says that women need to be helped into carriages, and lifted over ditches, and to have the best place everywhere. Nobody ever helps me into carriages, or over mud-puddles, or gives me any best place! And ain't I a woman? Look at me! Look at my arm! I have ploughed and planted, and gathered into barns, and no man could head me! And ain't I a woman? I could work as much and eat as much as a man—when I could get it—and bear the lash as well! And ain't I a woman? I have borne thirteen children, and seen most all sold off to slavery, and when I cried out with my mother's grief, none but Jesus heard me! And ain't I a woman?

Then they talk about this thing in the head; what's this they call it? (member of audience whispers, "intellect") That's it, honey. What's that got to do with women's rights or negroes' rights? If my cup won't hold but a pint, and yours holds a quart, wouldn't you be mean not to let me have my little half measure full?

Then that little man in black there, he says women can't have as much rights as men, 'cause Christ wasn't a woman! Where did your Christ come from? Where did your Christ come from? From God and a woman! Man had nothing to do with Him. If the first woman God ever made was strong enough to turn the world upside down all alone, these women together ought to be able to turn it back, and get it right side up again! And now they is asking to do it, the men better let them. Obliged

to you for hearing me, and now old Sojourner ain't got nothing more to say.[5]

Sojourner's work was not just as a preacher in the church, but as an activist in society. As her reputation grew, she was sought out by many of the prominent abolitionists of that day to work together to further the cause of justice. During the Civil War, Sojourner bought gifts for the soldiers with money raised from her lectures and helped fugitive slaves find work and housing. She became a powerful figure in several national social movements, speaking forcefully for the abolition of slavery, women's rights and suffrage, the rights of former slaves, temperance, prison reform, and the termination of capital punishment.[6]

In her lifetime, Sojourner was to become a great reformer during a time of horrific repression for slaves and women. She became a woman of great influence and was even received by President Abraham Lincoln in the White House for her work of recruiting black men to help with the war effort. In her lifetime, she won three precedent-setting court cases, a very unusual feat for a woman, let alone a black, illiterate ex-slave. In the first case, she protested the illegal sale of her son to an Alabama planter. Through a series of miraculous interventions, she won the case and her son's freedom. In the second case, Sojourner became the first black to win a slander suit against prominent whites. In the third case, she became the first black woman to test the legality of segregation of Washington, D.C. streetcars. Wherever she saw abuse, oppression, or prejudice, Sojourner brought a challenge to change. When she died at the age of 86, Sojourner Truth had left her mark on American society. She was truly a woman who made a difference![7]

## Endnotes

1. Strong's Concordance, 8199.

2. Jack Hayford, *Hayford's Bible Handbook* (Nashville, TN: Thomas Nelson, Inc., 1995), 57.

3. Henry Ramaya, *Arise, Daughters of Sarah, Arise* (Malaysia, Firstfruits Sdn. Bhd 1991), 4.

4. Sojourner Truth, *The Narrative of Sojourner Truth*, (1850) edited by Olive Gilbert, http://digital.library.upenn.edu/women/truth/1850/1850html.

5. Sojourner Truth, "Ain't I a Woman?", speech given at the Women's Convention, Akron, OH, 1851, www.wikisource.org/wiki/Ain't_I_a_woman%3F.

6. Sojourner Truth, *The Narrative of Sojourner Truth*, (1850) edited by Olive Gilbert, http://digital.library.upenn.edu/women/truth/1850/1850html.

7. About Personals, Women's History, Sojourner Truth, http://womenshistory.about.com/library/bio/bltruth.htm.

# Women Who Make a Difference Through Shaping Culture
## MICHELLE JACKSON

*Also, teach older women to be holy in the way they live.
Teach them not to speak against others or have the habit of
drinking too much wine. They should teach what is good. In
that way they can teach younger women to love their hus-
bands and children. They can teach younger women to be
wise and pure, to take care of their homes, to be kind, and
to obey their husbands. Then no one will be able to criticize
the teaching God gave us* (Titus 2:3-5 NCV).

Responding to the call to join in the fray of the cultural battle to
make a difference in your world opens new vistas of involvement.
Embracing that call reveals the depth of commitment required to
bring those desires to fruition. Whether in the living room or the
boardroom, your presence opens a plethora of possible outcomes.
Spurred by a sense of adventure, you can explore innumerable
options, both for vocations and avocations. Nontraditional choices
widen the gateway for a vanguard to infiltrate the culture with
values and principles that present a higher, nobler existence for
humankind.

Practical involvement in policy decisions that shape the
development of legislation or involvements in the development of
business protocols that govern commerce in the global village require
both a masculine and feminine perspective. Whether the option is
exploring possible outcomes from research isolating the human
genome or alternative uses of energy derived from exciting the rays
of light traveling through fiber optic cables, the potential influence on
society is exponential. In each of these arenas, the influence of the

*feminine perspective on policies regulating possible outcomes can determine the quality of life for generations to come. Who determines the quality levels of life society should experience? What values are used to measure the essence of the quality of life? How is the influence of the feminine perspective assessed? What should women be involved in that has enduring potential to shift the culture of a nation?*

*Interestingly, the Scriptures are not silent on women's potential influence on society. In the Book of Titus, chapter 2, verse 3, directives outline the nature of instruction that should pass from one generation of women to another. Directives outline matters of personal comportment, interpersonal and familial relations, and a general directive regarding the nature of the content of instruction. Burgeoning volumes describe familial interactions and shelves of self-help materials encourage proper interpersonal interactions.*

*So let us briefly focus on the content of instruction. Titus suggests that the exchange between women center on what is good. Current societal values do not always communicate a clear message supporting a definitive statement of what constitutes good. The Scripture on the other hand is quite clear. Perhaps Titus conveyed the Hebrew meaning of "good" despite the use of Greek language. Speaking to Hebrew women exposed to The Torah through the tutelage of their husbands and fathers, from the Old Testament perspective, "good" carried with it the connotation of economic benefit, moral rectitude, and aesthetic beauty. Teaching principles of money management, reasons for setting and adhering to standards, the value of chastity and the safety afforded males and females who practice it, and the importance of accepting self, celebrating self, while supporting, accepting, and celebrating others is indeed good for all humankind. Such practices can alleviate prejudice and*

*personal preference and create an overwhelming sense of acceptance and support for others.*

*Historically, many women have shared a fable of a small world, created by an impotent creator out of minimal resources. Images of good or goodness have been subjected to a capricious, grumpy man who might see fit to respond favorably. Good has been relegated to relativism that allows bad to be defined as good based on situational dynamics. The outcome is a culture characterized by self-centeredness, small-mindedness, and stinginess. It ought not to be so. Women can make a difference. However, that difference has to extend beyond personal fulfillment. That difference must encompass a perspective that reaches beyond the boundaries of personal comfort to embrace what is good.*

**Michelle Jackson** is a wife, mother, counselor, confidante, and executive. Together with her husband, Bishop Harry R. Jackson, Jr., she pastors Hope Christian Church in Bowie, Maryland. As a pastor and author of numerous books, she has a sincere desire to shepherd God's people and disciple them in the ways of obedience and personal holiness. She relentlessly trumpets the call to include young people in viable ministry, to prepare them to lead the Church of tomorrow. Michelle has two adult daughters and is currently completing her Ph.D. studies.

# CHAPTER EIGHT

# *Deborah and the Apostolic Mantle*

The term *apostle* is a New Testament word which means "sent one".[1] It is a descriptive term given to the early Church disciples who later became the leaders of the movement to take the Gospel to the ends of the earth. Though there was an initial group whom Jesus called "apostles," the term was used in a broader sense as the Church began to flourish and multitudes of ministers were raised up. The early apostles changed cities and nations as they were sent by God with the Gospel message and with a demonstration of power.

Today, God has restored the gifting and anointing of the apostle to the earth. Apostles are arising in the Church and impacting not only the Body of Christ to bring it into divine order, but also to impact culture and the social order by God's Word and power.

Not every saint who has an anointing to hear the voice of God and speak His purposes is called as a prophet; however, every believer can function under a prophetic anointing, moving in the gifts of the Holy Spirit and operating under the mantle of revelation. In the same manner, not all who lay foundations of reform or do signs and wonders are called to be apostles, but we are all to be apostolically *sent* into our places of influence with the apostolic anointing to challenge people to change.

Deborah exemplified an apostolic anointing. Some have questioned whether a woman can fill the role of an apostle. Romans 16:7 tells us of a ministry team, perhaps even a husband and wife ministry team, named Andronicus and Junia, and says

they were notable, or outstanding, among the apostles. Junia is a woman's name, and she is called notable among the apostles.

The following are a few characteristics of the apostolic mantle that God is releasing upon men and women in the Church today.

## 1. A Building Anointing.

*Having been built on the foundation of the apostles and prophets, Jesus Christ Himself being the chief cornerstone, in whom the whole building, being fitted together, grows into a holy temple in the Lord, in whom you also are being built together for a dwelling place of God in the Spirit* (Ephesians 2:20-22 NKJV).

The apostolic mantle carries an anointing to build the Body of Christ upon firm foundations. Jesus Christ is described in Hebrews 3:1-6 as the "Apostle and High Priest of our confession." He was a "sent one" from the Father, to come to the earth to build a spiritual house—a body of believers who would confidently carry out His will.

The early Church met regularly to hear the apostles define the doctrine of their new Christian faith. At these times, the apostles would challenge the mind-sets of the past and would speak words of truth setting the Church free to accomplish their divine mission (see Acts 2:42; 1 Tim. 2:7). Apostolic builders have an anointing to challenge dead religious patterns, destructive mind-sets of limitation, and oppressive systems that incapacitate Kingdom growth, all the while calling the Church to align to the cornerstone of the life of the Lord Jesus Christ.

In her book, *God's Bold Call to Women*, Barbara Yoder has this to say regarding apostolic building anointing:

What builders raise up, lasts. It is critical that they build and impart spiritual wisdom and insight into the generations. Builders build bridges between people, generations, ministries, leaders, nations, businesses and

governments. They connect disjointed parts through relationship and releasing vision. They gather and construct an inheritance for the next generation. They invest for long term results....They mobilize people and resources.[2]

Deborah was a builder who reconnected Israel's leadership to the heart of God. She first dismantled the hopelessness and despair that had kept them under Jabin's oppressive hand. Then, her wisdom and prophetic insight provided the building tools for God's general to lead the people to freedom.

## 2. An Equipping Anointing.

*And He Himself gave some to be apostles, some prophets, some evangelists, and some pastors and teachers, **for the equipping of the saints for the work of ministry**, for the edifying of the body of Christ, till we all come to the unity of the faith and of the knowledge of the Son of God, to a perfect man, to the measure of the stature of the fullness of Christ; that we should no longer be children, tossed to and fro and carried about with every wind of doctrine, by the trickery of men, in the cunning craftiness of deceitful plotting, but, speaking the truth in love, may grow up in all things into Him who is the head—Christ* (Ephesians 4:11-15 NKJV, emphasis added).

Paul's apostolic heart is seen in this passage as he expresses a desire to see each believer fully equipped for the work of the ministry. His fatherhood yearning was that the saints grow from spiritual childhood to maturity. He recognized that it would take all expressions of the fivefold mantle of Christ in order for that to be accomplished. The Church would need evangelists to equip them to win souls; teachers to equip them to make other disciples; pastors to equip them to nurture, care, and counsel other believers; prophets to equip them to hear the voice of God and speak forth

His purposes; and apostles to equip them with wisdom, divine strategies, and demonstration of power, to apostolically send them into the world. Apostles would set things in order so that the whole body could come to a unity of the faith and grow to a place of mature function.

In Judges 5:7, Deborah is called "a mother in Israel." A mother's heart has a desire to equip her children to be everything they were born to be. She is consumed with seeing the next generation made ready to face the future. Her heart is to reproduce her strengths in her children, yet to see them excel beyond where she herself has grown. She has a desire to do what she can, to bring positive change into her culture so that her children have a better world to grow up in. When we exemplify this kind of apostolic anointing, ministry achievement ceases to be all about us and what we can do and accomplish, but rather what we can impart to others to see them fulfill destiny.

Mothers give practical wisdom and skills as well as the gifts of inspiration and motivation. They lead by example, constantly pressing their own growth opportunities so that they have more to give to others. The early apostles prayed, "Lord, increase our faith" because they knew their level of faith would break the way open for others to manifest the Kingdom through their faith (see Luke 17:5).

### 3. A Governmental Anointing.

Those with an apostolic mantle will have an anointing for leadership. They will have the capacity to lay hold of vision and the divine strategies that must be implemented for breakthrough for the Kingdom of God. The early apostles would gather in councils and discern the voice of God regarding how the Church should conduct itself, and then exercised the governmental authority to decree what needed to shift in order for the Church to be strengthened (see Acts 16:4).

Apostles and apostolic people will walk in this same governmental authority. They won't be afraid to step up to the plate and deal with difficult issues and controversies that immobilize the Church. They will carry an ability to face difficult confrontations with the wisdom of God. They will be anointed to gather, to inspire, to motivate, and to mobilize.[3]

Deborah had the courage to face not only Jabin and his armies, but also the fear in Barak and the army of God. She challenged them to rise up and gather together at Kedesh and prepare themselves for battle. Through the governmental authority she carried, they mobilized and went out to battle against Sisera and his mighty army as she had instructed, even though not one of them possessed a sword or a spear! She inspired them with faith to see God bring a mighty victory as she apostolically decreed, "*God will deliver him into your hands*" (see Judg. 4:7).

Apostolic leaders understand that they can stand in this place of great authority because they have learned to be under authority. The early apostles declared, "*We ought to obey God rather than men*" (Acts 5:29b). They knew that God was their highest authority, yet also understood the concepts of submitting to one another and working as a team for the Kingdom goal. Apostolic people know that they cannot work alone but must work in tandem with others of like vision. They have an ability to gather others for a Kingdom cause and give specific assignments to mobilize the troops for battle. Deborah worked with the general, Barak, and the two led the army to victory.

A governmental authority employs an anointing to walk in dominion in the earth. God originally spoke to man and woman and told them to take dominion. Remember, dominion means, "the power or right of governing and controlling; having sovereign authority; rule, control, domination."[4] This means that as God speaks to us, we must rise up and take dominion over demonic spirits and forces of evil in the earth. Jesus is an example of this authority for us each time He healed the sick, cast out

devils, or raised the dead. He patterned this dominion for us when He spoke to the storm, "Peace, be still," and it obeyed Him. These are not just great stories to tell our children, but rather, living examples of exercising our governmental rights in the Kingdom.

Job 22:28 says, *"You will also declare a thing, and it will be established for you; so light will shine on your ways"* (NKJV). With this governmental authority, God is causing us also to lay hold of the power of the decree. We can speak things into the realm of the spirit and cause things to shift in the natural.

To illustrate, let me tell you the story of Hurricane Lily. In October 2002, Hurricane Lily, a powerful category 5 storm, was bearing down on the Louisiana coastline with 155 mph winds. The predictions by officials and scientists were that the devastation would be catastrophic to the areas affected. Some were even forecasting that the storm could grow to 180 mph before landfall. Note that a hurricane is strengthened when the barometric pressure in the eye of the storm drops. In this particular storm, the pressure had been plummeting for almost 48 hours, and there seemed to be nothing in its path that would stop the strengthening before it made landfall.

The night before Lily was expected to hit the coast, a church in Baton Rouge met for prayer. Under the direction of the Holy Spirit, apostles Larry and Brenda Bizette gathered their prayer warriors at Baton Rouge Christian Center at 8:00 in the evening and began to speak to the storm and to release decrees against the destruction that was predicted. They boldly decreed that God would "put His finger in the eye of Hurricane Lily." They further decreed that before Hurricane Lily made landfall the next morning, it would downgrade to a category 1 storm with winds no stronger than 90 mph.

Amazingly, between 8:00 and 9:00 that night, the barometric pressure that had been plummeting for days suddenly took an unexpected and unexplainable turn. Rather than falling, the barometric pressure began to rise! As the pressure rose, the storm

began to disintegrate and before it made landfall the next morning, it was downgraded to a category 1 storm with a mere 90 mph-wind speed! The scientists were astounded and the newspapers declared, "God Puts His Finger in the Eye of Lily." The decree had shifted something in Heaven and earth that averted a potentially devastating and costly natural disaster. Isaiah 10:22-23 boldly declares, "*...the destruction decreed shall overflow with righteousness. For the Lord God of hosts will make a determined end in the midst of all the land*" (NKJV).

We must learn to boldly decree into the heavenly realm those things that God has determined and align our faith to see it come to pass! Apostolic people must exercise their governmental authority to see God's dominion in the midst of darkness. The same way God shifted and dismantled that storm is the same way He desires to dismantle the storms that are focused on our destruction. On a personal level, God wants to cause the storms of infirmity, poverty, sickness, disease, grief, lack, oppression, depression, and strife to disintegrate as we decree God's righteousness into the center of the storm. On a national level, God wants to shift the storms that are brewing in our courts, in our schools, and in our military actions. God wants to shift our nation away from the anti-Christ agenda and back to the righteous foundations of our forefathers. It's time for the Church to rise in power and see nations turn.

## 4. An Anointing for Signs, Wonders, and Miracles.

It is clear as one reads the Book of Acts that those who had an apostolic mantle were not just full of wisdom and strategy, but also full of the power of the Holy Ghost. Consider the following Scripture passages to see that true apostolic people must operate in the supernatural realm in order to demonstrate God's Kingdom.

*Then fear came upon every soul, and many wonders and signs were done through the apostles* (Acts 2:43 NKJV).

*And through the hands of the apostles many signs and wonders were done among the people...* (Acts 5:12 NKJV).

*Truly the signs of an apostle were accomplished among you with all perseverance, in signs and wonders and mighty deeds* (2 Corinthians 12:12 NKJV).

*Now God worked unusual miracles by the hands of Paul, so that even handkerchiefs or aprons were brought from his body to the sick, and the diseases left them and the evil spirits went out of them* (Acts 19:11-12 NKJV).

One might say, "Well, I'm not really an apostle; I'm just an ordinary Christian," or "That isn't really my gift." Mark chapter 16 tells us that moving in the supernatural realm should be part of every ordinary believer's life.

*And these signs will follow those who believe: In My name they will cast out demons; they will speak with new tongues; they will take up serpents; and if they drink anything deadly, it will by no means hurt them; they will lay hands on the sick, and they will recover* (Mark 16:17-18 NKJV).

Deborah moved in the supernatural realm, and the army of Israel defeated the army of Sisera without even having a natural weapon among them. Judges 5 tells us the story of the supernatural victory that came by the hand of the Lord.

*Lord, when You went out from Seir, when You marched from the field of Edom, the earth trembled and the heavens poured, the clouds also poured water; the mountains gushed before the Lord, this Sinai, before the Lord God of Israel* (Judges 5:4-5 NKJV).

*The kings came and fought, then the kings of Canaan fought in Taanach, by the waters of Megiddo; they took no spoils of silver. They fought from the heavens; the stars from their courses fought against Sisera. The torrent of Kishon*

*swept them away, that ancient torrent, the torrent of Kishon. O my soul, march on in strength! Then the horses' hooves pounded, the galloping, galloping of his steeds. "Curse Meroz," said the angel of the Lord, "Curse its inhabitants bitterly"* (Judges 5:19-23 NKJV).

It was a supernatural battle with signs and wonders from the heavens and angelic intervention. As Israel gathered at the River Kishon, all of Sisera's armies came down to battle. God caused torrential rains to hit the area, which swept away the enemy. We can only assume that Deborah and Barak had positioned God's people out of harm's way. Then as others fled to take refuge in Meroz, the angel of the Lord rose up in battle, releasing a curse against them, resulting in utter destruction.

While this may not be the picture of signs, wonders, and miracles that bring life and liberty as we so often think of the supernatural works of God, we must also understand that this anointing releases God's judgment against evil and deliverance from our enemies. In times of terror, God can position His people out of harm's way while the angels fight our battles.

## 5. A Battling Anointing.

*A wise man is strong, yes, a man of knowledge increases strength; for by wise counsel you will wage your own war, and in a multitude of counselors there is safety* (Proverbs 24:5-6 NKJV).

In considering the anointing that comes with the apostolic mantle, we must recognize that it is an anointing for battle. If we are exercising dominion and governmental authority, if we are moving in signs, wonders, and miracles, we will need to put on warrior's armor to do battle against demonic forces that are holding the earth in captivity. The battling anointing not only releases the courage to go to war in the spirit, but also strategies to maximize effectiveness for victory. Most people don't like war. But

most people love victory. Unfortunately, there is no victory without a battle!

Jabin harshly oppressed Israel, and unless someone was willing to step forward to determine to make a difference, they would have continued in bondage. Likewise, unless apostolic people are willing to do battle with the forces of darkness, our families will continue to be devoured and our cities will continue to be destroyed! We must break off the yokes of apathy and complacency and rise to meet the challenge. Before David went in to battle with Goliath, he declared, *"Is there not a cause?"* (1 Sam. 17:29). God is looking for those who are looking for a Kingdom cause. The apostolic people aren't just waiting for someone else to do the job, but are willing to sacrifice to see freedom come to others.

Jabin's name means "the intellect."[5] While we study natural things to increase our intelligence, we must realize that there is a demonic spirit of intellectualism that desires us to back away from supernatural, spiritual things and trust only in what our minds tell us makes sense. Human reasoning often gets us in trouble with God.

Intellectualism will bury us in the paralysis of analysis. We think, think, think and never do, do, do. Consequently, we get overwhelmed by the natural realm and fail to trust that God's supernatural power can make a difference. Or we try to tackle a spiritual problem with a natural solution. However, in order to prevail and win any battle for the Kingdom of God, we must exercise faith in God's unseen hand. We must do what the psalmist has admonished us to do.

> *Trust in the Lord with all your heart, and lean not on your own understanding; in all your ways acknowledge Him, and He shall direct your paths* (Proverbs 3:5-6 NKJV).

This Jabin spirit of intellectualism holds people in spiritual bondage and oppression. Because it is a spiritual problem, it will

need spiritual answers. But faith has been decimated, leaving only feelings of fatalism. "This is just how it is. Nothing can be done to bring any real lasting change." This attitude leads to hopelessness and quiet despair.

The spiritual atmosphere in many cities today mirrors the atmosphere in Israel during the days of Deborah. Fear and intimidation rule. Because it is an oppressive spirit, there is violence in the streets. People no longer want to connect with others and are afraid to come out of their own homes. Isolation and separation then breed depression and discouragement. Young people become suicidal. Parents neglect their responsibilities, becoming lost in the fog of drugs and alcohol. Can anything really change?

In order to confront Jabin, God's solution was to raise up a Deborah to work with Barak to bring change. Today, God's solution is the same. Deborahs must awaken, and Baraks must arise in faith. Apostolic people must put off the oppressive garments of past failures and begin to see the victory that is at hand as we engage the enemy and break through his defenses. Things can change as men and women determine that there is a righteous cause and that we are called to make a difference.

## 6. A Reformer Anointing.

Apostolic people are reformers. The word *reform* means "the improvement or amendment of what is wrong, corrupt or unsatisfactory; the amendment of conduct or belief; to change to a better state or form; to cause a person to abandon wrong or evil ways of life or conduct; to put to end abuses and disorders; to abandon evil conduct or error."[6] Reformers confront abuse and error. They have heart and vision to bring improvement into systems that have become ineffective or unproductive. They challenge corruption and evil with a desire to bring forth a structure that produces life and fruitfulness.

Sojourner Truth, mentioned in the previous chapter was a reformer, working to free black people and women from society's

oppression. Harriett Tubman, an ex-slave who led more than three hundred other slaves to freedom, was a reformer. Florence Nightingale, who challenged a man's world of medicine, saved untold numbers of lives by improving sanitary conditions in hospitals and medical practices, and inspired the formation of The Red Cross, was a reformer. These women took on a cause, at great personal expense and sacrifice, to see change brought for future generations.

God is also raising up reformers in the Church. These reformers are pioneers who are not afraid to challenge the way things have always been done. They think outside the box with a creative flair that brings life. They pour over the Scriptures to bring God's people in alignment with biblical truth, knowing that truth has the power to make them free. These reformers hate the spirit of religion, which always constricts and constrains the Church from a place of growth. They are trailblazers who are willing to listen to the Lord for new strategies and implement new ideas that will facilitate increase and expansion.

Deborah was a reformer. As the only woman judge in that day, she destroyed paradigms that had held women in bondage, giving the woman Jael the courage to put the stake through Sisera's head. She was willing to listen to the Lord for divine strategies that were innovative and new, and forge a path of freedom that the entire nation of Israel could walk upon. She shifted the course of history by encouraging and mobilizing God's people to take the first steps towards victory. She set in motion a course of events that led to 40 years of rest upon the land. She turned the tide of the battle, mobilizing Israel to put on God's strength and then see His saving hand deliver them.

*So on that day God subdued Jabin king of Canaan in the presence of the children of Israel. And the hand of the children of Israel grew stronger and stronger against Jabin king of Canaan, until they had destroyed Jabin king of Canaan.*

*...So the land had rest for forty years* (Judges 4:23-24; 5:31 NKJV).

## 7. A Great Grace Anointing.

*And with great power the apostles gave witness to the resurrection of the Lord Jesus. And great grace was upon them all* (Acts 4:33 NKJV).

The apostolic mantle is a mantle of great grace. The early apostles walked under a spiritual covering of God's great power and grace to accomplish their Kingdom mission. The Greek word "great" is the term "mega,"[7] and the word "grace" is also the word translated elsewhere as meaning favor.[8] So we understand that God is releasing an anointing to His apostolic people of mega-power, mega-grace, and mega-favor so we can do Kingdom business.

Why did the early apostles need such an anointing? Because persecution and controversy abounded on every hand. We are living in a time in our western culture when we face very little persecution for the Gospel's sake. Yet, today there are brothers and sisters all over the world who are being persecuted and even killed because of their unwavering faith in the Lord Jesus Christ. These believers are walking in God's great grace to continue in their life in Christ, even if it leads to their death here on the earth. Whether we are called to literally die for our beliefs or whether we are to live as the apostle Paul did when he said, "I die daily," each believer needs the grace to walk out his or her obedience to the Lord (see 1 Cor. 15:31).

We are living in days when the darkness will grow darker and the light will grow brighter. Evil will grow stronger, yet the Church will grow even stronger. Isaiah 60 speaks of God's promise to us during these times.

*Arise, shine; for your light has come! And the glory of the Lord is risen upon you. For behold, the darkness shall cover*

*the earth, and deep darkness the people; but the Lord will arise over you, and His glory will be seen upon you. The Gentiles shall come to your light, and kings to the brightness of your rising* (Isaiah 60:1-3 NKJV).

The Church has always thrived in times of persecution. As darkness increases, so the glory of the Lord will increase over God's people, and unbelievers will be drawn to our light! This is due in part to God's anointing of great grace that will rest upon His people.

Apostles have an anointing to release God's favor into situations to bring freedom and life. Scripture encourages us that whenever God's favor shows up, everything changes. After the children of Israel were in Egyptian bondage for over four hundred years, the favor of the Lord showed up, and they were set free. Favor releases victory against impossible odds. It releases promotion to the righteous above the unrighteous. It looses financial blessings and transfers wealth from the hands of the sinners to the hands of the just (see Ex. 3:21-22; Josh. 11:20-23; Gen. 39:21-23; Deut. 33:23).

God released favor on Esther's life, and it resulted in a governmental shift for all of God's people, from death decrees to life decrees. The king extended the golden scepter to her, and her petition was granted in the face of pending destruction. Her favor enabled her to change laws and ordinances in order to set God's people free. It also brought promotion to her entire family, including Mordecai who became the right-hand man to the king (see Esther 2:17; 5:7-8; 8:4-6).

Favor gives us the edge in spiritual battles as the Ancient of Days shows up and releases righteous judgment to turn our battle and be overcomers.

*I was watching; and the same horn was making war against the saints, and prevailing against them, until the Ancient of Days came, and a judgment was made in favor of the saints*

*of the Most High, and the time came for the saints to possess the kingdom* (Daniel 7:21-22 NKJV).

## Modern Women Apostles

The Church is being transformed to facilitate the mobilization of the entire Body of Christ. No longer are women relegated to a second-class citizen positioning, but are being positioned and activated to serve in every aspect of Kingdom life.

So can women be apostles? We know they can be prophets, because there are numerous Scriptures that refer to women as "prophetess" or "women prophets." But is there any precedent for a woman to be an apostle? The answer is yes! In Romans 16:7, we are told of Andronicus and Junia who "are of note among the apostles." Junia is a woman's name. Furthermore, the Jewish historian, Josephus, says that Junia was the wife of Andronicus and that they were apostles of Rome who went about doing the works of the apostles,[9] which are many of the things I have just discussed.

Today, during this new season of breakthrough in the Church, God is positioning and anointing women to lead as apostles. Let me now introduce you to just a few of these incredible women who are effectively functioning as apostles and who are pioneering a worldwide thrust to empower women for destiny and equip apostolic and prophetic leaders for global impact.

## Naomi Dowdy

Dr. Naomi Dowdy is a prominent apostle in the Body of Christ who formally pastored Trinity Christian Center in Singapore. She is the Founder-President of Global Leadership Network, which has a heart to see the Great Commission fulfilled, bringing apostolic strategies for transformation to spiritual leaders. She has impacted local churches, regions, and even nations with her cutting-edge ministry through conferences and equipping summits.

Naomi is also a pioneer and the Founder of Care Community Services Society, an organization which has a focus of bringing wholeness to the community through practical outreach and training for families, youth, the elderly, the needy, and the challenged. She also has established the Theological Centre for Asia, a higher learning institute where students receive not only biblical training but focused development in creative arts, counseling, leadership skills, and divinity courses. She also has a passion to see leaders equipped and women arise to their places of destiny in the earth. She has spoken prophetically to the Church, challenging all to shift into God's purposes:

> I believe that there is a shift happening in the spiritual realm. God wants to move us from contentment to enlistment, to bring divine alignment for divine assignment....God is sending a wake-up call. Don't play with time. Don't use it for yourself alone—use it for God. The time is short—do you believe it? If we really believe time is short, it will alter our priorities. We will do things intentionally. We will redeem the time. We will accelerate our efforts to produce disciples and leaders. We will engage in warfare for the nations.[10]

## Barbara Wentroble

Barbara Wentroble is a strong apostolic leader and Founder of Wentroble Christian Ministries and International Breakthrough Ministries, which unites leaders from both the church world and the business world to bring a Kingdom impact in the earth. For more than 25 years of ministry, she has been a leader in the prayer movement, has led strategic teams to many nations for the purpose of bringing spiritual and social transformation, has authored numerous books and articles, and has convened business conferences that equip marketplace ministers for effective Kingdom service. She has a heart to see strong apostolic and prophetic foundations built in the lives of today's leaders and

has impacted nations through the powerful anointing for breakthrough, which she imparts. She is passionate about seeing women rise up all over the world to fulfill their call in these last days.[11]

Barbara's clear prophetic insight challenges the Church to arise in each new season to implement God's breakthroughs in the earth. She has prophetically declared to the Church:

> God is gathering a powerful group of people in these days. Lives are joining together in covenantal relationships. Ministries are aligned to see the Kingdom of God advance throughout the earth. Many of the ministries have been in Adullam in the past season. However, they are being properly aligned so the seed of destiny in them is released to accomplish great Kingdom exploits. Destiny has a time for fulfillment. Great courage will be needed as we embrace our destiny. These are days when we will see new enemies. Old war strategies and independent spirits will not be able to stand against these enemies. A synergistic alliance of powerful visionary ministries is emerging as a Davidic Army for the new season. They are anointed for powerful breakthroughs in cities, territories and nations. Their testimony proclaims that "Jesus is God of the Breakthrough!"[12]

## Jane Hansen

Jane Hansen serves in an apostolic role as President of Aglow International, a worldwide ministry that has touched the lives of women in 170 nations. She imparts a sense of divine destiny and purpose into the hearts of women, young and old, and gives them vision for bringing the Gospel message to their families and communities, encouraging them to make their homes "lighthouses" through simple hospitality. She has written numerous books and serves on the boards of many ministries.[13]

Her message releases God's healing and restoration so that women can arise and bring change in the earth. She has prophetically spoken to nations and has sensed a mandate from God to reach into the Muslim community to see transformation come. In an Aglow conference in Orlando, Florida, a prophetic word was given that initiated this burden:

The Lord said, "For you have seen the great darkness and yes, you have said it is a formidable enemy and how shall we penetrate the darkness." For yea, it cloaks the nations, and it cloaks the Muslim nations. And you say, "Oh Lord, my God, those religious beliefs are ingrained and woven into the very fabric of their being and yet, shall they be free?" And I say to you tonight, "Yes, they shall be free. For it takes only one thread to unravel a garment, so shall I unravel the garment of Islam, even as I have unraveled the garment of communism in this hour. Yea, My people, I cry unto you, lay hold of that thread in My power and My might and we shall disrobe the garment of Islam," saith the Lord.

In July 2005, Jane wrote to Aglow members the following encouragement:

In April, I attended the *All-Africa Conference* held in Zimbabwe titled, *Arise, Arise O Woman*. AFRICA IS EXPLODING! There were 23 nations represented. It was colorful, full of joy, dancing, worship, and powerful messages! Our leaders in Africa are powerful women of God who are truly apostolic in many ways. The strength that comes from them is astounding. Consider what so many of them live with on a daily basis...difficult governmental situations, struggling economies, overwhelming health issues (especially HIV) yet they have a strength and a joy that is amazing. This conference was divinely ordered by God! Before leaving, God gave me a

word. The warring spirit Africa is known for was actually given by God. It is a spirit that the enemy has twisted, distorted, and wreaked havoc with. But that warring spirit is Africa's redemptive gift and as the women of Africa would arise in the right spirit, they would teach the nations how to war, how to stand on level 12, God's governmental level, bringing order out of chaos. God was speaking strongly to the women of Africa...**ARISE O WOMAN...ARISE AND THRESH.**[14]

## Awake, Deborahs

God is calling Deborahs everywhere, from every background, every race, every culture, and every area of influence to wake up to our apostolic destiny. The Hebrew word *awake* means to "open up the eyes." It is time that we take our heads out of the sand and open our eyes to all that is happening in our world. It's time to awaken from our false identities and fears to embrace a vision for transformation. God is calling us to be reformers. He is calling us to blaze new trails. He is calling us to take up this apostolic mantle and begin to build where the enemy has torn down, to govern where lawlessness has ruled, and to triumph where hopelessness has prevailed. It's time to possess the Kingdom!

## Endnotes

1. Strong's Concordance, 652.
2. Barbara Yoder, *God's Bold Call to Women* (Ventura, CA: Regal Books, 2003), 120.
3. Yoder, *God's Bold Call to Women*, 119.
4. Webster's Dictionary of the English Language.
5. Strong's Concordance, 2985.
6. Webster's Dictionary of the English Language.
7. Strong's Concordance, 3173.
8. Strong's Concordance, 5485.
9. Yoder, *God's Bold Call to Women*, 51.

10. Naomi Dowdy, "Divine Alignment for Divine Assignment," 2006, www.naomidowdy.com.

11. International Breakthrough Ministries, www.internationalbreakthroughministries.org.

12. Barbara Wentroble, "Anointed for Breakthrough," The Elijah List Newsletter, March 2002, www.elijahlist.com.

13. Aglow International, www.aglow,org.

14. Jane Hansen, Visionary letters from Jane Hansen, Aglow website, July 2005.

෨෨෬

# Women Who Make a
## Difference Through Apostolic Strategies
### APOSTLE BARBARA YODER

We have entered the time when the Church no longer has a choice about arising and clothing itself with the war mantle. Either it puts on the war mantle, or it slips into oblivion, awaiting another generation that will go to war.

Traditionally, women have not been viewed as warriors. However, apostles and apostolic people are warriors, male and female. Both genders were given the mandate in Genesis 1:28 that they were not only to bear fruit, multiply, and fill the earth, but to also subdue the earth and take dominion. In the Book of Acts, we see apostles breaking into new regions and territories. For example, the apostle Paul took the city of Ephesus (see Acts 19), and Ephesus was transformed. Individuals were changed. The city was transformed both governmentally and economically because the people changed. Paul subdued an idolatrous structure to the point where he and the Church ruled over it and the territory.

Considering another example, Deborah came to rule in an adversarial time. The people of Israel had sinned, and God had given them over, into the hands of Jabin, a Caananite king and his armed forces commander, Sisera. Israel was in a mess. They could not even walk on the main paths because Jabin and Sisera ruled the land. Nothing was safe. They could not even walk to the market without the possibility of getting mugged, beaten, or killed.

Deborah arose as a mother in Israel. Because this passage is not talking about genealogical children, it means that she arose as a mother to the nation—a female apostle. She worked with Barak to enter into battle to take back Israel, and the woman Jael dealt the final

*blow to Sisera. They were a team of warriors, two of which were
women, who went to battle to take back their nation.*

*Today there is a company of true Deborahs who are arising as
"mothers," apostolic leaders, to take back cities, states, and nations.
When it speaks of being a mother, think of what happens when
someone makes a mother angry because he "messes" with her
children. She is out for the kill and will shred that person into pieces.
What would happen if key women across a city, state, or nation got
that upset?.*

*In the December 5, 2005 issue of the **Washington Post**, a true
story was printed about what happens when women get angry about
their people's plight. A hamlet called Bacontown in Anne Arundel
County was founded around 1860 by a free slave, Maria Bacon,
for her family. Eventually the community was ruled by drugs,
prostitution, and community blight. However, women turned this
community around. Note that these women rose up and turned
this place around because they said, "We didn't have a choice."
Their anger led them to action, which transformed a town.
Following is a statement from the **Washington Post**:*

*"When the women of Bacontown found their community in
trouble, their grit and patience and perseverance rescued Maria
Bacon's legacy from neglect, crime and encroaching development.
'It was a mess,' said community matriarch Lenore Carter. 'We
didn't have a choice.'"*

*On another occasion, God got the attention of an ordinary
mother, Marlene Elwell, while she was home taking care of her
children in the 1970s. She had the television on and saw this woman
with a big hat talking about women's liberation. She did not know
that woman was Bella Abzug. Something arose in Marlene that*

*said it's not right. Then in 1992, that righteous anger in Marlene took form when the "Women Libbers" decided to work to pass the Equal Rights Amendment in Iowa. Something in Marlene said, "This must not go through." She heard God speak to her to go and do something about it and defeat it. She went from Michigan to Iowa, stayed in a hot attic apartment, and almost single-handedly defeated the ERA in Iowa in 1992. She affected an entire state and ultimately the nation. She arose and went to war over an issue that was ungodly.*

*I have been working for nine years to bring transformation to the state of Michigan as the apostolic leader of the Michigan Global Apostolic Prayer Network. Many have gathered around to join our efforts, and corporately we are making a difference. Through sustained intercession as well as timely action, the atmosphere of our state is changing. Currently, government is about to make a big shift because someone arose and said, "Let's do something about this." Working with other spiritual leaders in the state, we arose with an apostolic mantle, retrieved the keys to the state that had been given to Saddam Hussein, and regained our voice. Now we are a corporate voice crying out, a forerunner state, declaring, "Prepare the way of the Lord." A platform for God's transforming power has been built, to change our state.*

*Judges 5:6-7 (NKJV) says, "In the days of Shamgar, son of Anath, in the days of Jael, the highways were deserted, and the travelers walked along the byways. Village life ceased, it ceased in Israel, until I, Deborah, arose, arose a mother in Israel."*

*Let the mothers in Israel arise with a righteous indignation forming a powerful war mantle to turn cities, states, and nations back to God.*

∞∞∞

**Barbara Yoder** is a powerful apostle who serves as Senior Pastor of Shekinah Christian Church, in Ann Arbor, Michigan. She also serves as the Michigan State Coordinator for the United States Global Apostolic Prayer Network and is on the National Apostolic Council for the United States Global Apostolic Prayer Network. She has authored several books and brings an anointing for breakthrough at the numerous conferences she speaks at worldwide.

# CHAPTER NINE

## *Deborah—Woman of Wisdom*

*That God of our Lord Jesus Christ may give to you the spirit of wisdom and revelation in the knowledge of Him, the eyes of your understanding being enlightened; that you may know what is the hope of His calling...* (Ephesians 1:17-18 NKJV, emphasis added).

The ability to receive great revelation is not enough to have a truly effective ministry for God. The apostle Paul prayed for the saints at Ephesus that God would give them not just the spirit of revelation, but the spirit of wisdom as well.

The apostolic and prophetic women whom God is calling to be a part of the Deborah Company must not just have the ability to clearly hear God or to see visions or dreams, but they must be women of wisdom and maturity who are careful with the revelation they receive. They must know how and when to speak these words in such a manner that will motivate God's people to turn from their wicked, self-seeking ways and come forth into His divine purposes for their lives.

Proverbs 31:25-26,30 describes the virtuous woman:

*Strength and honor are her clothing...she openeth her mouth with wisdom; and in her tongue is the law of kindness. ... Favor is deceitful, and beauty is vain: but a woman that feareth the Lord, she shall be praised.*

Proverbs 9:10 agrees that "*The fear of the Lord is the beginning of wisdom....*"

Most of us have probably seen or met someone who had accurate revelation, but when she opened her mouth, the word came out harsh, cutting, or in a presumptuous, prideful, or inappropriate manner. The individual probably didn't intend to come across so hard. Nevertheless, because of a wounded spirit, places of hurt, disappointment, or insecurity in her soul, she may have felt the need to project the word in such a forceful way so that it could not be discounted, argued with, or corrected. This is a dangerous place for any prophetess or prophetic woman to be.

Wisdom is never afraid to submit itself to godly authority for accountability and oversight. It recognizes that there may be blind spots that one may be unaware of, which may bring about destruction. Wisdom enables you to receive input, and at times, correction so that you can be the very best, most effective minister you can be. Wisdom is a necessary, vital ingredient to effectual, powerful, productive ministry.

James 3:13-18 says this of godly wisdom:

*Who is a wise man and endued with knowledge among you? let him show out of a good conversation his works with meekness of wisdom. But if ye have **bitter envying and strife in your hearts**, glory not, and lie not against the truth. This wisdom descendeth not from above, but is earthly, sensual, devilish. For where envying and strife is, there is confusion and every evil work. **But the wisdom that is from above** is first **pure**, then **peaceable, gentle** and **easy to be entreated, full of mercy and good fruits, without partiality and without hypocrisy**. And the fruit of righteousness is sown in peace of them that make peace* (emphasis added).*

## Wise in Words

Proverbs 31:26 instructs us that a virtuous woman *"openeth her mouth with wisdom; and in her tongue is the law of kindness."*

Most women love to talk! We are generally highly relational people and enjoy good conversation and interaction. Unfortunately, our tongue can get us in trouble and cause us to say things that are not in keeping with a spirit of wisdom. Proverbs 21:23 tells us, *"Whoever guards his mouth and tongue keeps his soul from troubles"* (NKJV).

Scripture is full of admonitions to keep our words pure and edifying and to avoid evil speaking, gossip, slander, backbiting and talebearing. If we desire to be women of wisdom, it is imperative that we carefully guard the words that come out of our mouths and allow all our conversations to be edifying and uplifting to those who hear (see Eph. 4:29).

James has much to say regarding the tongue and the difficulty we may have in controlling what we speak. He instructs us that the tongue may be a little member in our body, but it still has the power to kindle great fires, to spread deadly poison, and to defile the entire body. He tells us that if we can learn not to offend others by our words, we will be perfect! (see James 3:2,5,8).

Life and death are in the power of the tongue. As women of wisdom, we are given an awesome tool to release the nature and anointing of God as we speak words of edification, exhortation, and comfort (see Prov. 18:21; 1 Cor. 14:3).

Modern science confirms that sound waves continue even after they are out of our range of hearing. It has actually been recorded that radio broadcasts have left the earth realm, bounced off of satellites or meteorites in space, and have returned to earth to be recorded by scientists.[1] If sound travels like that, what happens to our words? Do our words continue to travel through the airwaves creating good or evil? Our prayer should be as the psalmist, David, who wrote, *"Set a watch, O Lord, before my mouth; keep the door of my lips* (Psalm 141:3)."

What we speak has the power to create an atmosphere of blessing and life or of cursing and death. When we speak positive,

edifying, encouraging words of faith, we create an atmosphere that the angels and ministering spirits are attracted to. On the other hand, when we speak negative, pessimistic, destructive words of doom and gloom, we create an atmosphere that draws demonic forces. It really is up to us to control what comes out of our lips. Sometimes, after we have created an atmosphere of cursing over our lives, we wonder why everything is going wrong. Rather than binding the devil, we ought to bind ourselves! My secretary, LaRue, taught me years ago that when she wants to say or do something that is less than Christ-like, she says, "I bind myself." Perhaps there is truth in that!

> *See, I have set before you today life and good, death and evil, in that I command you today to love the Lord your God, to walk in His ways, and to keep His commandments, His statutes, and His judgments, that you may live and multiply; and the Lord your God will bless you in the land which you go to possess. ... I call Heaven and earth as witnesses today against you, that I have set before you life and death, blessing and cursing; therefore choose life, that both you and your descendants may live; that you may love the Lord your God, that you may obey His voice, and that you may cling to Him, for He is your life and the length of your days...* (Deuteronomy 30:15-16,19-20 NKJV).

### Wise in Discernment

Webster's Dictionary defines the word *wise* as "having the power of discerning and judging properly as to what is true or right; possessing discernment, judgment or discretion."[2] As Deborah was positioned as a judge over the house of Israel, she had to also possess the qualities of wisdom and discernment in order to effectively govern her nation.

In Judges 5:15, we learn that the sons of Issachar were with Deborah and Barak when they went out to battle. First

Chronicles 12:32 describe the children of Issachar as those who could discern the times:

*And of the children of Issachar, which were men that had understanding of the times, to know what Israel ought to do....*

The sons of Issachar exemplified those who walk in the double portion anointing of wisdom and revelation, of the apostolic and prophetic mantles. They had prophetic insight in understanding the times, and coupled that together with an apostolic anointing for strategy of how to respond to those times. Many times during the prophetic movement, we may have heard a word about the season God had placed us in, perhaps that is was a time for a specific release of power, favor, or miracles. However, because apostolic strategies weren't also in place to instruct us regarding how we should respond to those seasons, those times and seasons would often come and go with only a minimum number of lives having been affected.

Those who are called to be a part of this company of women whom God is raising up must be willing to have spiritual discernment and the gift of discerning of spirits developed in their lives. This divine gift gives one the ability to distinguish between good and evil, to sense God's presence, to determine heart motives, and even detect demonic and angelic activity (see 1 Cor. 12:10).

When God gives such an ability to an individual, that person has a responsibility to respond wisely to the things that are discerned, both through natural wisdom as well as through supernatural revelation. True discernment does not come so that a person can become critical, condemning, or judgmental towards others. There is a big difference between judging righteously by the Spirit of God and entering into a judgmental attitude towards others. Matthew 7:1 warns us to *"judge not, that you be not judged."*

An apostolic woman moving in the Deborah anointing of "judge," must understand that the judgment she is stepping into is not to "sit in judgment" of other individuals and to pass sentence upon them. There is one Judge—God, Himself, who will judge the hearts and actions of men and women. We can, however, judge according to the Word of God and the principles contained therein, to distinguish between right and wrong, good and evil. We can also discern, by the Spirit, when a demonic force is present and determine the strategy that will cause it to loose its hold.

It is also important as we move with wisdom and spiritual discernment that we are able to discern the moving of God's Spirit. God is a big God, and Scripture is clear that the way He thinks is not the way we think. As God continues to restore the fullness of truth from His Word, we must open our hearts to the new things God might do. He might bring new experiences with His Holy Spirit that we are unfamiliar with, but our lack of familiarity does not mean the manifestation is not of God.

In this day, God is pouring out His Spirit in new measure. We have seen signs and wonders, healings, miracles, prophetic demonstration, laughter, tears, shaking under God's power, and other manifestations of His Spirit that we may not have seen before. We must have discerning hearts to be able to clearly hear God's voice, properly distinguish the move of His Spirit, and receive all that He is pouring out in this hour.

## Wise in Principle

Do you really believe what you believe you believe? When things are tough and it is difficult to understand what God is doing in a circumstance or situation, often our belief systems can be challenged with this question. We can say we believe something, but what do we really believe when we come under pressure? What are your core values? What are the principles you base your decision-making process upon?

What happens when someone pushes your button? "What button?" you ask. That button of overreaction, of anger, or of tears. Each one of us must identify our button of reaction so that we can fortify ourselves against an inappropriate response.

When I was a young mother in ministry, one of my buttons was for someone to suggest that I wasn't a good mother because I spent some of my time at the church rather than at home with my children. This would provoke a reaction of anger and defensiveness. What was really motivating my response was my own feelings of guilt for not complying with what others thought a good Christian mother should be doing. I was doing what God had called me to do; however, I allowed the pressure of what other people thought, to instill guilt in my heart. As I received healing from the Lord, and reassurance from my husband that I was doing what God was asking of me as well as taking good care of my kids, my button of overreaction was neutralized and I found peace.

We all have blind spots in our lives; therefore, it is good for others to speak into our lives, who can help bring a godly perspective. The trouble with blind spots is that we often can't see them. On one occasion, my husband and I felt it necessary to speak to a man in our church who was constantly offending people with his manner and delivery. Everyone could see his weakness, yet when we spoke to him, he was dumbfounded. His response to us was, "I'm sorry, Pastors. I hear what you are saying, but I just can't see it." Yes! That's the point. It is a blind spot.

It's so important that we place people in our lives who can tell us things about ourselves that everyone else can see, but that we remain blind to. It's similar to coming out of a public restroom with toilet paper stuck to the bottom of your shoe. It's a bit embarrassing when someone points it out, but it's better than everyone laughing at you without you knowing why.

We must find out what we believe to be truth, or else we will allow our emotions and our circumstances to dictate our belief

systems to us. In every challenge we learn a lesson. The question is: What lesson have we learned? We can learn right lessons or wrong lessons. God is requiring of His Deborah Company women to go back and unlearn our wrong lessons so that we can be fortified with truth.

Our belief systems will shape the decisions we make towards our destiny. Ask yourself these following questions: What do you really believe about God? Is He really concerned about your good? Does He hear you when you pray? Is He able to deliver you in times of crisis? What do you believe about others? Are people always out to get you or take advantage of you or mistreat you? Do you believe that you can't really trust anyone but yourself? What do you believe about yourself? Do you believe you are worthy of God's love, that you can do all things through Christ who strengthens you, that you are accepted by God and have no need to earn His love?

So what happens when we find ourselves in a place where nothing makes sense? We have prayed and read the Word of God, but still don't understand God's ways. When I found myself in this place after several miscarriages as a young mother, I felt that God was speaking a great plan to me. He said, "Rather than focusing on all the things you don't understand about Me right now, focus on what you do know about Me." That seemed to turn upside down, right side up again. I knew that God was good. I knew that He was just and fair. I knew that He was sovereign. I knew that He was in control. I knew that His power was greater than the devil's power. I knew that the power of life and death were in His hands.

### Wise in the Hard Times

We must choose to believe the right things in order to move forward, past times of grief and disappointment. This was especially true for me at the birth of my son, Jason. He was born prematurely with a facial birth defect called a bi-lateral cleft lip and

palate after a very difficult pregnancy. This meant that he had no upper lip, no hard or soft palate, and the gums where his front two teeth were supposed to be grew in a ball at the end of his nose. Obviously, it was a very traumatic time for my husband and me. Yet, when I first laid eyes on him after his birth, I heard the Lord speak two things very clearly to me. The first was that this wasn't my fault. The second was "Jane, you can handle this."

Hearing the voice of the Lord during such a difficult time brought great peace to my heart. He said it wasn't my fault. Now, I recognize that oftentimes, birth defects are caused by what a mother ingests while she is pregnant. However, I had always been extremely careful about what I had put into my body. Still, when God said I wasn't responsible for the condition of my son, it brought a peace that silenced any questions.

The second part of what God said proved to be more difficult for me to walk out. He said I could handle this. That meant there would be grace and strength for me to do all that was required of me during the difficult days and nights that were to follow. I have to say that this was initially true. I felt a great love for my son and a joy that God had entrusted him into my care. In many ways, I felt that God had paid me a compliment by giving me such a special child, knowing that I would draw on Him to face the challenges. I never really felt grief, but rather a deep sense of peace...until I got tired.

Caring for Jason was very tiring. He was born without the capacity to suck milk from a bottle. Subsequently, an orthodontist made a prosthesis for the roof of his mouth when he was only 12 hours old to help him be able to eat. He learned to chew the milk from the nipple, but the prosthesis would rub blisters on his gums, and he would often bleed while feeding. He was also born without the flap at the back of his throat to keep the milk from going into his lungs, so I had to be alert and ready to aspirate his lungs at any point during feeding, lest he drown in his formula. This process was very long and tiring for both of us. It would take

him one and a half hours to eat just an ounce of formula, and often he would spit everything up and we'd have to start again. He was getting smaller by the day, and my heart was breaking for him.

One night at three in the morning, I had just finished feeding him when Jason spit everything up, and I knew I was going to have to start all over again. My husband had already taken his turn, and I knew I needed to stay alert to begin the feeding session again. But I was so tired, and I began to cry. As I cried I said to the Lord, "I can't do this. I just can't do this. I know You said I could handle this, but I can't. I can't handle this." It was a very emotional moment. Then I heard the voice of the Lord come to me again. You would think that He would say something sweet and full of compassion. But instead I heard the Lord say, "Stop it, Jane!" Now, I thought that was a bit mean at the time because I was in such a pitiful state, but God knew what I needed to hear at that moment more than I did. He went on to say, "I told you that you could handle this. So you need to make a choice. Are you going to believe Me, or are you going to believe what your emotions are telling you? If you choose to believe My Words to you, I will continue to give you all the joy, peace, and grace you need to get through this. If you choose to believe your emotions and follow down the path of depression, My joy, peace, and grace can't go with you. So you need to make a choice."

My first response was, "Lord, why are You being so mean to me?" Then I realized that He wasn't being mean; He was saving my life! The Word of the Lord brings life! So I responded to the Lord that I would, of course, choose the path of believing His Word to me and repented for my unbelief. Suddenly, the room was filled with the presence of the Lord. Not only did I receive strength, but my son was able to eat without spitting up from that point forward. He began to gain weight and continued to eat until he was a fat and happy baby.

Jason is now a young adult. During his lifetime, he has gone through 12 major reconstructive surgeries and is doing well. He has had to make some choices of his own in His journey to believe the right things about God and his process, but the grace of God has been on his life in a miraculous way. He has served Him faithfully through good times and bad and has not allowed a root of bitterness to spring up in his heart.

We all have to make choices to believe the Word of the Lord or to trust in our circumstances or in our own abilities to save us. When we make the right choices, God gives us the strength, the grace, and the wisdom we need to grow and mature in Him. Sometimes, wisdom is imparted, just as God gave Solomon a mantle of wisdom through a dream. Most times, though, wisdom is developed in the furnace of life's afflictions.

### Endnotes

1. "Echoes from Ancient Supernovae," Universe Today, December 2005, www.Universetoday.com/au/publish/cfa_super nova.html.

2. Webster's Dictionary of the English Language.

CHAPTER TEN

# Wisdom and Authority

The apostolic anointing for wisdom is something that should be sought after by all, and is vital to those desiring to move into the new things of God. With wisdom will come a new release of authority, both in natural things as well as spiritual. In order to properly use this authority, one must be rooted and grounded in the Word of God, intimately acquainted with the Lord Jesus Christ through prayer, and have in place some type of personal accountability or mentoring. Maintaining a mature balance in all these areas will help to assure a legitimate use of the authority that God gives.

## Legislating From the Heavenlies

According to Ephesians 2:6, we have been seated together with Christ Jesus in heavenly places. It is from this position of rulership that we are to govern and legislate the things of the Spirit. This place is far above principalities and powers and those demonic princes that would attempt to rule from their place in the second heaven. It is time for us to realize that God has released the authority, anointing, and power to the Church to begin to execute His judgments in the earth and to enforce the victory that Jesus Christ achieved through His death, burial, and resurrection.

The anointing of "Judge" on this Deborah Company of Women will bring forth sound judgment on earth as well as the ability to shake the heavenlies with the authority of God, the Supreme Judge. We must have our own lives purified by the fire

of His anointing, so that we do not move in judgment according to our own natural wisdom or personal agendas, but only according to that which is declared from the throne of God.

## Dealing With Discernment

Several years ago, our ministry faced a very difficult situation dealing with an individual who led many people astray. I had always experienced a personal difficulty with this person, for though she was likeable and cordial to me, something within my spirit sent out warning signals that not all was as it seemed. Several of the leaders in the ministry prayed together after several families left us. We began to realize our great need for the gift of discerning of spirits and spiritual discernment to operate in our midst. Because I felt this gift was something God had already spoken to me, I asked for prayer that I would be able to understand how to administrate the gift He had given me.

After my husband and my spiritual father, Dr. Bill Hamon, laid their hands on me and released this gift in new measure, I began to see things with great clarity. I witnessed some things in the spirit realm and was able to determine what specific demonic entities we were fighting against, and how we could effectively battle through to victory. This seemed a bit intimidating; nonetheless, how to handle this aspect of the gift became very clear to me.

Much more difficult to deal with was discerning those things that were affecting men and women's lives. At times, there was a demonic stronghold; at other times, an impure heart motive or attitude. Quite honestly, this frightened me. I've never thought of myself as a critical person. I've always tried to believe the best of people and give them the benefit of the doubt. However, when I began to discern these things, I had a difficult time separating the person who Jesus loved and died for, from these ungodly, evil things that were motivating and controlling their lives. I found myself entering into a judgmental, critical attitude towards them,

and in my heart, condemning them for allowing these things to rule their lives.

God had to deal with my heart, because the purpose of this gift was being corrupted by my lack of maturity in properly administrating its function. He challenged me one day when I was contemplating something I had discerned within a man in our church. God rebuked me and said, "I didn't show that to you so that you could pass judgment on that man, but so that you would be alerted to possible danger, and that you might *pray for him* and minister to him with God's love more effectively!" My husband confirmed what God had spoken when he challenged me by saying that the gifts of the Holy Spirit are given to edify the Body, which means to build them up, not tear them down. God was showing me these things to alert us to prayer, but also that we might seek ways to set the individuals free (see 1 Cor. 12:12)

There are times when God gives discernment regarding a person's life as a warning to observe that person and be aware of certain areas of weakness, so that the flock of God can be protected; however, our first response toward them is to walk in compassion toward them, to pray for them, and to believe in the power of God to restore and deliver them. At times, the individual may need to be ministered to or even corrected, but our heart motivation must, first and foremost, be divine love.

This is a difficult area for many who have been given this gift, for some will at times struggle with feelings of being critical or judgmental when the Spirit of the Lord illuminates certain dangers in a person or a situation. God will normally reveal these things in order to bring warning, or more importantly, to alert people to pray for God's divine purposes to be brought forth in the situations they might be facing. It is vital that we keep our hearts pure before God and remember that for every person you have discerned something about, someone may have discerned you! "Judge not that you be not judged."

It is important when you feel you are discerning something in the spirit realm to determine what your responsibility is. False responsibility becomes a trap that you must be careful not to fall into. False burdens will only weigh you down and wear you out and will not bring God's solution into the situation.

What is God requiring of you in regard to what you are discerning? It may be merely to pray or perhaps there will be something you are to do. God may have you pray about the situation, and then share it with the appropriate people in leadership. After that, it becomes their responsibility to handle the situation as the Lord may direct them. Whatever God's instructions are, be faithful and obedient to follow where He leads.

## Warnings to the Wise

Regarding the development of the gift of discerning of spirits, there are some important cautions I'd like to give you based upon my experience.

1. *Discernment is not just about demons.* On the contrary, discernment involves discerning the moving of the Spirit of God during ministry times. It involves the presence and activities of angels in our midst. It involves impure human motives, and yes, it also involves discerning demonic forces for the purpose of deliverance and freedom.

2. *Discern by the Spirit, not the soul.* Be careful that what you are calling discernment is truly something from the Spirit and not from your soul. At times, someone may offend us, and then we might improperly begin to "discern" what is wrong with that person. On other occasions, the way a person looks may cause us to think about them a certain way. Our prejudices or mind-sets about how a person looks or acts are not accurate manifestations of this Holy Spirit gift.

For example, as a child, I suffered abuse from a man who wore a beard. In my adult life, I was healed of the effects of the abuse, but still couldn't trust any man who wore a beard and continued

to experience an immediate aversion to them. If I hadn't been careful, I could have decided that my soulish reaction was spiritual discernment, when in truth, it was a reflection of an unhealed area of my heart. Once the Holy Spirit brought this to my attention, I was able to pray and be free of this prejudice.

3. *Acts of immaturity aren't necessarily indication of a demonic presence.* Just because someone is not walking in maturity in their words or actions doesn't mean they have a demonic problem. We all are in the process of having our minds renewed. Remember, others have demonstrated grace toward you when you haven't displayed the best behavior.

4. *Don't take on territorial strongholds alone.* Scripture encourages us that one will put a thousand to flight, and two will put ten thousand to flight (see Deut. 32:30). It is important to understand that if you are discerning a territorial spirit that is controlling a geographical area, it will usually take others in the Body of Christ coming together with a strategy to see that spirit flee. Please don't ever try to unseat one of these spirits alone.

## A Charge to Women of Wisdom

Deborah Company, it is time to receive the impartation of apostolic wisdom to enable us to legislate God's agendas in the earth. Let us take up the apostolic mantle of power that we might be nation changers and culture shapers. We must allow our hearts to be pure and our lips to speak life in all that we do. Let us marry the anointings of revelation and wisdom within us that we might be fully equipped to effectively minister truth to our generation. Let us be women who can discern the times as did the sons of Issachar. Let us receive the gifts from the Spirit that will enable us to properly discern between good and evil. Let us put aside all criticism and judgment and walk righteously before God and man in love. Let us be the women of wisdom we are called to be, for this day and hour!

SECTION TWO

## *Questions for Consideration*

1. List a situation that you feel needs a breakthrough from God. Pray and ask God for discernment and a strategy to bring forth this breakthrough in a particular area.

2. What is your specific role and responsibility in this strategy? What aspects of the apostolic mantle do you feel called to employ to see this breakthrough occur?

3. Are there areas in which you have not used wisdom with your words? Describe the situation and how you plan to prevent falling into the same trap.

4. Make a list of things you feel you may have discerned by the Spirit about a person, a group, a situation, or a territory, and actively pursue these things in prayer. What are your responsibilities?

5. Have you learned to discern your personal resentments or personality clashes from Holy Spirit impressions? Yes_____ No_____ If yes, list one way you determine the source of your feelings.

## SECTION THREE

# Deborah the Wife: Woman of Balance

*Our success as a society and as a nation depends not on what happens in the White House but what happens in your house.*[1]

Barbara Bush
First Lady of the United States of America

## Endnote

1. Jane Hansen, *Fashioned for Intimacy* (Ventura, CA: Regal Books, 1997), 146.

# Deborah the Valiant Woman

*And Deborah, a prophetess, **the wife of Lapidoth**, she judged Israel at that time* (Judges 4:4, emphasis added).

Deborah was not only a respected prophetess and judge in the land of Israel, but she exemplified a woman of balance as a wife, probably a mother, and a homemaker also. Her house was on the road between Ramah and Bethel, in the hill country of Ephraim. Rabbis say that before she became a judge, she was a keeper of the tabernacle lamps.[1] This is interesting due to the fact that she would later become the keeper of a new spiritual vision that would light all the land of Israel.

Being women of balance and establishing the home is part of our calling that cannot be neglected or trivialized in order to fulfill other aspects of our ministry call. On the other hand, we must learn to walk in this balance so that we can be obedient to all God commands. As God is raising up this new breed of women, we will be those who have ordered our lives in such a way as to succeed in business, career, government, and ministry without losing our most important area of influence, our families.

As God is bringing women to the forefront and releasing their gifts and callings in Christ, it is important not to confuse what God is doing with that which is occurring in society. With the advent of the women's liberation movement over the last several decades, the concept of a woman setting a priority of staying home to raise children has been belittled and ridiculed. These women have been characterized as those who are simple, without

vision, without strength, and without intelligence. Marriage and children have been seen as confining or restricting to some who have a desire to pursue personal achievement and careers. On the other hand, those with traditional values have objected to the idea that their significance can only come as a result of being in the workplace. Still, those who have a desire to do more than care for a home and family defend their position and right to accomplish other goals.

## The Valiant Woman

The Scriptures paint a very definite picture of a woman who can raise a family and still run a business, minister to others, be a successful wife, and manage a household, all at the same time. The virtuous woman from Proverbs 31 was a woman who did it all.

*If you can find a truly good wife, she is worth more than precious gems! Her husband can trust her, and she will richly satisfy his needs. She will not hinder him but help him all her life. She finds wool and flax and busily spins it. She buys imported goods brought by ship from distant ports. She gets up before dawn to prepare breakfast for her household and plans the day's work for her servant girls. She goes out to inspect a field and buys it; with her own hands she plants a vineyard. She is energetic, a hard worker, and watches for bargains. She works far into the night! She sews for the poor and generously helps those in need. She has no fear of winter for her household, for she has made warm clothes for all of them. She also upholsters with finest tapestry; her own clothing is beautifully made—a purple gown of pure linen. Her husband is well known, for he sits in the council chamber with the other civic leaders. She makes belted linen garments to sell to the merchants. She is a woman of strength and dignity and has no fear of old age. When she speaks, her words are wise, and kindness is the rule for everything she*

*says. She watches carefully all that goes on throughout her household and is never lazy. Her children stand and bless her; so does her husband. He praises her with these words: "There are many fine women in the world, but you are the best of them all!" Charm can be deceptive and beauty doesn't last, but a woman who fears and reverences God shall be greatly praised. Praise her for the many fine things she does. These good deeds of hers shall bring her honor and recognition from people of importance* (Proverbs 31:10-31 TLB).

The word *virtuous* found in verses 10 and 29 (KJV) is yet another example of gender bias by the translators of the Scriptures. This Hebrews word *chayil* means "a force, whether of men, means or other resources; an army, wealth, virtue, valor, strength."[2] Interestingly, when this word is translated referring to a man, the translators used the terms "mighty men of valor" or "valiant men," yet when referring to a woman, they used the term "virtuous." The English word *virtue* means "moral excellence, goodness, righteousness," whereas the word *valiant* means "boldly courageous, brave, stout-hearted."[3] Both are obviously good terms to be referred by; however, when we read all that the Proverbs 31 woman accomplished, I think it would be appropriate and biblical to call her the *valiant woman*.

We can see from this description that being a valiant woman does not mean that we are limited in any way when utilizing the gifts and talents God has invested in us. The Proverbs 31 woman was a good wife, a godly influence on her children, managed a household, handled business affairs wisely, bought and planted a vineyard, sewed, cooked, cared for her household staff, and still found time to minister to the needs of the poor.

## The Homemaker Anointing

Providing a place of safety, warmth, and love for her family is an important part, not a limiting role, for the valiant woman. This is not just about taking care of the natural things such as

cooking, cleaning, doing laundry, and paying bills. It is about creating an emotionally stable place for her children, her husband, and herself, free from fear, rejection, and abandonment.

That said, there is still the aspect of creating a natural, physical environment in the home that is welcoming, clean, and friendly. Personally, I can tend to feel inadequate when I compare myself to such a woman (especially the part about getting up before dawn and cooking breakfast for her family!). But this example was not given in Scripture so that women would feel guilt and condemnation as they compare themselves to her; rather, it was given to enlighten us to all the possibilities of being women of destiny and significance.

One day as I was reading this passage, I received a revelation. This woman had handmaids! I thought, *I could do all this if I only had handmaids.* And because I don't cook very well, I also received the revelation that "bringing her food from afar" (KJV) could refer to calling for takeout! What do you think?

## The Business Anointing

We see throughout this passage that this valiant woman also carried a business anointing. She was industrious, creative, and took the initiative to turn a profit and bring increase into her home. This woman dealt in real estate, farming, and textiles. She considered and purchased a field, planted a vineyard, and worked with wool, flax, and a spindle.

Today, there are multiple business opportunities available to women. Some work outside the home; others may have a home-based business. Women are impacting the world through their involvement in the corporate world, in government, in the sciences, in entertainment, as well as in numerous expressions of business.

With this business anointing also comes a wealth anointing. It tells us that all her household were clothed in scarlet and that her apparel was fine linen and purple. These were signs of wealth

in that time. God is calling women to cast off the spirit of poverty and lack, and recognize that He has given us the power to obtain wealth (see Deut. 8:18).

We are living in a day where we are not limited to only our roles within the home, but are encouraged by Proverbs 31 that women can do it all, though at times it can be a challenge to make all aspects of our lives work in harmony with one another. I will be sharing more in the next chapter about becoming women of balance, so that while our businesses thrive, our families and ministry endeavors can do likewise.

## The Compassion Anointing

This virtuous–valiant woman also stretched out her hands to the poor and those who were less fortunate than herself. God loves justice and has a heart to reach those who are needy. When we minister to those who are physically, financially, or emotionally needy, we are representing the heart of God and sharing His infinite love with them.

Where do we start? At times, it is as simple as taking a meal to a friend who is sick, helping out at a thrift store or women's shelter, visiting people in prison, or visiting the elderly. If we look at our communities with the eyes of Christ, we will find that regardless of the affluence of our geographical area, there are always poor among us. At other times, we may consider the poor in other parts of the earth. Perhaps one can travel on a short-term missions trip to help build the Kingdom of God in other nations or neighborhoods who struggle to provide the basic things needed for existence. Or perhaps God may lay on your heart to financially support others who are on the front lines ministering to the less fortunate in the nations. Even today, in the 21st century, children are starving, women are abused, and families are struggling to survive.

Personally, we have been blessed whenever we have undertaken these compassion projects. We have ministered in orphanages,

children's hospitals, and medical clinics in Latin America, and have seen children's faces brighten with hope because strangers care. We have reached out to the poor in the dump communities and housing projects of Rio de Janeiro. We have ministered the message of hope and forgiveness to those who are incarcerated here in the United States. Each time, I leave with a greater sense of joy and fulfillment than I ever expected. I feel blessed to have been a part of expressing the heart of God to those who need Him.

## The Beauty Anointing

Some may ask, "How can there be a 'beauty anointing'? Either you have it or you don't." But when we look to the Word of God to define true beauty, we find that it is something that comes from the inside and works its way outward rather than the other way around. I have known some of the most physically attractive women who are insecure, fearful, and dissatisfied with life. On the other hand, I have known some women whom some might feel are physically plain, but who radiate such love and inner strength that they are transformed.

Proverbs 31 (KJV) tells us that strength and honor are the clothing of this valiant woman, but it also mentions that she is clothed with fine linen and purple. She doesn't just take care of inner beauty, but also spends the time necessary to clothe her outer person with care. God has created us body, soul, and spirit. We must care for our soul and our spirit man, but we must also take care of our bodies. Valiant women are not afraid to adorn themselves with beauty. Get a nice haircut, take care with makeup, and dress stylishly, yet modestly, to let your strong, healthy inner self shine through to the outward appearance.

## The Watchman Anointing

Verse 27 tells us that she "watches" over her household, which comes from the same word meaning "to be a watchman."[4]

She didn't just watch the natural things, but also was watchful and discerning in the spirit about any spiritual attacks coming against her family. A watchman doesn't just watch, she also prays with strategic insight that destroys every weapon formed against her family.

Wives and mothers must take up the spiritual call to become watchmen over their homes. Scripture tells us that the devil is as a roaring lion, seeking whom he may devour. He wants our husbands. He wants our children. We must watch and pray against the fiery darts from hell that are targeted upon our loved ones. We must stand against the spirit of deception that is taking so many hearts and minds captive today.

We must also extend that responsibility to watch and pray for the "household" of the family of God. We are called to be intercessors and to seek the Lord for and pray for our leaders. We are called to hear God for the Church and to pray for His divine purposes to unfold. We are to be God's instrument of transformation and change in our culture and society. As we watch, God will show us the devices of satan and the strategies needed to overthrow wickedness and injustice in our land. God is looking for those valiant women who will challenge the natural realm according to what they see in the spiritual realm.

## God Uses Ordinary Women

The amazing thing about the Proverbs 31 valiant woman is that she was just an ordinary woman who was made extraordinary by her service to her family, her community, and to God. It is not recorded that she was a great leader, speaker, or government official. She just did what she did with a spirit of excellence and made herself available to God.

In her book, *Fashioned for Intimacy*, Jane Hansen, President of Aglow International, tells of women in the Bible who were used of God to shape nations and cultures, not through powerful leadership roles, but through doing what was natural to them as

mothers and sisters. She points out that the destiny of a nation was changed when Israel was freed from Egyptian bondage through the lives of ordinary women: Jochebed, the mother of Moses; Moses' sister; and even Pharaoh's daughter.[5] Jane writes about ordinary women in the Scripture:

> They were not only beautiful women like Esther, who became a queen, or strong women like Deborah, who served Israel as a judge and prophetess, both of whom were powerfully used by God at critical junctures in Jewish history. God also moved through "ordinary" women, women not in high office, but in equally powerful, though perhaps less noticeable or "public" ways. He used mothers and sisters—women who just seemed by nature to be doing the most natural thing in the world. Yet, like Job, while in the midst of their circumstances, they were often unaware that they were actually working in concert with God for the furtherance of His plan on earth.[6]

Jane goes on to quote several powerful women leaders in nations who have encouraged women to touch their nation through affecting their families:

> To awaken the people, it is the women who must be awakened. Once she is on the move, the family moves and the nation moves.
>
> Former Prime Minister Nehru of India

> If you study history you will find that where women have vision that country attained a high position, and where they remained dormant that country slipped back.
>
> Indira Gandhi

> Educate a man and you educate one person. Educate a woman and you educate a nation.[7]
>
> "Women of Vision 2000 Newsletter," November 1992

## What About Single Women?

So does one have to be married and have children in order to be a virtuous or valiant woman or to be a part of this company of women God is raising up today? Absolutely not!

In this day in time, many women are single for many different reasons and circumstances. Some single women are parenting alone while others are managing the activities of a single lifestyle. Some women are widows, some divorced, and others have never married.

Regardless of marital or family status, you can be a part of the Deborah Company and seek to become a woman of balance, properly managing time and opportunity to be as effective as possible on the job, in the home and in ministry opportunities. The apostle Paul addresses the single person in the church and encouraged him or her, declaring that they have greater opportunity to give themselves to Christian service (see 1 Cor. 7:32). Single women may have greater opportunity to focus on ministry development and pursuit of the call of God. They have different priorities and are often more free with their time to expand personal vision and advance the Kingdom of God.

However, single women must be as strategic with their time as those who are married. Though priorities may be different between single and married women, single women must be especially careful to allow God to bring relationships into their lives for connection, care, and accountability. It must be a priority for single women to take the time to develop strong friendships and Kingdom interactions. Beware of isolation that can breed depression and separation from the plans and purposes of the Lord.

## Catherine Booth—A Valiant Woman

The story of Catherine Booth, the wife of William Booth and co-founder of the Salvation Army organization, is an inspiration to valiant women throughout the earth who have a call to work with their husbands in team ministry. She exemplified the

description of the Proverbs 31 woman who was a blessing to her husband and children, yet also reached out to others to bring an impact in her world.

As a young girl, Catherine gave her heart to the Lord Jesus Christ at the age of five. By the age of 12, she had already read and studied the Bible through eight times. At the age of 23, she met and married William Booth. William was a fiery Methodist minister whose message of spiritual and social reform stirred Catherine's heart. He preached about "loosing the chains of injustice, freeing the captive and oppressed, sharing food and home, clothing the naked and carrying out family responsibilities."[8]

In the beginning, William didn't believe in "women preachers." Catherine, on the other hand, felt a call to preach and minister, which became a point of contention in the early years of their marriage. One day in 1860, the Holy Spirit stirred Catherine's heart to get up and speak at a public meeting. She hadn't prepared anything and was afraid that she would look foolish. However, she obeyed the prompting of God and stood up and preached God's Word with power and anointing. Her words stirred and impressed everyone in attendance, but most of all her husband, William. He became her greatest supporter and encouraged her to preach often.[9]

She became almost a novelty in their meetings. "Come and hear a woman preach!" was the advertisement for their meetings. Her role was controversial, yet she pressed through the opposition and brought great progress in breaking open the way for women in ministry.

In 1864, they pioneered a new work in London's East End and held meetings right in the midst of the streets of London. The Christian Mission, which would later come to be known as the Salvation Army, reached out to the common people, homeless, and downcast of the area. They immediately began to realize strong success, and as a result, the organized Church of England

became hostile towards the work. Even a well-known politician of the day described William Booth as the "anti-Christ." One of the main complaints against him was his "elevation of women to a man's status."[10] You see, in the Salvation Army, a woman officer enjoyed the same rights as a man.

Catherine was a leader with strong determination and courage. She worked prayerfully to obey the will of God and studied the Scriptures diligently. She was a prolific writer and theologian, and a visionary who was not afraid to challenge the status quo of the day. One of her projects was the "Food for the Million Shops," which provided hot soup and meals for the poor at an affordable price. She also took on social issues, confronting the sweat shop labor where women and children worked under poor conditions for long hours receiving little wages. Her efforts brought improved working conditions in many industries. Eventually, she became known as the "Army Mother"[11] and was loved by all.

The Salvation Army became one of the most influential missionary organizations of that day, reaching into the United States, Canada, and Australia. The spiritual atmosphere of nations was changed as they spearheaded the emerging holiness renewal. Catherine was instrumental as an evangelist, preacher, and theologian, all which were unheard of for a woman of that time. She also raised eight children, all of whom grew up and worked in the ministry with their parents. She said, "He [God] doesn't ask you to go to chapel or join the church and pray, but to get down and give up your heart to Him, to choose whom you will serve and do it at once, and everything else will follow." Catherine Booth broke open the way for women to rise up to fulfill God's call on their lives. She was a woman who truly made a difference!

## Endnotes

1. Edith Deen, *All of the Women of the Bible* (New York, NY: Harper and Row Publishers, Inc., 1955), 69.

2. Strong's Concordance, 2428.

3. Webster's Dictionary of the English Language.

4. Strong's Concordance, 6822.

5. Jane Hansen, *Fashioned for Intimacy* (Ventura, CA: Regal Books, 1997), 146.

6. Hansen, *Fashioned for Intimacy*, 145.

7. Hansen, *Fashioned for Intimacy*, 146.

8. John Simkin, "Catherine Booth", Spartacus Educational Website, 1997, www.spartacus.schoolnet.co.uk/wbooth.htm.

9. Simkin, "Catherine Booth."

10. Simkin, "Catherine Booth."

11. The Salvation Army, "Catherine Booth," www.salvation armyusa.org.

## *Women Who Make a Difference in Business*
### CHRISTINE GEAR

*"God, all I want to do is honor and obey You in all I do....Please show me the path...." That has been the prayer of my heart since I was a teenager, and now I am a mother of teenagers! This prayer has led our family down some interesting paths, but ones that are the precious milestones of our spiritual journey.*

*As a teenager, I would visit old people in nursing homes, sing in the choir, play in youth bands, lead youth groups, and was very actively involved in the church world. But I knew that there was something God had for me that wasn't within the scope of the church world—something other than being a pastor, evangelist, or missionary. This concerned me because I thought other occupations weren't godly enough, yet there was no passion or leading in any of these areas for us. Consequently, I thought there was something wrong with us!*

*After beginning a family and doing those "mom" things, we decided to begin a home-based business, which led us to a seminar for businesspeople where I had one of those "God moments." I felt like God took the sword of the Spirit and cut me to the heart. He wanted us to be ones to create wealth for His purposes, and to minister into the marketplace! At last we knew the direction God had for our lives! This was so exciting to us. It was okay to create wealth, and we could impact the lives of people where they were at—in the community!*

*Very quickly we began the spiritual "school of preparation for promotion," where we faced those challenges that develop character, trust, and commitment to the journey. The company we worked with went broke, and we found ourselves looking to God for our*

day-to-day needs—a great start to our "wealth creation" program! Subsequently, we encountered spiritual attacks, financial attacks, emotional and family attacks—you name it, we've encountered it. However, the Lord has carried us through each one by His grace.

Through that time, we learned to trust God in a new way. For several years, I would wake up at 3:00 a.m. to listen to Joyce Meyer, play worship CDs, and pray, as I developed a new walk with my Lord. How precious that time was for me. Also, during that time, we developed a business in the network marketing arena, and the Lord blessed us abundantly, to the point where we are now the top-ranking distributors in the world outside Japan!

The Lord challenged us during this season to become a bridge into people's lives through our business. Consequently, we have seen many develop a personal relationship with Him, and carry Jesus in the marketplace to others. Our heart's desire has been to bring transformation in the lives of those we associate with, and we have seen that occur in a significant way through our business that has developed globally.

Encouraging us to step us out further, the Lord convicted us to reach into the community by providing a place for women and children in crisis called Eagle House. It is a loving home environment where girls can live and deal with life issues. This project is in stage one; however, the vision is to provide many homes, in many communities, both nationally and internationally, self-funded by the provision of retirement villages and apartments that would generate funds for more homes and training centers. It is exciting to see the Lord open and shut doors as we step out with Him.

There are so many ideas for wellness centers and clinics bubbling up inside of us, which confirms to us that this is just the

*beginning of a journey that will see the transformation of people's lives around the world.*

*When I consider that all of this started with a simple prayer and a desire to obey the direction of the Lord, I want to also encourage you to allow the Creator of the universe to invade every part of your life, including your business life; and you will experience the peace that passes all understanding and the joy of the Lord as your strength. What an awesome journey walking with the Lord has been and continues to be!*

**Christine Gear** is CEO of GHS International and CEO of Eagle House Projects and Shine Business Awards. She has attained a level of Crown Triple Diamond in her organization, which is the highest honor achieved by distributors in her industry. Christine uses her business environment to minister the heart of God, and mentors many people in fulfilling their destinies as Christians in business. She lives in Brisbane, Australia with her husband and business partner, Neil, and her three children.

CHAPTER TWELVE

# *Deborah—Woman of Balance*

For those who are married and have families, it is important to realize that the role of wife and mother is our most important calling in Christ. We must make the ministry to our families our first priority. Unfortunately, many people, both in the areas of business and ministry, have failed to set this priority, and while they achieve great success in their career or their calling, too often they lose that which is most important to them—their families. Sadly, they normally don't realize their mistake until it is too late.

We must be careful not to put ourselves in a position to choose between our home life and fulfilling our calling in God. Rather, just as the valiant woman modeled for us, we can be assured that we can do both! And for many whom God is calling in these days, it is imperative that we do both.

## Balancing the Call of Family and the Call of Ministry

For years, women have thought that in order to fulfill God's call upon their lives, they would have to sacrifice their families to the ministry to do so. On the other hand, others have felt that they had to sacrifice their calling in God in order to fulfill their calling as wife and mother. Some, in an effort not to abandon one for the other, have postponed any ministry growth or opportunities until their children were grown, thinking that at that time they would obediently embrace the call of God.

## Obedience Is Key

The main problem with this way of thinking is that it dismisses the importance of hearing what God is saying and what

He is requiring of an individual's life at a specific point in time. The key to fulfillment in any area of our lives is to obey God's will.

The Lord impressed this on me several years ago when I was struggling with the complexities of a lifestyle that involved three growing children, a wonderful, supportive husband, and a strong call of God on my life. I was in a place of making decisions regarding some ministry opportunities that God had obviously opened up to me and who was, in fact, pressing me forward to embrace a new level. I was hesitant because I knew that this new level of anointing would cost something valuable—time, effort, and involvement that would detract from attention and time with my children. Quite honestly, I wasn't sure I was willing to pay that price.

But as I sought the Lord on the matter, I was impressed by the Spirit that God was asking me to be obedient to the call at this time in my life. He showed me that while focusing my heart solely on my family was noble, it was not what He was asking of me. He went on to make it clear to me that should I determine not to follow where He was leading me, I would have taught my children disobedience by my example!

This reminded me of King Saul who chose that which seemed good rather than that which was God's will. It seemed noble to keep the animals to sacrifice to God, and to capture the Amalekite king as a prisoner of war, but God had instructed through the mouth of His prophet, that none should be spared— not the animals nor the king. Saul's disobedience cost him his destiny as king over Israel.

*And Samuel said, Hath the Lord as great delight in burnt offerings and sacrifices, as in obeying the voice of the Lord? Behold, **to obey is better than sacrifice**, and to hearken than the fat of rams. For rebellion is as the sin of witchcraft, and stubbornness is as iniquity and idolatry. **Because thou***

*hast rejected the word of the Lord, He hath also rejected thee from being king* (1 Samuel 15:22-23, emphasis added).

How many times have we chosen what seemed right and good to us, over what God was asking of us? It is vital that we set good examples for our children. However, if we want them to fulfill their destinies, it is also important that we model that for them by fulfilling ours. My husband and I have raised three children who are now adults. By the grace of God, they have never gone out into the world in rebellion and have never gotten involved with the wrong crowd. They have each served the Lord, have been obedient to Him according to their individual callings, and are working with us in some aspect of the ministry.

## The Balancing Act

In any case, hearing what God is saying and requiring from us doesn't mean that all issues will be settled and all our decisions will be made for us. Once we understand the will of God, then we must seek Him for His perfect way to bring it forth in the midst of our already busy lives. If He is speaking to you to step out into areas of involvement in the church or community, He will also give you wisdom regarding how to make it work with your family commitments. It is not a surprise to God that you have children! He didn't place this calling on your life and then say, "Oops! I forgot you have kids!" God knew your situation when He called you, and He has a plan and plenty of grace to help you walk it out.

Some have considered balancing all these areas of responsibility as an impossible task, or as more trouble than it is worth. They see themselves walking on a tightrope, with family, business, community, ministry, and other responsibilities balanced just so, and if things get out of balance, even slightly, everything will fall apart, plunging them to their doom. It can feel like building a house of cards—one wrong move will cause all to topple down.

I have found myself in situations where I felt that there simply wasn't enough of me to go around. Indeed, the truth is that if I try to do it all and be it all in my own strength, attempting to make everything work according to my plan, I will fail. However, as I draw on the grace of God and depend on His wisdom and strength, He has always been faithful to show me His divine way that is a blessing to all.

One day, when on vacation with my family, I learned an important lesson about balance. We were snow skiing (which I do rather poorly but have fun trying), when I began to see how this balancing act worked. I noticed that to successfully and safely navigate the mountain, you must maintain a balance between the two skis. I quickly learned that this does not mean keeping equal pressure on both skis at the same time, which results in heading straight down the mountain at breakneck speed, usually ending in a messy crash! The proper and ultimately safer way to ski is to flow back and forth between the skis, alternating the pressure, controlling the speed. When more pressure is applied to the right ski, it doesn't mean that you kick the other one off (though unfortunately, I have inadvertently tried that). I found that I may be putting pressure on that right ski now, but around the next turn, all my pressure would change to the left ski. Back and forth, ebb and flow, give and take until I was safely down the mountain.

So it is in balancing the responsibilities of a woman's busy life. Just because the family is requiring a great deal of time and attention doesn't mean that you kick the "ski" of ministry or business off. Around the next turn, it will be appropriate for you to give time and attention to those areas of involvement and yet keep just enough pressure on the "ski" of family to keep it running in line and available for the next turn.

It is challenging. It would not be truthful to say otherwise. But for those who desire to be all they can be while also being godly examples of fulfilling destiny, the joy and sense of contentment

that comes through that fulfillment far outweighs the discomfort of the challenge.

## Maintaining Proper Perspective

In the midst of the balancing game, it is often easy to lose perspective and begin to feel you are failing at everything and succeeding at nothing. I want to give you some keys for effectively walking in balance.

1.  *Make obedience to God your number-one priority.* If you can do this, God will give you strategies to work through the daily grind. Just remember, there are seasons in God. One season might be very demanding with family needs while the next season might have you reaching out to others. Remember, back and forth, ebb and flow, give and take, from season to season of success.

2.  *Have faith in the God in you.* It is important to take some time to nurture your personal relationship with God. This will keep you positive and focused on all you need to do. Faith keeps you free from fear and doubt and full of Holy Ghost optimism. If you can't find a prayer closet, you may want to do what I did. I had a prayer tub. Each day I took a few moments for a quick bubble bath and time of prayer. I did this at nap time, or after the kids went to bed, or when my husband could watch them for a few minutes. It was my time with the Lord, and I'm convinced it kept me sane during those busy years.

3.  *Lose the superwoman complex.* Superwoman feels she has to be perfect in all she does. She has to be available to everyone who may need her, 24 hours a day, 7 days a week. She thinks that a good mother needs to be with her children 24/7; she thinks a good wife has to be available to her husband 24/7; and she has to be there for other people in need 24/7 (an especially dangerous trap

if you are pastoring a church). This produces loads of
false responsibility and will wear you out!

As a pastor of a local church, I used to tell people they
could call me anytime they needed me, regardless of the
time, day or night. Then one week, they all did! I was
constantly receiving phone calls through the night for
counseling and prayer. Once when the phone rang, I
asked my husband if he would answer it because I was so
tired from other phone calls, and he informed me, "No.
I didn't tell them they could call." I realized that I had set
myself up for such a predicament through my own sense
of false responsibility. False responsibility opens the door
to feelings of guilt and failure that lead to depression and
exhaustion. We must remember that the Lord promised
He would not give us more than we can handle.
Likewise, we must be careful not to carry burdens of our
own making. His yoke is easy and His burden is light!
The joy of the Lord can always be our strength when we
put things in right perspective (see Mt. 11:30; Neh.
8:10).

## Dealing With Guilt

In an effort to balance their lives, many women whom I
speak with share that they have a particular problem dealing with
the bondage of guilt and condemnation. In our efforts to try to
be good at everything, it can feel like we are succeeding at nothing. If the job or the ministry is thriving, it feels like the family is
suffering. Conversely, if our time has been spent ministering to
the needs of the family, it seems job and ministry lack or are neglected. How can we do it all and be it all?

One of my favorite Scriptures is Second Corinthians 12:9
which says, *"And He said unto me, **My grace is sufficient for thee:
for My strength is made perfect in weakness....**"*

When we feel weak or incapable, God's grace is a tangible force that makes up the difference if we choose to draw on it. When pressures come, we can take time to reevaluate our priority system for that time. If we feel that all is in order, then it's time to draw on the grace of God. By His grace, He takes things that are natural and makes them supernatural! He gives strength for the task at hand, and can remove time-consuming obstacles as we look to Him as our source.

# CHAPTER THIRTEEN

## Husband and Wife Team Ministry

From the beginning, God created man and woman and set them in the beauty of the garden to start fulfilling His plan for the earth. God instructed them to be fruitful and multiply, to replenish the earth and subdue it, and have dominion over it (see Gen. 1:28). This instruction was not just given to Adam, but to both Adam and Eve. God intended for them to work together as a team, each with his and her unique giftings and abilities to accomplish His purposes.

Eve's name means "life giver" or "mother of all living".[1] She was God's original picture of what a woman should be. Women should be life-givers in all they do. They should bring the life of God into their homes, release that life to their children, and minister the life of God to their husbands. Women have the power to release this life even in the world system, which is so full of death and darkness. Women should be life-givers in our schools, in our communities, and in the marketplace. We were created to give not just natural life, but spiritual life as well.

Man and woman were commissioned to work together to accomplish God's apostolic mandate in the earth. However, sin came with its resulting curse, which disrupted God's original intention of co-laborship between man and woman. Consequently, Adam and Eve were driven from the garden and lost certain privileges of ultimate dominion, which were forfeited because of sin. Also lost was the intimacy of fellowship and communication between mankind and his Creator.

Jesus then gave His life and redeemed mankind from the curse. He also restored free access to the throne of God, providing us with an open channel of communication to receive divine revelation. God is still speaking today, be it through His Word, through a still small voice in prayer, through His prophets, or through His gifts flowing through His prophetic people.

Through Jesus' redemption from the curse, He has also prepared the way for women to be restored to their place of co-laborship and Body of Christ membership ministry. This in no way negates the principles of divine order in regards to the husband with his wife in the home. Neither, however, does a woman's heart of submission towards her husband negate the gifts of the Spirit or the specific calling or destiny of God in her life.

I have personally been blessed to serve the Lord in co-laboring with my husband, Tom, in ministry for over 25 years. We function as co-pastors in our church. At the same time, I joyfully receive from my husband's place of authority as my husband and ministry covering. We have raised three wonderful children, all who love and serve the Lord. We both travel in ministry, often separately and sometimes together, fulfilling God's plan for us as a team, as well as God's personal commission individually.

I am so blessed to be married to a man who not only has a divine revelation about women in ministry, but who also feels that part of his call as a husband is to make sure I am fulfilling God's call on my life. He has often spoken to men and encouraged them that their place as head in the home carries with it a divine responsibility to not only fulfill God's call personally, but also to provide a place for their wives and children to step into their God-ordained destinies and purposes. He believes that he will stand before God and give an answer as to what he did with my destiny and the destiny of our children. Did he help us or hinder us? He will have to give an account.

As Tom and I have grown and developed as a team, it has become clear that being a part of a team does not mean that we

do everything the same, or even at the same time or same place. We are able to be a team, not because we have the same gifts, talents, and abilities, but because we share a common goal and vision, and a common sense of purpose. With any good team, each team member contributes his or her part according to the abilities he or she has developed. And as each member of the team completes his or her part, the goal and vision is accomplished...*and it's fun too*!

## A Team Requires Diversity

Think of any sports team and notice that each position on that team has specific functions to perform and special training needed to fulfill the requirements of that position. If you have a football team full of quarterbacks, it will not matter how great or talented those quarterbacks are; the team will not be successful.

A team requires diversity to be winners. Out of the differences among team members comes a well-rounded unit that can face any obstacle and overcome any opponent.

It's the same with husband and wife team ministry. You each may have different divine giftings or spiritual abilities, but if you can join your lives together towards specific goals and purposes, you can function as a team. The beauty of a team is that where one member is weak, the other is strong.

## The "Help Meet" Ministry

We have been made to be a compliment to one another. When God formed Eve from Adam's side, she was called his "help meet."

> *And the Lord God said, It is not good that the man should be alone; I will make him an **help meet for him*** (Genesis 2:18, emphasis added).

The term "help meet," when translated from the Hebrew word, is defined as one who is a helper, who is an opposite, a

counterpart, mate, or one that completes the other. The Hebrew word, *neged*, actually comes from a root word which means "to stand boldly out opposite."[2] In this definition, we can see the beauty of what God had in mind regarding how a husband and wife were created and formed to work together. We are to complete one another. Where one is weak, the other is strong.

The interesting and challenging part comes in the other part of the definition that indicates that we are opposites. The old saying "opposites attract" is true to some degree with every marriage.

Often during courtship, couples marvel at all the areas they have in common and enjoy discovering the ways in which they are alike. But as time goes on, it becomes clearer how different they are. Communication styles, values, interests, approach to child rearing, spiritual gifts, abilities, hobbies, and a general approach to life and love will often be areas where differences will be revealed. While each partner fell in love with the other person's unique qualities, now tensions begin to build as you spend all your efforts trying to make the other person just like you. But rather than being irritated by differences, you should be celebrating diversities. Differences don't have to be a negative factor in a relationship, but can be the spice that adds a unique flavor to the team God is building.

Some may have heard teachings that Eve was inferior to Adam because of "creative order." In other words, because Adam was created first, he was superior to Eve, who was created second. However, if this philosophy is ascribed to, then one must also consider the fact that animals and dirt were created before Adam. According to this philosophy of creative order, Adam would then be inferior to animals and dirt!

God made Eve as a help meet. This term is not defined as an assistant or a server, but with the connotation of being an associate or a coworker.

## Opposites Attract

When my father-in-law, Dr. Bill Hamon of Christian International Ministries, preaches about husbands and wives working together, he talks about how God loves to take opposites and put them together for His purposes. He says that in every marriage God takes a Clydesdale horse (a huge horse that is slow and steady, yet very strong) and teams it up with a racehorse. He yokes them together and says, "Pull in unity!"

When this happens, the Clydesdale must speed up, and the race horse has to slow down in order to accomplish the goal. And this is the challenge! The Clydesdale doesn't want to be pushed and will get frustrated with the racehorse, believing that he or she is nothing but impetuous and impulsive, leaping before he or she thinks, always pushing and pressing harder than necessary. The racehorse becomes irritated with the Clydesdale, assuming that he or she is passive, unimaginative, unenthusiastic, without vision, always resisting change or moving forward into new things. But the truth of the matter is that each one has something valuable to contribute to the relationship that is actually vital to accomplishing the goal in the most productive manner.

God delights in joining men and women together who have individualized strengths so that the whole unit of the marriage is enhanced. Ephesians 1:17 speaks of God giving both the spirit of *wisdom and revelation.* God will generally place one partner in the marriage who is stronger in revelation, vision, prophetic insight, and discernment, while the other partner has a stronger gifting of wisdom, practicality, reason, and prudence. Sometimes, because of these two different areas of strength, partners will have contrasting approaches to a situation. This does not always mean that one partner is right and the other wrong, but that God may intend to use the two different perspectives to bring the greatest benefit of resolve.

In the same manner, Scripture tells us that God has seemingly contrasting attributes to His nature and character. He is

both a God of goodness and a God of severity. He is a God of judgment and a God of mercy.

> *Behold therefore the **goodness and severity** of God* (Romans 11:22, emphasis added).

> *But after thy hardness and impenitent heart treasurest up unto yourself wrath against the day of wrath and revelation of **the righteous judgment of God**; who will render to every man according to his deeds* (Romans 2:5-6, emphasis added).

> *So then it is not of him that willeth, nor of him that runneth, but of **God that showeth mercy*** (Romans 9:16, emphasis added).

> *God is rich in mercy* (Ephesians 2:6).

God will often take these aspects of the strengths of His character and nature, and place them in individual partners of a marriage to create a balance between them. One partner may approach situations with the aspect of the character of God that may seem more goodness or mercy oriented, while the other partner may deal with matters from more of a righteous judgment and severity approach. One may see things more black and white, while the other may see things more grey. Both are qualities of God's nature, and when deposited within two people in a marriage, a completed view of a situation may result, balancing judgment and mercy, goodness and severity, revelation and wisdom. Again, the challenge comes when partners feel that their perspective and approach is the only right one, and they cannot value the input or approach of the other.

In my marriage, I tend to be more the one who approaches things from the "righteous judgment" aspect. I tend to see things more black and white, than grey. My husband, Tom, will see things more from a mercy motivated perspective. I tend to draw on discernment and revelation, and he is more apt to draw on

wisdom and principle. While I can operate and deal with situations with wisdom, and he can certainly draw on the gifts of revelation, the other areas are our individual strengths that we flow in most comfortably and naturally.

Over the years, I have learned to appreciate his heart of mercy and his ability to see things from all angles. He has demonstrated wisdom and principle in his approach toward difficult situations. Likewise, he has learned to trust my gift of discernment and the revelation that I receive. He has also been able to see value in my more direct way of approaching things with more of a black-and-white viewpoint.

As we have worked together in ministry and family, we have been able to support one another with our strengths while learning from one another and developing the other qualities that we may personally lack, but that our partner possesses. I have learned the redemptive value of applying mercy, and have submitted myself to the process of developing wisdom, and he has pressed in to greater areas of revelation and discernment.

## Heirs Together of the Grace of Life

> *For this is the way the holy women of the past who put their hope in God used to make themselves beautiful. They were **submissive to their own husbands**, like Sarah, who obeyed Abraham and called him her master. You are her daughters if you do what is right and do not give way to fear. **Husbands**, in the same way be considerate as you live with your wives, and **treat them with respect** as the weaker partner and as **heirs with you of the gracious gift of life**, so that **nothing will hinder your prayers*** (1 Peter 3:5-7 NIV, emphasis added).

Scripturally, women are to submit to their husbands and respect them. In like manner, husbands are to love their wives, and dwell in knowledge with them. As we work together in

agreement and as a team, we will inherit the wonderful, gracious gift of life; in addition, our prayers won't be hindered. As we seek to understand and value the individual gifts within our mate, our life and love will only be enhanced.

> *Submitting yourselves one to another in the fear of God.* **Wives, submit yourselves unto your own husbands,** *as unto the Lord. For the husband is the head of the wife, even as Christ is the head of the Church: and He is the savior of the body. Therefore as the Church is subject unto Christ, so let the wives be to their own husbands in every thing.* **Husbands, love your wives,** *even as Christ also loved the Church, and gave Himself for it…. So ought men to love their wives as their own bodies. He that loveth his wife loveth himself* (Ephesians 5:21-25,28, emphasis added).

Some have heard teaching that describes "submission" as an oppressive system geared to keep women "in their place." This is not God's concept at all! Husbands are to love and support their wives. They are to love them as Christ loved His Bride, the Church.

In like manner, women are to submit to their own husbands, just as the Bride/Church is to submit to its Head, the Lord Jesus Christ. He is there to protect us, to guide us, and to direct us, just as husbands are to provide the same for their wives.

A prominent Bible commentator, Matthew Henry, has this to say in regards to the husband/wife relationship:

> If man is the head, woman is the crown, a crown to her husband, the crown of the visible creation. The woman was made of a rib out of the side of Adam, not made out of his head to rule over him, nor out of his feet to be trampled upon by him, but out of his side to be equal with him, under his arm to be protected, and near his heart to be beloved.[3]

Scripture does not state, "Wives submit to your husbands only if they are men of God and always do everything right." Your husband, of course, is not perfect, but if you use his imperfections as an excuse to become stubborn and self-willed, you may find yourself outside of God's planned provision for your security and destiny.

## Domestic Abuse

Friar Cherubino in his book, *Rules of Marriage*, instructs men in their treatment of their wives. He says, "Take up a stick and beat her, not in rage, but out of charity and concern for her soul, so that the beating will rebound to your merit and her good."[4] An English ordinance instructed men that they could beat their wives, but only with something no wider than their thumb; hence, our term "rule of thumb."[5]

Unfortunately, many cultures continue to perpetuate crimes against women, merely because there are no laws against domestic violence. Sadly, the church has also failed to take a stand on the issue. In a survey completed in the 1980s by Jim M. Alsderf, a graduate of Fuller Theological Seminary, 5700 Protestant ministers were asked what they told women who were victims of domestic violence. Following are the results: Twenty-six percent told abused women to continue to submit to their husband; pray and trust God that it will stop or that He'll give the strength to endure it. Twenty-five percent told the wives that the husbands' violent actions were caused by her rebellious actions; in other words, it was her fault! Seventy-one percent said they would never advise a battered wife to leave her husband or separate because of abuse, claiming it is better for the woman to tolerate some level of violence in the home rather than to separate or divorce. Ninety-two percent said they would never counsel her to seek a divorce.[6]

God opposes violence, especially in a marriage relationship. Malachi 2:13-16 says:

*And this is another thing you do: you cover the altar of the Lord with tears, with weeping and with groaning, because He no longer regards the offering or accepts it with favor from your hand. Yet you say, "For what reason?" Because the Lord has been a witness between you and the wife of your youth, against whom you have dealt treacherously, though she is your companion (partner, associate) and your wife by covenant. But not one has done so who has a remnant of the Spirit. And what did that one do while he was a godly off-spring? Take heed then, to your spirit, and let no one deal treacherously against the wife of your youth. "For I hate divorce," says the Lord, the God of Israel, "**and him who covers his garment with wrong,**" says the Lord of hosts. So take heed to your spirit, that you do not deal treacherously* (NAS, emphasis added).*

God bears witness against the man who is violent and treacherous with his wife. This phrase "*and him who covers his garment with wrong*" is very interesting when studied in the original language. According to translators, there are two meanings to this phrase. The Revised Standard Version speaks of "*covering one's garment with violence.*" God says he hates it. What does this mean? Interestingly, the word that is translated "garment" is the Hebrew word *lebush,* which literally means "garment," but is also a term that by implication means "wife."[7] So, it could read, "*I hate divorce and him who covers his wife with violence.*" Secondly, the King James Version translates this portion of the verse as "for one covereth violence with his garment." The word "covereth" means to conceal or cover up. God chastises a man according to how he treats his wife, and also says He hates it when men conceal violence with their garments[8]—when they cover it up. Either way, suffice it to say that no godly man should even begin to think that hitting or physically abusing his wife is acceptable in

the eyes of God. God hates divorce, but He also hates domestic violence.

## Esther's Favor

So how does one handle a situation where you long to work together as a team with your husband, but he is not interested in following the plan of God? The answer is…very carefully! I don't mean to sound simple, but as you carefully seek God and His wisdom, He can and will give you keys that can open your husband's heart. It will never work to force the issue, make demands, or issue ultimatums.

If you find yourself in such a situation, it is important to remember to trust God and believe for His timing and His way to be brought forth. In the meantime, allow God to do His work in you. God has given women the strength and the ability to pursue their destinies as individuals. It is important that whatever your marital circumstance is, you as an individual can press in to God's purposes through prayer and relationship with Him, and your gift will make room for you. Our destinies are in the hand of God, and as we diligently seek Him, He will watch over His Word to perform it (see Rom. 4:21).

Remember Esther, who was a Jewish maiden married to a powerful, heathen king. When the king irrevocably signed a decree to put all Jews to death (not realizing his new bride was Jewish), Esther had to seek a plan to reach his heart. She didn't march in and demand her rights as queen. This would have meant certain death! Rather, she honored the king with a feast and softened his heart.

God designed most women with a strong need for security and love and most men with a strong need to feel respected and honored. When a woman honors, respects, and affirms her husband's leadership, she will reap his heart of love. Conversely, when a man really loves his wife and serves her the way Christ served His Church, he can't help but reap honor and respect.

When a woman gives her husband his rightful place as head of the home, rather than him have to take it, blessings will flow in the house.

I have seen women put their husbands down and criticize them because they perceive themselves to be more spiritually mature than the men. However, women can be strong individuals without usurping the husband's role. You do this by refraining from threatening the husband's place and by giving him honor and respect. Esther gave her husband, the king, honor and respect, and he in turn gave her favor—whatever her heart desired for her people!

When trials or disagreements come, first ask God what He is requiring of you, then sincerely listen to your mate's perspective. Remember, God's purpose for creating Eve was to be a completer of Adam. Just as Adam and Eve completed one another according to God's plan, so husbands and wives are completers to one another, also according to God's plan. That means we are not sufficient within ourselves, when we are joined in marriage. Each partner has something valuable and life-giving to bring to each discussion and situation. We must learn how to bring out the best in one another so that we can flow together as *heirs of God's gift of life*.

## Smith and Polly Wigglesworth—A Dynamic Team Ministry

Most people have heard of the powerful ministry of Smith Wigglesworth and the stories of signs, wonders, and miracles that surrounded his life. What some may not realize is that his wife, Polly, was instrumental in challenging him to break out of passivity and complacency and to arise in faith to the call of God upon his life.

Mary Jane Fetherstone, otherwise known as Polly, and Smith Wigglesworth married in 1882 in Bradford, England, after meeting each other during Salvation Army services. Both Smith and

Polly felt the call of God upon their lives; however, in the early years of their marriage, Smith was sidetracked from his call, working long hours to develop his plumbing business in order to make money. Eventually, his passion for the Lord began to wane and his heart for ministry grew cold.

In the meantime, Polly's passion for the Lord grew and her ministry as an evangelist began to expand. She became a woman of great faith and would preach fiery salvation messages that caused many to run to the altar to give their hearts to Jesus. Her love for God and her compelling vision for what God had called her and her husband to do, caused her to lovingly draw Smith back to his relationship with the Lord and to re-embrace his call to ministry.[9]

Though Smith was mightily used of the Lord to release dynamic miracles of healing, he was plagued by personal insecurity and feelings of inadequacy. Often, when he would preach, he would speak for two or three minutes before breaking down in tears and begging someone else to finish for him. Polly would often get up and preach the message for him, and then Smith would give the altar call with miraculous results.

Polly helped her husband by teaching him to read and write, and encouraging his faith to higher levels. During one season in which there were many healings and miracles in their meetings, Smith was personally challenged with hemorrhoids and took medicine every day to help him deal with them. Polly stirred his faith in this area, suggesting that he rise up and believe for healing for himself. He anointed himself with oil and was instantly healed.

In the early 1900s, Smith was baptized with the Holy Spirit and began to preach with new zeal and fire. Polly soon received the Holy Spirit as well. Subsequently, their ministry at Bowland Street Mission dramatically changed, and they became pioneers in the Pentecostal Movement. Polly died in 1913, and Smith went on to become known as the "Apostle of Faith." He wrote

volumes of material, sermons, and books, and recorded the testimonies of many miracles. It is documented that he raised 14 people from the dead during his ministry. He became a legendary figure in church history demonstrating the reality of the power of God.[10] It has been said that behind every great man is a great woman. Polly was that great woman in Smith's life and had a passion not only to fulfill her own destiny, but also to see her husband become everything God had called him to be. Polly was a woman who made a difference!

## Endnotes

1. Strong's Concordance, 2331.

2. Strong's Concordance, 5048.

3. *Matthew Henry's Commentary on the Whole Bible in One Volume*, 1960. by Marshall, Morgan and Scott, Ltd. and 1961 by Zondervan Publishing House, Grand Rapids, MI.

4. Angela Brown, *When Battered Women Kill* (New York, NY: The Free Press, 1987), 240.

5. Survivors Against Domestic Abuse, "History of Battered Women's Movement," Lady Madona Graphix.

6. "Marriage Help: Women and Submission, Finding Middle                                    Ground," http://www.mywebpages.comcast.net/wolfpackron/womensub.html.

7. Barnes' Notes, Electronic Database. Copyright (c) 1997 by Biblesoft.

8. Barnes' Notes, Electronic Database. Copyright (c) 1997 by Biblesoft.

9. Gary B. McGee, Enrichment Journal: A Journal for Pentecostal Ministry, "The Revival Legacy of Smith Wigglesworth."

10. Smith Wigglesworth, *Ever Increasing Faith* (Springfield, MO: Gospel Publishing House, 1971).

# Women Who Make a Difference Through Balance
## QUIN SHERRER

*I started my Christian walk as a shy young mother, hungry
for God, especially after I received the baptism of the Holy Spirit. My
friend Lib and I began praying on the phone for five minutes every
morning right after our seven children left for school. We did this
for 17 faithful years.*

*From that came my first book, **How to Pray For Your Children**,
which sold over 155,000 copies. While learning to pray in the trenches
raising children, I never once dreamed I'd someday be in "ministry."
To date I've written or co-authored 26 books and have appeared on
more than 300 radio or television stations. Each time I travel to speak
I am in awe that God can use me to reach other women for Him.
Along my journey, I have learned that God wants to use us in some
simple basic ways—often right where He plants us. We may not
gain a big-name ministry, like Deborah, but we can have a Jael
ministry of spiritual warfare in our own tent. If I could offer you
some advice today, it would be these practical keys:*

*1. **Be baptized in the Holy Spirit**. Just before Jesus ascended
to Heaven, He promised His followers that His Father would send
them the Holy Spirit and they would be "clothed with power." The
Holy Spirit would empower and equip them to fulfill their assign-
ment to carry the Gospel message to the ends of the earth (see Matt.
27:19-20; Acts 1:8). They were equipped with this "dunamis" power
on the Day of Pentecost. We all need this empowering! (See my book,
**The Beginner's Guide to Receiving the Holy Spirit**.)*

*2. **Provide a safe haven of hospitality**. Make your home a
sanctuary for the family God has given you and all others He sends
your way. Since biblical days, the home has always been a woman's*

greatest sphere of influence. Be hospitable. A good deal of Jesus' ministry was home-centered. Over 20 times the Bible records that He was either eating or telling a story that took place around a meal. Much of our ministry should be to our family and to those whom we invite home. I write from experience because for years we had 12 at our Sunday dinner table—many times they were strangers we brought home from church.

3. **Stay humble.** Jesus, knowing who He was, where He had come from, and where He was going, took a towel and washed the disciples' feet. If I have learned anything in years of ministry, it is this: Stay humble. I read of an evangelist who experienced times of blessing in his ministry. Whenever he got home from a service, he knelt down and symbolically placed the crown of success on the brow of the Lord, to whom he knew it rightfully belonged. It saved him from the peril of keeping for himself any glory that belonged to God.

4. **Guard your time.** Make the most of your time (see Eph. 5:16). Concentrate on the things of paramount importance. Jesus fulfilled the work committed to Him within the allotted hours. He did not appear in a hurry as He moved through life, though crowds demanded His attention. Learn to be a good steward of your time, talent, and money. In putting priorities on my time, I've carefully considered God's agenda for me, and I have learned to say "no" to all the invitations that I don't think fit that call. I want most of all to finish the race God has for me, knowing I was faithful in His assignment. I learned the hard way that I need to please God, not people.

5. **Train, teach, mentor.** Always be investing in someone else, teaching her your talent or skill. Mentoring means "passing down knowledge and training from one who is more experienced to one less experienced." Help someone else reach her God-given potential.

*Peter wrote: "God has given each of you some special abilities; be sure to use them to help each other, passing on to others God's many kinds of blessings" (1 Pet. 4:10 TLB). In every place I've lived, I've taught women on two subjects that are dear to my heart: how to write for the Lord, and how to pray more effectively. Some of my students have outdistanced me, for which I thank God.*

*6. **Make and keep friends.** Make several close "keeper friends" who will see you through the hard times and the good—ones whom you can call anytime to pray and counsel you. Because we often become like those we are around, carefully choose your friends. Collect them like pearls. I stay in close contact with my out-of-town keeper friends via e-mail or phone. Those of us who live near each other get together on a regular basis for food, fun, fellowship, and prayer. We call ourselves the "Keeper Club." Remember that while Jesus invested His ministry time with 12 men, three were especially close to Him.*

*7. **Get a prayer partner.** Find prayer partners and make a commitment to pray for each other on a regular basis. Pray about shared concerns, similar goals, and focus. Your spiritual battle will seem less daunting when you have a prayer team to strengthen you and spur you on to victory. I've had prayer partners who have prayed with me over several decades, and I don't think I would have made it without their prayers, encouragement and support.*

*8. **Choose a secret place.** Spend quality time each day with the Lord. It goes without saying that you must have a personal relationship with Jesus and a daily time to talk with Him. Never neglect that intimate time to get refreshed and refired! Ask Him daily, "What do You want me to do for You today?" Learn to discern His voice!*

*While there is no formula for prayer, I use a pattern of sorts. I start my prayer time with three W's:* **Worship** *the Lord; then I wait, silently asking Him to give me His* **word** *to pray for a current situation. Sometimes I add* **warfare** *—to stand against the enemy's tactics by quoting Scripture and making declarations. Keeping several translations of the Bible nearby when I pray helps me when I am in my waiting mode. You will find the right time and place to diligently seek Him.*

*My last advice comes with this Scripture: "Put on a heart of compassion, kindness, humility, gentleness, patience, bearing with one another, forgiving one another, just as the Lord has forgiven you. Put on love which is the perfect bond of unity" (Col. 3:12). May God give you His unique plan for your life and ministry.*

**Quin Sherrer** has written or coauthored 26 books, many of which have become national best-sellers. She and her husband, LeRoy, have six grandchildren, and make their home in Florida.

## A Charge to Women of Balance

Women coming to their place of co-laborship or team ministry alongside their husbands in the church today, is a sign of the corporate Church, the Body and Bride of Christ, arising to her rightful prepared place of co-laborship with her Husband and Head, the Lord Jesus Christ. As women are recognizing the divine abilities that have been deposited in us, and the significance of our purpose and destiny in Christ, so the entire Church is embracing the same principles of purpose and destiny. If we desire to be a Church of power and dominion, it is vital that all members of the Body are thriving, connected to one another and ultimately to our Head, Jesus Christ.

Let our hearts be fully committed to the families God has given to us, and yet embrace the fullness of the calling of God. Let us endeavor to walk in obedience, drawing on His grace. Let us be disciplined with our time and invite the wisdom of God to release our focus of priorities. Let us open our hearts to our husbands in a new way, to be joined together to flow as one in all that God has called us to. And as we minister and function, let us allow God's strength to be made perfect in our weaknesses that we might rise up as the mighty company of women God is calling forth, and be all that we can be in Him!

## SECTION THREE

# *Questions for Consideration*

1. After reading Proverbs 31, list three valiant attributes that you feel are your strengths.

2. List three areas that you feel are areas of weakness.

3. List two areas of your life that you need to balance. Describe your plan for achieving balance in these areas.

4. Are you a Clydesdale or a racehorse? What areas of your life do you need to slow down or speed up to be more effective?

5. Are you bearing a yoke of guilt or condemnation in any area of your life? How you can become free?

## SECTION FOUR

# Deborah the Warrior: Woman of Courage

*A woman is like a tea bag. She only knows her strength when put in hot water.*

Nancy Reagan
First Lady of the United States

*You gain strength, courage, and confidence by every experience in which you really stop to look fear in the face.*

Eleanor Roosevelt
First Lady of the United States

CHAPTER FOURTEEN

# Deborah the Warrior

When Deborah came into her ministry, the land of Israel was in great turmoil. The streets were not safe, there was war in the gates, and they were suffering under oppression, bondage, and fear of the wicked Canaanite king. Indeed, the men of Israel had lost their will to fight, so much so that you couldn't find even one sword or a spear among forty thousand.

> *In the days of Shamgar son of Anath, in the days of Jael, the* **roads were abandoned; travelers took to winding paths.** *Village life in Israel* **ceased,** *ceased* **until I, Deborah, arose,** *arose* **a mother in Israel.** *When they chose new gods,* **war came to the city gates,** *and not a shield or spear was seen among forty thousand in Israel. My heart is with Israel's princes [governors], with the willing volunteers among the people. Praise the Lord!* (Judges 5:6-9 NIV, emphasis added).

Because Israel had been held in bondage for half a generation, Deborah knew that she could potentially face much resistance in rising up to confront their oppressor, for people were truly afraid and convinced that they could not stand up to their foe. Yet they cried to the Lord, and He answered them through the authority that He had delegated in the land during that day.

Deborah had received a plan from the Lord to bring Israel out of captivity and into God's promised freedom. She also had the faith and courage to boldly confront the fears of the people, and even the other leaders, to see the plan come to pass.

In the natural, Israel was severely outnumbered; in fact the odds of them succeeding in any kind of revolt against their enemy were totally ridiculous! Jabin, the cruel Canaanite king, was very smart. As previously stated, his name means "intelligent."[1] The land Canaan means "to humiliate, vanquish, bring into subjection, subdue."[2] And this is just what he did to Israel. He robbed them of their strength, courage, and dignity, which is exactly what the devil still tries to do today. He attacks our minds and our intellect, and develops a stronghold in our belief systems. From this stronghold, he subdues our faith in God, robbing us of our courage and shaming us into passivity with no will to fight.

Jabin's power was the result of his military strength. He had nine hundred chariots of iron, which in those days were mighty war machines intimidating any foe. These chariots generally were made with spikes on their wheels that would slash and destroy the ground troops of the opposition. Judges 4:3 (KJV) says that he *"mightily oppressed Israel."* The word "oppressed" comes from a root word meaning, "to use force to crush, to afflict, to distress, to hold fast, to oppress."[3] This describes the condition of the people of Israel when Deborah commanded the general, Barak, to call the men to war.

> *And she sent and called Barak the son of Abinoam out of Kedesh-naphtali, and said unto him, Hath not the Lord God of Israel commanded, saying, Go and draw toward mount Tabor, and take with thee ten thousand men of the children of Naphtali and of the children of Zebulun? And I will draw unto thee to the river Kishon Sisera, the captain of Jabin's army, with his chariots and his multitude; and I will deliver him into thine hand. And Barak said unto her, If thou wilt go with me, then I will go: but if thou wilt not go with me, then I will not go. And she said, **I will surely go with thee**: notwithstanding the journey that thou takest shall not be for thine honor; for the Lord shall sell Sisera into*

*the hand of a woman. **And Deborah arose**, and went with Barak to Kedesh* (Judges 4:6-9, emphasis added).

Deborah was a woman of courage who fulfilled her calling and destiny in God. She had to have courage in order to answer the call of God, and to obey His plan regardless of what the circumstance looked like in the natural realm; she had to face not only her own fears, but also the fears of her leaders and the people; and she had to have the boldness and courage of a warrior to lead her troops into victory.

Even General Barak would not go into the battle without Deborah by his side. He was not only drawing on her prophetic insight and revelation, but upon her courage, which she readily received from the Lord. He had faith in the prophetic word and is even listed as one of the heroes of the faith in Hebrews 11:32. But beyond his faith, he needed the courage to come into agreement with the prophetic word and walk it out in obedience.

The relationship between Deborah and Barak is another example of men and women co-laboring to accomplish God's purposes. It is also a picture of the apostolic and prophetic anointing flowing together to win victories for the Kingdom of God.

Deborah was willing to do whatever was required to position Israel for victory, even if it meant going into battle. Sometimes, God may call you to be just a messenger of His Word to someone, but at other times you will have to be willing to join the battle and fight in order to bring His will to pass. God may not require you to only bring a message, but to also help bring about its fulfillment. Having vision is not always enough. We must be courageous and sensitive to God's Spirit to press the battle to the fullest!!

## Joan of Arc—A Warrior With a Cause

In 1425, France was embroiled in the midst of the one hundred-year war with England. It was during this time of political

unrest that a young French girl first heard the voice of God. Joan, or as she was often called in her village of Domremy, Jeanne, was 13 years old when she heard God's voice challenging her to pray, be a good girl, and obey her parents. In the next three years, she experienced many visitations, which led her to believe that God was calling her as a revolutionary to bring governmental change in the land and to install Charles VII as the rightful king over France.[4]

Though she was only 16 years of age when she first set out to pursue the call of God on her life, she was blessed with a determination, confidence, and courage that was contagious. Indeed, she convinced the then future king to give her an army to help break the siege of Orleans. As a woman full of vision from the Lord she told him, "I am God's messenger sent to tell you that you are the true heir to France. And France is to be a Holy Kingdom."[5]

Upon Joan's arrival at the troops' camps, she found them beaten down and discouraged. She then began to prophetically challenge them saying, "I have a vision from God. He has called me to raise an army for our nation and for Him."[6] Though she was unconventional in her approach, wearing men's clothing into battle, the soldiers were inspired by her valour and moral fortitude, and they began to hasten to her command. Before taking them into battle in Orleans, she had persuaded all the soldiers to go to confession and attend mass daily. (Remember, the Catholic Church was the only expression of Christianity in Europe in that time.) She also chased away the prostitutes who were following the army. She knew righteousness was her most effective shield. When asked if she was afraid before going into battle, she replied, "I fear nothing for God is with me."[7] As a result, the siege of Orleans was broken, paving the way to victory in four more battles and on to Reims where Charles VII was coronated.

Unfortunately for Joan, for some unknown reason, the new king withdrew his support of Joan after his coronation. She was

later captured in battle and sold as a prisoner to the English whom she had conquered in battle numerous times. Subsequently, they tried her as a witch, claiming the voices she heard was the voice of satan, and as a heretic, for dressing in men's clothing. She was questioned repeatedly by theologians, to whom she gave very clear answers and a defense of the call upon her life. However, in the end, she was condemned as a heretic and at the age of 19, burned alive at the stake.

Her executioner was instructed not to show the usual mercy of strangling the prisoner as soon as the flames began to spread; rather, Joan was completely conscious as she faced the blaze. As she died, she asked to have the crucifix set before her eyes and repeatedly spoke the name of Jesus. The bravery she exemplified in her death moved many to tears. It is reported that some were even converted to Christ, and even others claim to have seen the name of Jesus written in the flames and a white dove fly out of the fire. The verdict against her was later reversed by the Church, and Joan was canonized as a "saint" in the Catholic Church to commemorate her life of purity, strength, and tremendous love of God.[8]

From her humble beginnings as an ordinary peasant girl who heard the voice of God, Joan became a great military leader for France who changed the course of history. She was not hindered by her gender or her age, but obeyed the command of God upon her life. Like Deborah, she was moved by the hopelessness and defeated state of her people, and was determined to follow the leading of the Spirit of God to bring change. These women directed generals, inspired armies, and shifted governments according to the will of God. They were both inspired by the prophetic voice of God, who gave them courage to break the entrapment of the enemy and lead people to victory. Joan is recorded hearing God say to her, "'Daughter of God, go on, go on, go on! I will be your help. Go on!' When I hear this voice, I feel such great joy that I wish I could always hear it!"[9]

As modern day Deborahs arise, we must acquire that same ability to hear the voice of God and rise to the challenge to bring change. We must hear that same voice saying, "Daughter of God, go on, go on, go on! I will be your help. Go on!" We must be consumed by our love for God and for obedience to His call. Though we may not be asked to die a martyr's death, we can die daily to the things that would position us outside of His will for our life—self, human agendas and ambitions, insecurity, and fear. Courage is not the absence of fear, but the ability to face fear and overcome it! We must be like Joan, who when asked about the mission God had called her to, responded, "I was born for this!" Deborahs, we were born to make a difference!

## Endnotes

1. Strong's Concordance, 2988.

2. Strong's Concordance, from root words from 3667 and 3665.

3. Strong's Concordance, 3905.

4. Herbert Thurston, "St. Joan of Arc" (The Catholic Encyclopedia, Volume VIII, Online edition, 2003 by K. Knight, www.newadvent.org/cathen/08409c.htm.

5. Virginia Frolick, "The History of Joan of Arc" St. Joan Center Website, www.stjoan-center.com/#bio.

6. Frolick, "The History of Joan of Arc."

7. Frolick, "The History of Joan of Arc."

8. Thurston, "St. Joan of Arc."

9. Frolick, "The History of Joan of Arc."

CHAPTER FIFTEEN

# The Story of Jael, A Woman Who Staked Her Claim

Through her anointing of courage, Deborah became a woman of influence and inspired many others to also take courage. Her courage was contagious and was able to influence the general, Barak, the armies of Israel, and other women as well. Jael was one such woman who rose to Deborah's challenge for change.

Jael was an ordinary housewife. She spent her days washing, cooking, cleaning, and caring for the children. However, things in her community were becoming more and more difficult. The armies of Jabin, the king, were terrorizing the inhabitants of the land, especially the Israelites. Though she was not a Jew but a Kenite, she greatly respected "God's chosen people," as had her ancestor Jethro, who served with the great prophet, Moses. Now, as Jabin tormented Israel, it had become unsafe for her own children to play freely on the hillsides. They had become sullen and depressed. Even her husband, Heber, from the Kenite tribe, had been forced to sign a treaty of allegiance with Jabin so that his family could dwell in peace. Her husband was a good man, but these dealings of compromise had nearly broken his spirit. Day after day, she hoped things would change.

Jael spent her days lost in dreams of her childhood when Ehud had led the armies of Israel to mighty victories. Those were times of great celebration and festivities throughout the whole land. Her mamma and poppa took her often to see her grandparents in

a village close by. There was always plenty of food, and friends always came to visit. Oh, how times had changed. Now, it was too dangerous to visit family in other villages. Even friends who lived just over the hill never stopped by. Food was scarce, and it had become too dangerous for her husband to go out to find more.

There was something stirring among the men of Israel though. While she did not dwell with the tents of Israel, she still heard the rumors. It seemed that the new judge—that woman, Deborah—was calling the men to battle. They said she had a message from God and that He was going to deliver them from Jabin's cruel hand. Jael even heard that Deborah was going to the battlefield with them. A woman on the battlefield? Unheard of! But for some reason, this act seemed to give the men courage, and everyone respected Deborah's ability to hear from God.

As Jael observed the men mobilizing for battle, she thought this was crazy! When Jabin had become king, he had forced all the men of Israel to give up every weapon they owned. There were no swords and no spears to be found in all of Israel. In addition, Sisera, Jabin's general, was a fierce man. No one messed with him. He had chariots and horses and the most modern weapons of the day. When he assembled his armies, it seemed that the number of men was as the sands of the sea. Soldiers lined up as far as the eye could see. Still, the men of Israel seemed anxious to go to war. Their God must have given them a plan for victory!

As the day wore on, Jael waited, listening for news of what was happening. All the troops had gathered at the river Kishon, which was just a short distance from her tent. Then in the middle of the day, there was some kind of commotion as suddenly the sky became black as night. Jael had never seen a storm like this one. It seemed the very heavens had opened over her head. As she took refuge in her tent, she could see that the sky was even blacker still in the direction of Meggido, a branch of the river

Kishon. "Lord, help Your people, the Israelites, to stand against the formidable foe," she prayed.

Little did she know at that time, God was indeed helping the Israelites on that day. The very heavens were fighting for the cause of Israel. God then opened the skies and rain waters poured down on Kishon. The river overflowed its banks, and many of Sisera's soldiers were washed away. The remaining men ran to Meroz, where the very angel of the Lord rose up and fought with the armies of Israel. God would have His victory!

> *O Lord, when You went out from Seir, when You marched from the land of Edom, the earth shook, the heavens poured, the clouds poured down water. The mountains quaked before the Lord, the One of Sinai, before the Lord, the God of Israel.... From the heavens the stars fought, from their courses they fought against Sisera. The river Kishon swept them away, the age-old river, the river Kishon. March on, my soul; be strong! Then thundered the horses' hoofs—galloping, galloping go His mighty steeds. "Curse Meroz," said the angel of the Lord. "Curse its people bitterly, because they did not come to help the Lord, to help the Lord against the mighty"* (Judges 5:4-5,20-23 NIV).

Suddenly, Jael saw men begin to flee from the direction of Kishon. These men were Sisera's soldiers. And look! Right behind them was the army of Israel who had the Canaanites on the run!

## Sisera—Our Spiritual Enemy

Then she saw him—Sisera, "the man of the iron chariots." He was coming right in her direction. What was she to do? Was he going to kill her? Where were Israel's soldiers to help her? Looking around, Jael realized that she was alone. But something needed to be done, and it seemed she was the only one around to do it. Quickly she ran to the door of her tent and called Sisera's name. "Sisera, come. I will hide you in my tent. No man will find you." Sisera accepted her invitation and took refuge in her tent.

This is the part of the story that many do not understand. Was it a good thing for Jael to welcome this man into her tent under the rules of hospitality (there was a peace treaty in place between Jabin and Heber) and then do him harm? How could this be an act of courage rather than an act of treachery? How is it that Deborah declared Jael a heroine, saying, "Blessed is Jael" when she murdered a man whom she had welcomed? We know that God prophesied through Deborah to Barak that the victory from this battle would come through the hands of a woman, so we must know that God had a plan, one that inspired Jael to acts of great bravery at the risk of her own life and one that caused the utter destruction of Israel's enemy.

First, we must recognize that Sisera is a type of demonic spiritual enemy, not an enemy we can fight with flesh and blood. His name means "battle array,"[1] thus we know that he is a symbol of our enemy, the devil who longs to destroy God's people. The Word of God constantly gives us permission to rise up and aggressively attack our spiritual oppressor, the devil. Yet when we deal with actual people, Jesus teaches us to operate under the principle of opposites.

> But I say to you, love your enemies, bless those who curse you, do good to those who hate you, and pray for those who spitefully use you and persecute you (Matthew 5:44 NKJV).

> For we do not wrestle against flesh and blood, but against principalities, against powers, against the rulers of the darkness of this age, against spiritual hosts of wickedness in the heavenly places (Ephesians 6:12 NKJV).

> For the weapons of our warfare are not carnal but mighty in God for pulling down strongholds, casting down arguments and every high thing that exalts itself against the knowledge of God, bringing every thought into captivity to the obedience of Christ, and being ready to punish all disobedience when your obedience is fulfilled (2 Corinthians 10:4-6 NKJV).

Whether Jael realized these spiritual principles or not is doubtful. However, she did have a sense that she had to choose between standing by a peace treaty made with the devil (Jabin and Sisera) and standing in peace with Israel and her God. Likewise, as God is raising up modern Jaels, we must be willing to break our own peace treaty with the devil and fully embrace our covenant with God. Some have backed away from spiritual battle, having negotiated with the enemy saying, "Devil, I'll leave you alone if you leave my family alone"; or "…if you leave my finances alone"; or "…if you leave my marriage alone." The problem is that you can't make a treaty with a liar. The devil will always go back on his promises, and you will end up more enslaved than before.

## Spiritual Keys to Spiritual Warfare

What Jael did from this point in the story on, gives us spiritual keys, revealing how we are to enter in to times of spiritual warfare in order to defeat our demonic enemies.

*1. Jael brought her spiritual warfare under the covering of God.*

As Jael invited Sisera into her tent, she covered him with a rug or a blanket. This signifies covering our enemy with the blood of Jesus and the anointed hand of God. The devil has no covering of his own. Job 26:6 tells us, "*Sheol* [hell] *is naked before Him, and Destruction has no covering*" (NKJV). God stripped the covering off lucifer, the "covering cherub," when He cast him to the earth in judgment (see Ezek. 28:16). Therefore, when we extend our covering—which is the anointing of God, the glory of the Lord, and the blood of Jesus—over our spiritual warfare, it brings the enemy into subjection to that authority. It also causes an uncovering of every work of darkness and every strategy of hell that has been set in motion to cause our demise. We need not fear, for Psalm 91:4 tells us, "*He shall cover you with His feathers, and under His wings you shall take refuge; His truth shall be your shield and buckler*" (NKJV).

It is so important that we conduct spiritual warfare with wisdom. It is not prudent just to run out and throw down the gauntlet to every territorial spirit and take them on. As we submit ourselves to God and bring ourselves under His covering, His authority, and oftentimes the authority of other spiritual leaders, we will find ourselves safe, protected, and victorious.

*2. Jael gave Sisera the "milk of the word" to lend him unconscious.*

Sisera had asked Jael for a drink. But instead of just water, Jael gave him leben, which is an Arabic drink made of soured milk.[2] Its fermentation has an almost intoxicating effect. This milk could be a type of the most basic principles of the Word of God.

> *For though by this time you ought to be teachers, you need someone to teach you again the first principles of the oracles of God; and you have come to need milk and not solid food. For everyone who partakes only of milk is unskilled in the Word of righteousness, for he is a babe. But solid food belongs to those who are of full age, that is, those who by reason of use have their senses exercised to discern both good and evil* (Hebrews 5:12-14 NKJV).

> *... as newborn babes, desire the pure milk of the Word, that you may grow thereby* (1 Peter 2:1-2 NKJV).

In this Scripture, we see that milk is given to those who are babes in Christ. This means that even the youngest Christian can have victory over the devil when given the milk principles of the Word. When the enemy comes against us and we battle him with the Word of God, it has the power to knock him out and put him down for the count. When we speak the Word, pray the Word, and decree the Word, it immobilizes the enemy. It places him at our mercy, rather than us being controlled by him.

The Word of God includes both the written (logos) Word as well as the spoken, inspired (rhema) Word of the Lord. It has the

power to bring breakthrough into every situation. We can declare a Scripture verse to him, or we can quote a prophetic promise given to us. This is just what Jesus did when the devil came to Him at the mount of temptation. Jesus responded to each temptation by saying, "It is written...." The more we hide God's Word in our hearts, the easier it will be to quote His promises the next time the enemy knocks on our door.

*3. Jael staked her claim.*

Once Sisera had fallen asleep, Jael knew what she had to do. If she allowed him to live, he would continue to terrorize the lands of her people and of Israel, and her children would never play in freedom. If she killed him, she could be risking her very life, for King Jabin could retaliate against her in a harsh way. On the other hand, the God of Israel just might bring a complete victory against Jabin, and the entire land could have peace. Then she thought of the judge, Deborah, a woman on the battlefield. If God could help her to do something that bold and brave in order to bring freedom for her nation and for generations, perhaps that same God could give her the courage she would need to finish the task. Jael suddenly felt a surge of confidence that she could make a difference in this battle.

She wondered, *What do I have in my tent to destroy Sisera?* She realized she had no weapon of war, no sword, no spear. But was there something here that could be used to bring victory? Then the idea came to her mind—she could use a hammer and a tent stake. She was accustomed to using these tools; she knew how to pull stakes up when her people moved, and she knew how to wield the hammer and stake to put down roots and stake her claim in a new territory.[3] This time she would be staking a claim of a different nature.

As Sisera slept, Jael went quietly to him, realizing that if he awakened she would be instantly killed. She carefully placed the stake at his temple, raised the hammer in her other hand, and quickly drove the nail home. Sisera died instantly. With that

stake, Jael secured the future of her children; and with that act of bravery, she secured the freedom of a nation. Jael staked her claim for her spiritual inheritance.

## Called to Do Battle!

Though this is a rather gruesome story, we cannot afford to be squeamish little girls. Instead, we must awaken to the warrior's call that is being trumpeted by the Spirit of God. Right in your own backyard, there is a Jabin or a Sisera on the rampage warring for the future and destiny of your children. Whether it is manifesting in a spirit of fear and violence or capturing minds to bring them into submission, make no mistake, we are at war!

In her book, *Women on the Front Lines*, Michal Ann Goll issues a challenge to answer this clarion call to arise and be heroes.

> We live in an age that is sorely lacking in heroes. Think about it. Who can we look at today and regard as a hero? Certainly there are some, but they sure are hard to find! Isaiah the prophet said that when a people comes under judgment, God takes away wise leadership from the land—the hero, warrior, judge, prophet, elder and others (see Isaiah 3:1-4 NIV). During a time of restoration the Lord restores these to the land. We are now entering such a time of restoration, and the Lord is calling us to be heroes. He is preparing us for a time soon to come when the world will cry out for leaders who are in touch with the heart and mind of God.[4]

Some women are called to be Deborahs, to lead others to the field of spiritual battle. Other women are called to be Jaels. These are ordinary housewives who become extraordinary heroes under the anointing of the Spirit of God as they answer a call to bring change. These women may never speak in front of a crowd or lead a great movement, but they might champion the cause of change in school systems or communities, local governments, or

even in their own families. Just as Jael did, these women will often look in their own tents to find their weapons of war—spiritual weapons such as prayer and praise, or the not so spiritual weapons of the internet and the telephone. They will use whatever means they have available to stand up for a righteous cause against a rising tide of evil in the land. They are warriors for the cause of Christ.

Has God called you to be a Deborah? Or perhaps you see yourself as more of a Jael. Whichever woman you most identify with, it is important that you answer the call. Wake up to the heroine of the faith inside you and boldly believe that you can make a difference.

## Endnotes

1. Brown Driver Briggs Hebrew Lexicon, 5516.

2. Jamieson, Fauset, and Brown.

3. Matthew Henry's Commentary on the Whole Bible: New Modern Edition, Electronic Database. Copyright (c) 1991 by Hendrickson Publishers, Inc.

4. Michal Ann Goll, *Women on the Front Lines*, (Shippensburg, PA: Destiny Image Publishers, Inc., 1999) 145.

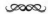

# Women Who Make a Difference Through Courage
## IQBAL MASSEY

*Mother Teresa picked up people from gutters and garbage dumps, brought them to her hospital, and cared for them with love, even though most of her patients died in matter of days or weeks. A news reporter once asked her why she was wasting her limited resources on people for whom there was no hope. Mother Teresa answered softly, "These people have been treated all their lives like dogs. Their greatest disease is a sense that they are unwanted. Don't they have a right to die like angels?"*

*I thought of this story while I was recently in a sewing center handing a sewing machine to a young girl who was crying bitterly. She was caught just in time as she was pouring kerosene oil over herself to commit suicide. She was a rape victim, a poor girl working in a Muslim home where she was beaten by her mistress and raped by the men. One day, she ran away from that home and told her mother all about the treatment she was receiving while working there. While they were both crying, the police showed up and arrested the girl. The Muslim family had falsely reported to the police that she had stolen 10,000 rupees, about $160, and some jewelry from their home. God used a local Christian lawyer to defend her, and she came home, but to no hope and no bright future. Because she was raped and she had been to the jail, no one would ever ask for her hand in marriage. In that culture, there is no hope for a girl once raped. She just wanted to end her life.*

*The Lord led me to start the sewing centers for our poor, uneducated Christian girls who have been raped or beaten and/or with nowhere to go. In these centers, they learn that Jesus loves them, died for them, and forgave them. Their guilt feelings (albeit without*

*basis) are washed away with the blood of Jesus. Not only do they work in a Christ-centered Christian atmosphere with unconditional love, but they learn to earn money to help their poor families. The sewing centers indeed have made a difference in the lives of these poor women. They are encouraged and work with hope. Accordingly, we call these sewing centers "The Centers of Hope." Each center has 20 machines, 20 students, and two teachers—one to teach them how to sew and the other teaches them how to read and write.*

*We rent a room in a Christian home for security reasons. There are about 20 centers in Pakistan, and there is a plan to open more, because the need is much greater than the resources we have right now. The sewing centers are becoming quite popular, economically and spiritually helping these poor girls and widows. They learn how to read the Bible through an adult literacy program and learn to pray and sing short Bible songs and Bible stories. The girls who come to the Centers of Hope with long faces and tear-filled eyes, facing a bleak future, are transformed before our very eyes into vibrant Christian girls in love with Jesus. This is what makes the difference in their lives.*

*I am a woman of that culture, and I understand the trauma of being a woman in that man's world. No wonder families cry when a girl is born in a home. Women are thought of as inferior, physically, culturally, and even religiously. She lives, moves, and has her being in this hostile culture where boys are preferred over the girls. The dreaded dowry system is also a curse. It is difficult for parents, and it is a slow poison for girls to have to bear the criticism each time that she doesn't bring much dowry to a boy's home.*

*When I accepted Christ in the convent school where I was a teacher, an unspeakable joy and peace filled my heart. My first*

prayer on my knees was, "Lord, there are hundreds upon thousands of Pakistani girls like me craving for this peace." I wanted to shout about the rights of a girl, but a "cultural glue" sealed my lips. I prayed, "Lord help me share this peace with other Pakistani girls," and God answered my prayer. A few days later, my marriage was arranged with the very man in whose meeting I had first heard how to have a personal relationship with God through Jesus Christ. Glory to God who gave me a husband and a ministry to serve with him.

Our area of service is the Middle East and the Muslim world, where a woman is a true second-class citizen. She is considered a man's possession, where the veil system and man's ego and pride always dominate. I have a deep compassion to reach women with the message of Christ's love. I implore to them with words from the Bible about God-given equality and the right of being a woman. I teach them biblical examples about several Middle Eastern women who made a difference in their failing nations.

At one particular time, I prayed and fasted for three weeks while we were in Iran. At that time, the Lord helped me to start a women's ministry in the Middle East and Central Asia. I believe that as women are changed, families are changed, then communities are changed. People influence others around them to make a difference. God made women to be helpers, and I believe women can be the backbone of a family, community, and country.

The major objectives of our ministry are prayer and fasting, evangelism and discipleship, training nationals, planting churches, and helping feeble churches learn how to follow Second Timothy 2:2. With prayer as my priority, I have started to develop prayer groups. If Christians learn to do their part in praying, the Lord will do His part of moving in the Muslim world. If we are ever going to reach the Muslim world for Christ, it has to be on our knees with fasting and

prayer. God is using prayer and Bible study groups to make a difference. We encourage our Christian brothers and sisters to fast every first Friday and pray diligently for the Muslim world. Sometimes we use 40-day prayer and fasting programs, specifically choosing 40 people in your area or Sunday school class and asking each person to select a particular day to pray and fast, so that there is fasting and prayer continuously for 40 days. The number 40 has special significance in the Bible. If we do not have 40 people, we start with less and ask some people to fast and pray two or three days, as the Lord leads.

Sewing centers, prayer groups, intervals of fasting and praying for your country, community, church, children, and Christian outreach are making a difference in many lives. God wants to move mightily in the nations of the earth, including the Muslim nations. We must work with the Lord to see His plan accomplished.

**Iqbal Massey** and her husband, Kundan, are national missionaries serving with United World Missions in the Middle East, Central Asia, and Pakistan. They have established over 20 Centers of Hope, sewing centers in Pakistan, and travel throughout the Middle East, training leaders and holding Gospel crusades. They live in Corona, California.

CHAPTER SIXTEEN

# Dismantling the Stronghold of Fear

Whenever God speaks to us regarding our call or destiny, it may seem that what He is saying is too impossible to accomplish. But we must always remember that God's perspective and our perspective are usually two different things. Words such as *impossible* and *can't* are simply not in God's vocabulary.

By definition, courage is not the absence of fear but the "capacity to meet danger without giving way to fear."[1] One should not feel condemned because fear is present; rather, it is what you do in the face of fear that counts. Do you press through to freedom and victory; or do you give in, give up, and retreat?

Referring again to the book, *Women on the Frontlines*, we find that Michal Ann Goll reveals where our courage comes from and how God must be our source of strength.

> *Courage arises out of the security of knowing who God is and who we are in relation to Him. We can take courage in the Lord, not because of who we are or what we have, but because of His indwelling presence with us through the Holy Spirit. By ourselves we are weak and can do nothing. But because He dwells in us, we have His power, wisdom and courage.... Courage arises from confidence in the vision the Lord has given to us; it comes from the quiet place of contemplation before the Lord where He visits us and speaks to us. Courage comes out of glorying in our own weaknesses and resting in His strength.*[2]

In order to embrace the fullness of our calling, we must be willing to face our fears. The term "fear not" appears over one hundred times in Scripture. Why? Because God knew when He was writing to us, we would have cause and reason to feel afraid.

## Courage to Possess

In Joshua chapter 1, God tells Joshua to go in to possess the land that He had already given to him. He also told him four times in that chapter to "be strong and of good courage." Why did He say this so many times when He was also clearly stating that the land was already theirs, and all they would have to do is go in and take it? Because God knew there would be plenty of opportunities for Joshua and the people of Israel to look at the natural circumstances and become overwhelmed by the impossibility of the situation. After all, there were mighty giants in the land, some of whom stood nine and ten feet tall.

God instructed Joshua to possess all that He had promised them and not settle for second best on the other side of the Jordan. God was also letting him know that he would have to face his fears and overcome them before he could overcome his enemies.

Many times God speaks something wonderful to us in the same manner that He spoke to Joshua. "I've given you your healing, your finances, your family, your ministry, and so on. Don't be afraid, go on and take it! Oh, by the way, did I mention that you'd have to face, and defeat, a few hundred giants along the way? But don't worry! Don't be afraid! I've already said you could do it!"

Most of us turn and run at the first sign of opposition. We then try to convince ourselves that the word we heard must not have been God after all. How many times have we sold ourselves short of reaping all the blessings and possessing all that God has made available to us because of a stronghold of fear over our lives?

## The Stronghold of Fear

What is a stronghold of fear? Very simply put, it is something that has a strong hold on you! Vain imaginations, ungodly beliefs, fear of man, fear of failure, fear of success, fear of death, fear of the devil—and the list goes on and on. We must learn to identify our fears, confront our fears, and destroy our fears in order to be all God has called us to be.

## Overcoming Fear's Paralyzing Effect

There was a time when the apostle Paul recognized that the young man he was mentoring in ministry was not pressing in to the fullness of his potential. He knew that Timothy had many gifts that had been imparted to him by God; nevertheless, they were lying dormant within him. Fear had paralyzed Timothy's gifts and caused them to be ineffective.

> *Therefore I remind you to stir up the gift of God which is in you through the laying on of my hands. For God has not given us a spirit of fear, but of power and of love and of a sound mind* (2 Timothy 1:6-7 NKJV).

Scripture is clear that God is not the author of fear. There is an appropriate fear of God, born out of respect and awe for His sovereignty. But it is not this type of fear that controls and dominates people's lives, preventing them from fulfilling destiny. This type of fear comes from the devil and forms in our own minds, coming into agreement with the powers of darkness. It will torment us, paralyze us, and prevent us from receiving all the good things God has for us. It is a bondage that shows no mercy and keeps us from walking in the life of His great love toward us.

> *There is no fear in love; but **perfect love casteth out fear:** because **fear hath torment**. He that feareth is not made perfect in love* (1 John 4:18, emphasis added).

By the anointing of His Holy Spirit, God has given us the power to be free from tormenting spirits of fear. As we break our agreement with the power of fear, and receive instead the power of God to deliver us and make us free, God releases faith—which is the opposite of fear—to go in and possess our promise.

> And **deliver them** who through **fear of death** were all their lifetime subject to bondage (Hebrews 2:15, emphasis added).

## The Pioneer Spirit

Pioneers are those who venture into unchartered territory to explore and discover the qualities of that area. They face a world of uncertain danger in order to settle and establish their new land and make it fruitful. They are people who have a spirit of adventure and who are willing to risk safety and security in order to obtain a better way of life. Pioneers are people of courage!

Deborah was a pioneer. Her role as the first woman judge and her task of leading an army were new experiences not only to her, but to many in her nation. She could have chosen a life of known comfort and refused to step into her call, but she had a spirit of adventure that inspired her to do it differently than anyone had seen before! Deborah was a risk taker!

Pioneers are usually leaders too. People will follow those with a courageous spirit. Many settlements in America's far West were birthed with only a couple of pioneer families who forged ahead through many trials, oppositions, hardships, and adversities to settle the land. Later, others followed in the path that had been laid down, and they shared in the blessings of the land.

Deborah's pioneer spirit caused many to follow her example of courage. As she walked in courage, she also released an impartation of courage, both to those she directly affected, as well as throughout the land.

General Barak obeyed the Word of the Lord and drew on Deborah's courage to bring victory. The army of ten thousand

soldiers became convinced that they could win, even against impossible odds, because Deborah and Barak's courage were contagious. Through her courage, born out of her faith and trust in God, courage was restored to the armies of Israel.

Fear is contagious, but so is courage! God is looking for those who are willing to pray as the prophet Isaiah prayed when he said: "*Here am I; send me*" (Isa. 6:8b).

## Corrie Ten Boom—A Woman of Courage

"God has plans, not problems, for our lives."[3] These are the words of a true woman of courage—Corrie Ten Boom. Born April 15, 1892 in Amsterdam, Netherlands, Corrie was the daughter of a Dutch watchmaker. Her family members were devout Christians who believed their faith was something that should impact the lives of others in their community. They believed they should make a difference.

As a result, their home was always open to anyone in need. Corrie planned and led weekly worship services for the mentally handicapped in her community for over 20 years. She also organized a "girl's club" for 12 to18-year-old young women. She taught them to have fun through gymnastics, music, and camping, and also led them in prayer and Bible study. This club later grew to be known as the Triangle Club, which touched the lives of thousands of young women in Holland.[4]

When the Germans invaded her small Dutch town of Haarlem in 1940, Corrie was 48 years old and had never married. She had been working in the family's watchmaker business and became the first licensed female watchmaker in the land. Now, living conditions were deteriorating for the people of the land as the Nazi occupation ravaged the livelihoods of many, especially the Jews. Neverthless, the Ten Boom family continued to open their hearts and their home to those who were in need.

As Jewish persecution mounted, they began to hide some of the hunted Jews in a small room they had constructed behind a

false wall in Corrie's bedroom. The room was only 18 inches wide, but could hide seven people for several days. As Corrie prayed, God would bring miraculous provision of survival resources such as food ration cards so that they could feed their guests. The family also installed an illegal, forbidden radio to track the news and set up a warning system so that they could quickly hide their Jewish friends. In addition, Corrie was instrumental in establishing a Dutch underground to help multitudes of Jews escape. Before her capture and arrest, she had organized 80 homes who helped Jews escape certain death at the hand of the Nazis.[5]

In 1944, a local man betrayed the Ten Boom family, and they were arrested and sent to concentration camps. Corrie's father died after only ten days, while Corrie and her beloved sister, Betsy, spent the next ten months in three different prisons, the worst of which was Ravensbruck near Berlin, Germany. There they lived in the flea-infested Barracks 28, which was built to shelter 400 women yet actually housed 1400 women.[6] They were forced to do backbreaking work with very little food to sustain them. Yet it was here, in this barracks, which overlooked the crematorium in the death camp, that Corrie shared the Gospel with hundreds of women and led them to Christ. She shared the message of God's love and the power given to believers to forgive their enemies. Barracks 28 became known as "the crazy place where they still hope."[7]

Corrie's sister, Betsy, did not survive her time in the death camp, but went on to meet her Lord a few days before Christmas in 1944. Before she left the earth, though, she was to give Corrie a prophetic word of direction that would set the course of her life. She told her, "We must tell them what we have learned here. There is no pit so deep that God's love is not deeper still. They will listen to us because we have been here."[8] She also went on to describe two visions. In the first, she saw a beautiful home where concentration camp survivors could go to heal physically,

emotionally, and spiritually. In the second, she saw a Nazi concentration camp converted into a place where Germans who had been damaged by the perverse Nazi doctrine of hate could have their lives transformed. Corrie saw both of these visions come to pass in her lifetime.[9]

In December 1944, just a few days after the death of her sister, Betsy, Corrie was singled out at roll call and asked to report to the prison guards. She wondered if it was her turn to die. Instead the guard said, "Entlassen," which means "released." She was set free that day by a mistake in paperwork. Afterward, she found out that all the women at that camp were mercilessly killed later on that same week. God delivered Corrie from her "hell on earth" so that she could preach God's message of love throughout the earth.

After her release, Corrie spent the next 30 years traveling to over 60 nations preaching reconciliation and forgiveness. She found that those who were able to forgive those who had beat, tortured, and stole their lives, were those who were best able to rebuild their lives. She went on to write nine books, the most famous of which are *The Hiding Place* and *Tramp for the Lord*. She also produced five movies.

Corrie Ten Boom was a woman who inspired many to a love relationship with Jesus and taught the Body of Christ about true forgiveness. She exemplified a life in which believers can be full of joy rather than bitterness when trying times press in all around. She said it best when she declared, "The school of life offers some difficult courses, but it is in the difficult class that one learns the most—especially when your teacher is the Lord Jesus Christ. The hardest lessons for me were in a cell with four walls. … After that time in prison, the entire world became my classroom."[10] Corrie was a woman of great courage who made a difference!

# Endnotes

1. Webster's Dictionary of the English Language.

2. Michal Ann Goll, *Women on the Front Lines* (Shippensburg, PA: Destiny Image Publishers, Inc., 1999), 26.

3. In Touch Ministries, The Joy Filled Life, Corrie Ten Boom  www.intouch.org/myintouch/mighty/portraits/corrieten Boom159770.html.

4. www.en.wikipedia.org/wiki/CorrietenBoom.

5. David Wallington, *The Secret Room, The Story of Corrie Ten Boom*, Soon Online Magazine, www.soon.org.uk/true_stories/ holocaust.htm.

6. Wallington, *The Secret Room, The Story of Corrie Ten Boom.*

7. Corrie Ten Boom, *The Hiding Place*, in Corrie Ten Boom: Her Story (New York, Inspirational Press, 1995), 158.

8. Ten Boom, *The Hiding Place*, in Corrie Ten Boom: Her Story, 159.

9. Goll, *Women on the Front Lines*, 123-124.

10. In Touch Ministries, The Joy Filled Life, Corrie Ten Boom.

# Deborah the Bee

## Persistence to Overcome

One of the greatest keys to overcoming fear is exercising patient persistence to obtain our goal. Fear will try to paralyze us, but as we activate and stir up our gifts from God, the bondages will be broken and released off our lives.

Those who are part of this Deborah Company of women understand that quitting is not an option. We might face adversity and difficulty. It may seem like God's timetable and our timetable are two different things. (This is probably because they are!) We may feel overwhelmed by the seeming impossibility of the situation, but we can never adopt a quitter's mentality!

## The Persistence of the Bee

Deborah's name means "the bee."[1] The bee is an example of order, intelligence, persistence, patience, and overcoming difficulty and adversity. In studying the nature and character of a bee, we can be inspired to achieve new levels as we endeavor to press on and press through. The following quote exemplifies this persistence:

> A beekeeper told me a story of a hive—how when the little bee is in the first stage, it is put into a hexagonal cell and enough honey is stored there for its use until it reaches maturity. The honey is sealed with a capsule of wax, and when the tiny bee has fed itself on the honey and exhausted the supply, the time has come for it to

emerge into the open. But, oh the wrestle, the tussle, the straining to get through that wax! It is the straight gate for the bee, so straight that in the agony of exit the bee rubs off the membrane that hid its wings and *on the other side is able to fly!*[12]

Just as Deborah was an example of a woman who pressed through adversity and challenge, those who are a part of the Deborah Company must also determine not to allow hindering circumstances to discourage us and convince us to quit along our path to destiny. Unless the bee was willing to fight its way through the wax to freedom and breakthrough, it would remain trapped within the walls of wax until it died. As the bee pressed through, so must we if we hope to discover our wings and take flight!

> *Cast not away therefore your confidence, which hath great recompense of reward. For ye have need of patience, that, after ye have done the will of God, ye might receive the promise* (Hebrews 10:35-36, emphasis added).

Another interesting analogy is that of the busy bee. Those who are a part of this new breed will be busy about the business of the Kingdom.

> The busy bee. The bee has aptly been described as "busy." To produce one pound of honey the bee must visit 56,000 clover heads. Since each head has 60 flower tubes, a total of 3,360,000 visits are necessary to give us that pound of honey for the breakfast table. Meanwhile, that worker bee has flown the equivalent of three times around the world. To produce one tablespoon of honey for our toast, the little bee makes 4,200 trips to flowers. He makes about ten trips a day to the fields, each trip lasting twenty minutes average and four hundred flowers. A worker bee will fly as far as eight miles if he cannot

find a nectar flow that is nearer. Therefore, when you feel that persistence is a difficult task, think of the bee![3]

## A Passion for Freedom From Fear

I have a real passion to see women overcome their fears and become women of courage. Fears will rob from you, accuse you, and cause you to feel helpless, hopeless, and defeated. I know. One of my greatest personal battles has been in overcoming fear. I know firsthand how fears can affect your life and dissuade you from pursuing destiny.

On the outside, you might never realize that I have struggled with fear. I have always portrayed a lot of confidence, and I am somewhat of an extrovert. We tend to think of people who are controlled by fear as shy, timid, meek people. But the fact is that fear can affect even the most outgoing of people in the hidden places of their heart.

Regardless of our upbringing, we all have obstacles that we must learn to overcome. I was not raised with a great deal of biblical understanding; however, my parents were supportive, loving people, which gave me a good foundation of self-confidence that enabled me to face many challenges. We moved many times, so I had to learn how to face my fears of confronting new situations and meeting new people. Yet, even though I was outgoing, friendly, and bold, I was tormented by secret, hidden fear. I had endured sexual abuse from a neighbor as a child. Subsequently, I suffered much fear, intimidation, and vain imaginations later on in life, which the Lord had to heal within me.

## Unreasonable Fear

Fear brings with it a great deal of shame. After all, as adults with rational minds, we think that we should be able to see through the deception that enfolds a spirit of fear. So when we find ourselves actually battling fear, we tend to battle it alone, feeling ashamed that something so ridiculous could frighten or intimidate us.

What we fail to realize is that fear, quite often, is not just a struggle with our mind, but is a demonic spirit that comes to rob, steal, and destroy. Demonic spirits love to operate in the darkness of deception and will attempt to prevent you from getting help by adding shame. This plays into their plan of binding you in darkness, instead of exposing their fear tactics to the light of reason, revelation, and counsel. They feed the vain imaginations into your mind; and once fear and intimidation take root, we inadvertently come into agreement with them and empower them.

I was an adult woman with three children, and *I was afraid of the dark*. It was an unreasonable fear, but it didn't change the fact that once the lights went out, I would be frozen with fear.

I would get up in the middle of the night to take care of one of my babies, and I would turn all the lights on between my room and my child's room. Then after I had tended to the baby, I would go back to my room, turning the lights off throughout the house as I went. The problem came when I got to the last light before getting in bed. After turning it off, I would still have approximately three steps to take to get back in bed. Then I would be fine. But quite often, I would turn that last light off and be completely paralyzed with fear.

I felt foolish and refused to wake my husband. After all, I was a rational, intelligent woman. I knew there was nothing in the dark to be afraid of. I knew the Word of God and how to use it to confront satan. I was a prophetess and a minister who prophesied, preached, cast out devils, and such. Why should I be afraid of the dark? It was just not reasonable!

So I faced it alone. I would stand in the dark quoting Scripture over and over. "God has not given me the spirit of fear but of power, love, and a sound mind…. God has not given me the spirit of fear but of power, love, and a sound mind…. God has not given me the spirit of fear…" Then I would generally turn the light back on and get back in bed!

I found that there were two things that I needed to do in order to free myself from this fear. First, I needed to learn to stop the process before it started and not give in to vain imaginations. I needed to realize that I wasn't just warring with my mind, but with evil forces that were unreasonable and unmerciful in their attack against me.

> *For though we walk in the flesh,* **we do not war after the flesh:** *for the weapons of our warfare are not carnal, but* **mighty through God** *to the* **pulling down of strong holds;** *casting down imaginations, and every high thing that exalteth itself against the knowledge of God, and bringing into captivity every thought to the* **obedience of Christ** (2 Corinthians 10:3-5, emphasis added).

Secondly, I needed to remember the power of agreement. I was obviously struggling all alone to win a victory in this situation. Because I felt ashamed and foolish, I refused to reach out to my husband, who was three steps away, and ask him to pray a prayer of agreement with me. I needed to remember what God's Word has to say about the power that is released when two people come together and pray.

> *How should one chase a thousand, and two put ten thousand to flight...?* (Deuteronomy 32:30).

> *Again I say unto you, That if two of you shall agree on earth as touching any thing that they shall ask,* **it shall be done for them of My Father which is in heaven** (Matthew 18:19, emphasis added).

So one night, after I had experienced the terror of this fear one more time, I got in bed, woke my husband, and asked him to pray. He prayed a very simple prayer, took authority over the fear, then rolled over and went back to sleep! Then a strange thing happened to me. I felt peaceful, calm, and free from fear! Since that time, if I experience fear, I immediately ask someone to come

into agreement with me, and the power of that fear is broken and driven out.

## Reasonable Fear?

I shared the previous example because it seems so foolish. Being afraid of the dark is a completely unreasonable fear. But what about areas of reasonable fear? Those should be all right…right? Wrong! Fear is a spirit, and whether it is an area of unreasonable fear, or even a reasonable fear, it can bring torment into your life. My other predominant area of fear was one that most women feel is reasonable. I was terrified of snakes. Reasonable…right? Reasonable, yes; righteous, no. Fear is a spirit, and no matter how reasonable it seems, it will begin to take over your life and torment you into paralysis.

So the Lord decided that it was time for me to be set free from a binding spirit of fear. And guess where God moved our family many years ago? Florida! The snake capital of the United States! I couldn't walk to my car at night without totally panicking over a fear of snakes. Vain imaginations had taken over my mind—and I had allowed them!

Fear can have the opposite effect of faith. With faith, you have a hope and an expectation for blessing and good. With fear, you have an anticipation and expectation for evil. I expected to encounter snakes, and it was just a matter of time before my expectations were met!

God loved me enough to take me through a period of time in which I had to confront my fear of snakes. That sounds wonderful, but if you know how to read between the lines, you will know what that means! It means that every time I turned around…there was a snake! One fell off my roof when I opened my front door and landed at my feet. One lay waiting for me on my driveway as I walked to my car. One slithered through the grass next to me as I was playing in the yard with my children. I even found a snake in my laundry as I was sorting clothes!

God was making it abundantly clear to me that He was not going to allow me to give place to fear in any area of my life. The fear of the dark may have been an unreasonable fear, but the fear of snakes was entirely reasonable to me. Even in Scripture, satan is represented as a serpent! I know that people say there are good snakes and bad snakes, but to me, the only good snake is a dead snake!

God took me through a process of confronting this fear, even though it didn't seem like something I needed to be delivered from. I learned that we cannot compartmentalize our lives and think that the spirit of fear (or anything else for that matter) will remain confined to this one area. It will eventually begin to spread and undermine our faith in other areas as well until it has a *strong hold*.

I found that if I hoped to be used of the Lord to confront spirits of darkness, I would have to first confront my fear of natural darkness. If I was going to be used to expose the hidden, slippery demonic strongholds of hell and do spiritual battle against them, I would first have to confront my fear of death and evil. How could God use me to deal with demonic snakes if I was afraid of natural snakes?

## Press on to Possess the Rest!

God is raising up women like Deborah who are willing to confront and overcome their fears and insecurities and go forth into battle. Though there is no record that Deborah actually wielded the sword, we do know that she went to the battlefield and led the troops to victory.

God is raising up warriors! We must be those full of the Holy Ghost anointing, free from our own fears, and determined to persist in the face of adversity. We need to realize that our warfare is not only about releasing our own freedom; we must release the freedom that Jesus died to bring mankind—freedom to a lost and dying world. It's not about us—it's all about *Him*! Jesus has

already won the victory for us and passed sentence on the forces of darkness, but it is up to us to execute the vengeance that He has written (see Ps. 149:6-9).

Because of the victory brought forth through Deborah and Barak's leadership, Israel entered into a season of blessing and rest that lasted one full generation.

*And the land had rest forty years* (Judges 5:31b).

## Endnotes

1. Strong's Concordance, 1682.

2. *Encyclopedia of 7700 Illustrations*, Tan, Assurance Publishers, Rockville, MD, 1521.

3. *Encyclopedia of 7700 Illustrations*, Tan, Assurance Publishers, Rockville, MD, 996.

# *Women Who Make a Difference Impacting Generations*
## CRYSTAL HAMON

*The madness of the Christmas shopping season was upon us, as local mothers and out-of-towners alike zipped from one store to the next, hoping for a good parking place and a great deal on the perfect gift. Lost in the fray after a long day of beating the pavement, I decided to stop in at my old workplace, The Gap. I smiled to myself thinking about the previous year's work in retail and concluding that I was happy that I was not currently in it.*

*As I walked passed tousled piles of sweaters and clearance racks, I spotted the familiar face of a former coworker. Her brown eyes and East Indian complexion brightened at the sight of a friendly, recognizable shopper. But two seconds into the conversation, her bright eyes dimmed as she buried her face in the hug of greeting and began to weep and tell me about the issues in her life that were burdening her.*

*It had been a year since I had seen Prema. She knew I was a Christian, and I knew she was a Buddhist, and most of the time our conversations had been brief, kind, and surface level. This sudden open display of emotion and friendship was a surprise, but I felt that God was in it. With such sadness she poured out her heart, then she looked up at me and through broken English said, "No one knows about these things, but there is something I saw in your eyes and I knew you would understand." Right there, standing in the women's new apparel section, I asked if I could pray with her, and she consented. This began a season of discussions about God and visits to our church. A few short months later, I walked in the store to hear her tell me, "Crystal, I am no longer a Buddhist. I am a Christian.*

*Do you remember when I used to be so sad? Ever since I started praying to Jesus, I don't feel sad anymore!"*

*When I first started working there, a job at The Gap didn't feel like much more than a short-term stint to earn some extra money. Little did I know that God had put me there to introduce this sweet soul to the greatest love of her life.*

*Far too often, we underestimate our place or position, devaluing our lives and ourselves, and we fail to see the rich tapestry God is weaving with the texture of our lives. Today's world is interesting and frightening for a younger generation. Five-year-old children are being taught to hate, to kill, and to sacrifice their lives and the lives of others for a god they do not know in Islamic nations. Young girls are being pervasively sold into the sex trade in Asian nations. Kids are killing kids in schools throughout America, and children under five years old are being raped in Africa because it is the rumored cure for the AIDS virus. While we have seen and will continue to see some of the greatest technological advances of our day, at the same time ancient struggles of good and evil continue to flare up in terrorist acts of mass murders on a monumental scale and fear grips our hearts. And if you aren't caught in the crosshairs of a suicide bomb or the deadly rage of a classmate, there are still the treacherous blows to the heart from abandonment, shame, and rejection of abuse, divorce, and other branches of selfishness in society.*

*So, what could this broken and hurting generation have to offer? What redemption can be found in the wake of such loss? It is interesting to note that throughout history and the Bible whenever a great revolution or turning point was about to happen, a massive stream of evil attempted to swallow it up. Just at that point, God also brought a young person on the scene. Think of David or Esther and*

*their times of revolution. Consider Moses, the great deliverer. Just before he was born, an order had been given that Hebrew boys in Egypt should be killed at birth. At another time, when rumors of a fulfilled prophecy about a Savior being born were whispered to King Herod, an edict was issued that all baby boys, two years old and younger, in Bethlehem must be killed. Could it be that the many atrocities and challenges we see directed at our young age group today are an attempt by the enemy of our souls to drown out rising voices of cultural change and deliverance?*

*Hitler understood the secret that he who holds the minds and hearts, and shapes the ideologies of the youth in a nation will capture that nation's future in his grip. In his evil and maniacal strategies, he recruited boys as young as ten years old to serve as members of his corrupt Reich. But these same strategies used for dark reasons have also been used to spread light. It is commonly believed by many scholars that the majority of Jesus' disciples were in their teens and early 20s, and of them it was said that they turned the world upside down!*

*My friend Lou Engle said it this way: "There are moments in history when a door for massive change opens. Great revolutions for good or for evil occur in the vacuum created by these openings. It is in these times that the key men and women, even entire generations, risk everything to become the hinge of history—that pivotal point that determines which way the door will swing."*

*Personally, I believe that we are living in a time when God is whispering to young artists, educators, public servants, business leaders, and filmmakers, breathing life into their souls and vision into their hearts to be the vessels of change, an army of purity and compassion, to the world around them as they encounter it daily.*

*Some will reach out past their borders of comfort to walk into dark and frightening places.*

*I will close by leaving you with a quote by Pete Greig, author of Red Moon Rising. He challenges our generation by saying: "Perhaps He longs that we would vacate our buildings from time to time, that we would turn our temples into tabernacles. That we would become like Him, the friend of sinners. We are the light of the world, but no one wants to stare at the bulb. We are the salt of the earth, but a whole plate of the stuff will make you sick. The people of God are called to scatter and mix, to mingle and move, to influence from a position of weakness, like a small child in a large family, like yeast in a loaf, like a mustard seed beneath a pavement. Could it be that the Holy Spirit is weary of attending our meetings and hungers for our presence at His? Perhaps He's dreaming up a thousand new meeting places, where new sounds and sights burn the eyes and break the heart!" (p. 191).*

*Let us allow God's heart to echo in our generation through the reverberations of our lives.*

## A Charge to Women of Courage

Deborah Company, arise! It's time to receive a fresh impartation of boldness, courage, and confidence in the Lord. No longer must we cower with fear or intimidation, but it is time to step into the fullness of the gifts and callings God has placed in our lives. We will confront the forces of darkness. We will be God's sword of judgment thrust forth against evil spirits. We will put on the whole armor of God and stand with God's army of believers, fighting for the advancement of His Kingdom. We will do our part and stir up our gifts. We will be mighty, for God's Spirit is within us and *He is mighty*!

> *Finally, my brethren [or sisters], **be strong in the Lord**, and in the power of His might. Put on the whole armor of God, that ye may be able to stand against the wiles of the devil. For we wrestle not against flesh and blood, but against principalities, against powers, against the rulers of the darkness of this world, against spiritual wickedness in high places. Wherefore take unto you the **whole armor of God**, that ye may be able to withstand in the evil day, and **having done all, to stand**. Stand therefore, having your loins girt about with truth, and having on the breastplate of righteousness; and your feet shod with the preparation of the gospel of peace; above all, taking the shield of faith, wherewith ye shall be able to quench all the fiery darts of the wicked. And take the helmet of salvation, and the sword of the Spirit, which is the Word of God: **praying always** with all prayer and supplication in the Spirit, and watching thereunto with all perseverance and supplication for all saints* (Ephesians 6:10-18, emphasis added).

## Section Four

# Questions for Consideration

1. Identify three areas of fear in your life.

2. Describe God's plan for freedom from these fears.

3. Are there areas in your life in which you have stopped pursuing destiny because of resistance, difficulty, or barriers; and which you feel God now wants you to persevere and persist in developing? Describe these.

# Deborah the Worshiper: A Woman of Passion

*The Church's worship today must correspond to the worship that is going on in heaven.*

Chuck Pierce
*The Worship Warrior*

## CHAPTER EIGHTEEN

# Deborah the Worshiper

## A Woman of Passion

*Then sang Deborah and Barak the son of Abinoam on that day, saying, **Praise ye the Lord** for the avenging of Israel, when the people willingly offered themselves* (Judges 5:1-2, emphasis added).

Deborah was not just a prophetess, a judge, a warrior, and a wife; she was also a worshiper! Her heart overflowed with praise for the greatness of God, His might, power, and majesty. Through her praise, she poured out her heart towards God and towards His people, giving thanks to Him for His great deliverance. She was a woman of passion!

Judges chapter 4 tells us the facts regarding Deborah and Barak's victory over Sisera and his armies, and Judges chapter 5 passionately retells the story through poetry and song. This song was an expressive declaration that flowed out of hearts of worship from Deborah and Barak. They weren't just warriors; they were worshipers!

Those who will be a part of the Deborah Company of women will be those who have learned to passionately embrace worshiping the Most High God. We will understand that He is worthy of all our praise, and that all our victories are because of Him. We may prepare ourselves in pursuing wisdom, revelation, courage, and balance, but until we fully allow the Lord to be enthroned upon our hearts and lives, we will constantly find ourselves falling short of being all He has called us to be.

## Created for Intimacy

In the beginning, Adam and Eve walked with God in the cool of the day. Fellowship with the Lord of all creation was a part of their daily routine. They lived their lives in openness before their Father and were clothed with His glory. Though they were naked, they were unashamed for the glory of the Lord covered them. They thrived in their personal, intimate relationship with their God until the day when deception from the enemy entered in, and Adam and Eve sinned against their Lord and King. As a result of their fall, they exchanged their covering of glory for a covering of shame (see Hosea 4:7). No longer did they run to Him when He walked in the cool of the day, but rather they hid themselves from God, full of disgrace and dishonor. A wall of separation arose, cutting all humanity off from having an intimate, personal love relationship with their God.

This was the state of humanity until Jesus came to destroy every curse that sin had released in the earth. When He gave His life for our sins, He restored us to a place of right relationship with God. Isaiah 61:7 says that He exchanged our shame for His glory once again. He clothed us with His presence and gave us access to His throne room so that we could boldly come before His throne of grace. We were created to have a close, intimate, transparent relationship with the Creator of the universe!

God is calling us to live lives of worship before the Lord and to press into His presence in prayer, so that we can fully understand the greatness of His power. By worshiping God and spending time in His presence, we begin to comprehend how big He is, and how big He is in us.

Worship opens up the river of God's anointing, which releases empowerment in our lives. Worship brings our lives into proper perspective and places the focus of our hearts, attitudes, and actions where it belongs—upon Jesus and His plans and purposes.

Worship and prayer are tied together. One cannot have an effective prayer life without also being a worshiper. Likewise, one

cannot truly enter into true worship without a heart that has been prepared in prayer.

## What Is True Worship?

When Jesus met the woman at the well, they had a discussion regarding true worship. Jesus gives us insight about what God the Father is looking for in our worship towards Him, and how we are to approach this vital realm of relationship with God.

> *But the hour is coming, and now is, when the **true worshipers will worship the Father in spirit and truth; for the Father is seeking such to worship Him.** God is Spirit, and those who worship Him must worship in spirit and truth* (John 4:23-24 NKJV, emphasis added).

Worship is not just a time when we gather at church and sing a few songs. It is not just a ritual that we perform, nor a duty to be carried out. It is not silently striking a pious pose with heads bowed and eyes closed or with hands raised. True worship is not found in an act of performance, but rather in a life of heartfelt dedication and commitment. In other words, it is not relegated to a specific time or place, but rather becomes an all encompassing lifestyle.

The Father is seeking those with sincere hearts to worship Him. The woman at the well was seeking for a simple convenient formula for worship. Jesus made it clear that God would not be satisfied with His children going through a ritual or by merely performing certain religious actions. God is a Spirit, and He is satisfied only as His children wholeheartedly worship Him in spirit and in truth.

The Deborah Company will be free from dead religion and from empty form and ritual. Those moving in this anointing will be full of life, passion, and excitement for their Lord and King! They will be motivated through love to serve the Kingdom cause.

How do we worship in spirit and in truth? We must live our lives as an open book before the Lord, realizing that He knows all and sees all. As we look at the gifts He has given us, and at the same time, acknowledge the struggles and weaknesses that we endure, we are able to come before Him without shame, receiving His grace and His strength. We can carry all that we are and all that we hope to be, to Him, and lay it down at His feet as an offering of our lives unto Him.

True worship will cause us to desire His will above our will, His plan above our plan, His way above our way. Having hearts of true worship will cause us to live our lives out of obedience to the One we love. It will cause us to yield ourselves completely and utterly to Him. In this manner, *every act of obedience becomes an act of worship.*

True worship doesn't start on the outside and work its way inside. Quite the opposite. It begins in our inward parts—our mind, our heart, our will—and flows outward into actions. Nevertheless, a true worshiper understands that there may be times that you *don't feel like* worshiping or demonstrating your heart of love towards God. These are the times that you enter into the presence of the Lord through actions, by faith, because of obedience and by an act of your will, *choosing* to give God glory, honor, and praise. These acts of faith will stir the worship of the heart and will produce the sacrifice of praise that is a sweet-smelling savor unto God.

## The Purpose of True Worship

True worship before the Lord is a multifaceted experience. Just as my relationship with my husband has many dynamics to it, so my personal relationship in worship to the Lord has different purposes and varied dimensions to it. Let's look at how worship impacts us as we come into this secret place with our God.

*Worship Prioritizes*

> *One thing have I desired of the Lord, that will I seek after;*
> *that I may dwell in the house of the Lord all the days of my*
> *life, to behold the beauty of the Lord, and to inquire in His*
> *temple* (Psalm 27:4).

When we enter into a lifestyle of worship before the Lord, it tends to put our lives into perspective. We begin to realize that life is not all about us, but rather it must be about Him—His purposes and His people. David wrote in this psalm that he had desired one thing of the Lord. One thing. He put his life into perspective and prioritized the importance of his relationship with God.

His greatest desire was to dwell in the house of the Lord, to behold the beauty of the Lord, and to inquire in His temple. He was describing a place of intimate relationship with God. He made the house of the Lord a priority in his life. This doesn't refer to some religious duty or pious ritual, but rather speaks of living with God in an intimate, family relationship.

David's desire was then to see the beauty of the Lord. He is full of glory, full of majesty. He radiates light and life. Even the angels in Heaven that surround His throne continuously cry out "Holy, Holy, Holy, Lord God Almighty"(Rev. 4:8). They are overwhelmed by His magnificence. He is truly worthy of all praise and glory and honor!

Finally, David spoke of inquiring in His temple. David was crying out to hear the voice of the Lord. He desired to hear God's wisdom, His counsel, His words of love and affirmation. David was saying of all the other needs, wants, and desires he had in life, this "one thing" was most important. It was all about knowing the Lord and being known by Him.

In Romans 8, we are told of the power of the love of God, how far reaching and how indestructible it is.

*Who shall separate us from the love of Christ? shall tribulation, or distress, or persecution, or famine, or nakedness, or peril, or sword? As it is written, For Thy sake we are killed all the day long; we are accounted as sheep for the slaughter. Nay, in all these things we are more than conquerors through Him that loved us. For I am persuaded, that neither death, nor life, nor angels, nor principalities, nor powers, nor things present, nor things to come, nor height, nor depth, nor any other creature, shall be able to separate us from the love of God, which is in Christ Jesus our Lord* (Romans 8:35-39).

Yes, we are more than conquerors through our love relationship with our God.

## Worship Empowers

*For in the time of trouble He shall hide me in His pavilion; in the secret of His tabernacle shall He hide me; He shall set me up upon a rock. And now shall mine head be lifted up above mine enemies round about me: therefore will I offer in His tabernacle sacrifices of joy; I will sing, yea, I will sing praises unto the Lord* (Psalm 27:5-6).

Being in the presence of the Lord empowers believers to fulfill their destinies. When Jesus walked and talked on the earth, people recognized that He was unique because He spoke with an unusual authority that others did not possess. This came out of His personal time of being with the Father, hearing His voice and discovering His will. In the same manner, the disciples were recognized as ones who had been with Jesus, because of the boldness of word and action that they walked in.

*Now when they saw the boldness of Peter and John, and perceived that they were uneducated and untrained men, they marveled. And they realized that they had been with Jesus* (Acts 4:13-14 NKJV).

Worship strips us of our own armor and self-protection and brings us into His pavilion of safety. In this place, no demon can touch us. Our heads are lifted up above our enemies in victory, and we are free to perform the will of God. We are empowered to live the life we were created to live.

## Worship Awakens

Deborah was told to awaken and to sing a song. When we wake up in the morning, we arise from a place of slumber or sleep, and we clear the fogginess from our minds in order to think clearly during the day. There are places to go and things to do that we must be ready for. Worship sets the course for the day and sharpens our spirit man to be prepared for all that is ahead.

Many people wake up to an alarm in the morning because they have an appointment to attend. Today, God is sounding an alarm for all those with ears to hear. Get ready! Something is about to happen. Things are moving and shaking. Are you prepared?

When we worship, our hearts and minds begin to align with the purposes of God. We awaken out of the fog of anger, unforgiveness, hurt, and shame. We wake up to who we are in Christ and who He is in us. When we sing a song, we begin to cause the words of our mouths, the confessions we make before God, to line up to His divine purposes and order our day.

## Worship Magnifies

*Oh, magnify the Lord with me, and let us exalt His name together. I sought the Lord, and He heard me, and delivered me from all my fears* (Psalm 34:3-4 NKJV).

*I will praise the name of God with a song, and will magnify Him with thanksgiving* (Psalm 69:30).

When we magnify something we make it bigger in our sight. How can we make God bigger? We can magnify Him by exalting His name and who He is. We can make Him bigger by bragging

on all the great things He has done. We can amplify all that He is by exploding with thanksgiving for all His wondrous ways.

Right now, take time and make a list of all the great things God has done for you. He has saved your soul from hell. He has given peace to your mind and health to your body. He has provided all the things you need in order to live—food, shelter, clothing. He has blessed you with other people who love you and care for you. Be specific about all He has done for you, and you will find that all the cares and the worries that seem so big before your eyes will suddenly begin to pale in comparison with how awesome He is.

If you take a little penny and hold it up to the sun, you will notice that it blocks out only a small portion of the sun's rays. However, if you bring the penny closer and closer to your eye, that tiny penny blocks out the entire radiance of the great big sun. This is what happens when we focus on problems rather than on the Lord. Our comparatively small problems begin to loom greater and greater, blocking out the rays of God's love and comfort. On the other hand, when we magnify Him, how great He is and how all-powerful He is, all our difficulties are overshadowed by the warmth of His love.

## Worship Transforms

*Now the Lord is the Spirit; and where the Spirit of the Lord is, there is liberty. But we all, with unveiled face, beholding as in a mirror the glory of the Lord, are being transformed into the same image from glory to glory, just as by the Spirit of the Lord* (2 Corinthians 3:17-18 NKJV).

One cannot come into the presence of the living God and not be changed. His presence will challenge you to become all you were formed to be.

In this passage, we find the word "transformed," which comes from a Greek word *metamorphoo*,[1] from which we get the English word, *metamorphous*. It literally means "to change forms."

It brings to mind the picture of the caterpillar which must go through a metamorphous process in order to emerge as a beautiful butterfly. It begins as a small worm, and as it grows, it sheds its skin. (As we grow, we shed our sin!) It grows to a point to where it must change. We know that the caterpillar then spins itself into a cocoon in order to go through the transformation process. In the cocoon, rapid change occurs although no human eye can see what is happening.

Many times God will take His children through this spiritual metamorphous process. We eat His Word and grow until the Lord says, "It's time for a change." Then the Lord takes us to a secret place and begins the transformation process. Sometimes this happens through times of prayer, personal devotion, and hearing His voice. At other times, God shapes our lives through the furnace of fiery trials and affliction. All the while, God has something in mind. He wants to see us come forth as the butterfly so we can spread our wings and fly!

Living a life wholly devoted to the Lord will change us from glory to glory into His image. As we walk in humility and obedience before Him, our hearts and minds will shift into alignment with His will until finally we break free of the confines of our cocoon, catch the wind of the Spirit, lift our new wings, and soar!

*Worship Teaches*

> *Let the Word of Christ dwell in you richly in all wisdom, teaching and admonishing one another in psalms and hymns and spiritual songs, singing with grace in your hearts to the Lord. And whatever you do in word or deed, do all in the name of the Lord Jesus, giving thanks to God the Father through Him* (Colossians 3:16-17 NKJV).

Times of worship, whether in a personal, devotional setting or in a corporate meeting atmosphere can be times when the Holy Spirit teaches us and when we teach one another. As we sing God's Word and exalt His divine nature, we are destined to learn

more about Him. As we agree with His spiritual principles and confess them with our mouths, truth begins to sink down into our hearts and we can be made free.

## Worship Connects

> *Behold, how good and how pleasant it is for brethren to dwell together in unity!* (Psalm 133:1).

> *I, therefore, the prisoner of the Lord, beseech you to walk worthy of the calling with which you were called, with all lowliness and gentleness, with longsuffering, bearing with one another in love, endeavoring to keep the unity of the Spirit in the bond of peace. There is one body and one Spirit, just as you were called in one hope of your calling; one Lord, one faith, one baptism; one God and Father of all, who is above all, and through all, and in you all* (Ephesians 4:1-6 NKJV).

It is very difficult to worship with someone and yet remain at odds. Somehow worship of the Lord brings a halt to divisive issues and creates a peaceful place for resolve to come. Worship can melt even the hardest heart when one comes before the throne of God with openness and sincerity. Worship brings a Kingdom connection that words and discourse cannot, and creates an atmosphere of unity and love that bridges the chasm of separation.

Worship also reconnects one with the Lord after a trial or difficulty where it is hard to see the hand of God in the situation. I have recently watched a woman in our church tragically lose her husband to cancer at a young age. She believed for his healing, as we all did, and prayed fervently that his life would be spared, to no avail. Since his death, she has felt abandoned by God and is finding it difficult to understand how a loving God could allow such a horrible thing to happen. She has more questions than she does answers. Yet every time the church doors have been open,

she has been there to worship before Him. She feels the need to connect with God, and worship is one of the vehicles that helps her achieve this. Worship connects her to God's heart even though her mind is full of sorrow, grief, pain, and doubt. Though she doesn't understand the hand of God, she is pressing in to touch the heart of God. Through this heart-to-heart connection, healing and life can flow to her, even in her hour of greatest distress.

God is breaking the curse of passivity and stirring passion in the heart of women throughout the earth. We are called to connect to His presence and know Him intimately as a Person. He is not a thing or an "it". He is our loving, heavenly Father who longs to spend time with us, to empower us, to encourage us, and to love us. He is knocking on the door of your heart. Will you open up and let Him come in?

### Endnote

1. Strong's Concordance, 3339.

CHAPTER NINETEEN

# The Worshiping Warrior

*And Deborah arose, and went with Barak **to Kedesh**. And Barak called Zebulun and Naphtali **to Kedesh**; and he went up with ten thousand men at his feet: and Deborah went up with him* (Judges 4:9b-10, emphasis added).

Prior to going out to battle, Deborah and Barak gathered the troops at Kedesh. "Kedesh" comes from the Hebrew word *qadash*, which means "to make clean, ceremonially or morally; to consecrate, dedicate, be holy, sanctify, purify, to prepare."[1] Kedesh was a place of worship and prayer! It was a place of empowerment. It was a place of sanctification (setting apart), purification, consecration, and dedication to the Lord.

Deborah and Barak recognized that in order to win the battle that God had set before them, their hearts would need to be prepared. This preparation would come as they consecrated themselves unto the Lord in worship and prayer and made fresh commitment of their lives to His purposes.

Let's face it. The Israeli army was going out to a battle that in the natural spelled certain destruction and death. It would not be won through their might or through their great abilities. *Only God* could bring their victory. As they consecrated and dedicated their lives to this cause, God filled them with courage *and began to fight with them* against their enemies!

It is through Deborah's song that we learn the rest of the story of how God brought victory to these worshiping warriors.

*The people of Zebulun risked their very lives; so did Naphtali on the heights of the field. Kings came, they fought; the kings of Canaan fought at Taanach by the waters of Megiddo, but they carried off no silver, no plunder. From the heavens **the stars fought**, from their courses they fought against Sisera. **The river Kishon swept them away**, the age-old river, the river Kishon. March on, my soul; be strong!* (Judges 5:18-21 NIV, emphasis added).

As these consecrated, dedicated warriors fought, *God caused all of Heaven to fight with them!* Then He sent torrential rains and caused the river Kishon to swell unexpectedly and sweep away the armies of Sisera. Josephus says that not only did God send torrential rain, but rained hailstones down on the enemy armies as well.

## Kedesh Before Kishon

*Kishon* means "to set a trap, to ensnare."[2] God set a trap against the enemies who had held His people in bondage, brought them to total annihilation, and released His beloved people to victory! Today God is setting a trap for your enemy. Will you be obedient to show up for the battle? It is critical to recognize that one cannot go to *Kishon* until you have first been to *Kedesh*. We cannot expect bondages to be broken and the enemies to be defeated unless we are willing to die the death to ourselves and set our lives apart in dedication to God and His purposes.

The Deborah Company will understand that this is a time of fresh dedication and consecration before the Lord in worship and powerful prayer. If we are wise, we will know that having a revelation regarding battle strategy is not enough to bring victory. We cannot take God's plan and attempt to execute it in our own strength. It simply won't work!

God's strategies must be accomplished only through lives who have endured the process of preparation through purification and sanctification. This complete yielding of ourselves to

God *positions us to receive power* that will destroy the very forces of hell and release all of Heaven to fight the battle with us.

In God's Kingdom, there is no successful warfare without worship and prayer. Throughout Scripture, we see great victories preceded by times of dedication, consecration, and worship. After Israel had crossed Jordan, but before they began to conquer the land, they sanctified themselves and submitted to circumcision (see Josh. 3:5; 5:3). Before Jehoshaphat went out to face the enemy nations who had surrounded Judah, he proclaimed a time of seeking the Lord and fasting. He lifted up his voice in the midst of the people and began to give God praise (see 2 Chron. 20:3).

*Judah*, which means "praise,"[3] went out to meet their enemies with music, singing, and rejoicing. They sang, "Praise the Lord for His mercy endures forever." God fought for them and caused the enemy nations to become confused and begin to fight and destroy each other. Judah's praise and worship brought confusion into the enemy's camp, resulting in a mighty victory in battle (see 2 Chron. 20).

Even Jesus worshiped God through submission and prayer, immediately before the world's greatest time of spiritual warfare when He hung on the cross for our sins, and defeated death, hell, and the grave. He prayed, "Not My will, but Thine be done" (see Luke 22:42). This was an act of obedience. This was an act of spiritual warfare. This was an act of worship.

## The Lord Is a Man of War!

*The Lord is a man of war; the Lord is His name* (Exodus 15:3).

God loves a good fight! While it is true that God is a lover, who loves with an intensity not known or understood by man, we must also acknowledge that He is also a fighter! He will rise to the challenge to contend with His enemies.

In Miriam's song, she glorified the God who not only delivered the Israelites from Egypt, who didn't just roll back the Red Sea supernaturally so that Israel could cross over on dry ground, but who also cast Pharaoh and his armies into the sea! She was actually dancing and celebrating the death of her enemies! She was a woman who was not afraid to represent herself as a worshiper and as a warrior in declaring God's purposes in the earth.

In Joshua 10, we read the story of Joshua fighting against the Amorites, one of Israel's mortal enemies. God told Joshua not to be afraid for He had delivered the enemy into Joshua's hand. As Joshua rose up and fought, God decided to get in on the battle, and He began to rain hailstones down upon the Amorites as they fled away. Joshua 10:11 tells us that more were killed by the hailstones from Heaven than were killed by Israel and the sword. Perhaps the Lord was making a point? "I killed more than Joshua!" Then to make sure that Joshua was able to have a complete victory, God caused the sun to stand still and prolonged the day until all was accomplished in the battle. Our God is a Man of War!

If God would do all those things against Israel's natural enemies, can you imagine what He would love to do to our spiritual enemies? Of course, there is actually no contest with Him. He is the Ruler of the universe, the Master of the heavens and earth. No demon from hell and no man on earth can truly contend with Him.

When we shout and praise the name of the Lord, it stirs up His Warrior's zeal and releases His war cry. God is looking for worshiping warriors who will stand with the Lord to see His judgments executed on all spiritual enemies.

*Sing to the Lord a new song, and His praise from the ends of the earth.... Let them give glory to the Lord, and declare His praise in the coastlands. The Lord shall go forth like a mighty man; He shall stir up His zeal like a man of war. He*

*shall cry out, yes, shout aloud; He shall prevail against His enemies* (Isaiah 42:10,12-13 NKJV).

## Praise Is a Weapon of War

*Let the high praises of God be in their mouth, and a two-edged sword in their hand, to execute vengeance on the nations, and punishments on the peoples; to bind their kings with chains, and their nobles with fetters of iron; to execute on them the written judgment—this honor have all His saints. Praise the Lord!* (Psalm 149:6-9 NKJV).

When America and the Coalition armies went to war against Saddam Hussein in Iraq in 2003, the soldiers searched for weapons of mass destruction, otherwise known as WMD's. There was no doubt that the enemy possessed such weapons, for they had previously been used to devastate entire communities in the Middle East; the question was, where had they now be hidden? In the same manner, the devil has used weapons of mass destruction against the Church, devastating churches, families, and even nations through corruption, idolatry, and fear. But just as the natural WMD's have remained elusive, so are the tactics of the enemy as he subtly defies the people of God. The enemy comes in planting seeds of doubt and worry, repeatedly whispering, "Hath God said?" The devil immobilizes the people of God through fear and intimidation, when we have in fact been ordained to execute God's vengeance and release His written judgments in the earth. The Church has become weak, passive, and ineffective in the face of this enemy with his evil artillery and demonic bombardments upon our minds and hearts.

But the Church is waking up to battle and recognizing the spiritual WMD's that have been put in our hands by our Commander in Chief. It is time for us to rise up and do damage against the forces of darkness through the authority given to us in Jesus' name. As we pray, Heaven begins to shift. As we decree God's purposes, earth begins to align. As we shout, we break the

enemy's strategies to pieces. As we praise, demonic foes are silenced. Psalm 8:2 tells us:

*From the lips of children and infants you have ordained praise because of Your enemies, to silence the foe and the avenger* (Psalms 8:2 NIV).

Praise is a weapon of war put in the hands of the Church to silence our enemy! In his book, *The Worship Warrior*, Chuck Pierce writes:

Today God is raising up an army of worshipping warriors. No force on Earth will be able to withstand this army.... This group was called to worship Him. They are also called to enlist others. They are established under His authority. They have a sure foundation. They demonstrate His redeeming death by exercising the power of His resurrection. They know that He is the head. They are members. They fellowship together to gain strength and access the mind of their leader. They are fighting against an enemy and his hierarchy. They are bold witnesses and they have a hope of their leader's return to fill and restore all things in the earthly realm. They worship unrestrained so they can obey and further their Master's Kingdom plan. They are a Bride ready for war at all times to avenge the enemy and defeat his plan of darkness. Arise, worshiping warriors! Let the Church arise![4]

## Praise Brings Breakthrough

Breakthrough is actually a very aggressive military term, which is used in many church circles today. We pray for "breakthrough," but do we really understand what we are asking for?

Webster's Dictionary defines *breakthrough* as "a military movement or advance, all the way through and beyond an enemy's front line defense; an act or instance of removing or surpassing an

obstruction or restriction; the overcoming of a stalemate; any significant or sudden advance, development achievement or increase that removes a barrier to progress."

Deborah was definitely a woman with a "breaker" anointing. She enabled the armies of Israel to break through Sisera's defenses and go beyond into a place of victory. The Church has done an adequate job of breaking through, but we must learn to press the battle to the full and go beyond into a place of possessing the spoils of the enemy. Most people love victory; they just don't like the battle involved. Unfortunately, there is no victory without a battle!

Praise positions believers for breakthrough. In Acts 16:16-34, Paul and Silas were locked up in prison for preaching the Gospel and casting a spirit of divination out of a girl. They had been beaten, locked in stocks, and placed in the innermost part of the prison. This is where we see the supernatural hand of God bring breakthrough in their praise:

> *But at midnight Paul and Silas were praying and singing hymns to God, and the prisoners were listening to them. Suddenly there was a great earthquake, so that the foundations of the prison were shaken; and immediately all the doors were opened and everyone's chains were loosed* (Acts 16:25-26 NKJV).

Notice the "breaker anointing" in this passage. Not only were Paul and Silas' chains loosed, but the chains of everyone in the prison were loosed as well. A "breaker" doesn't just receive the answer for her own personal needs, but receives a breakthrough that opens the way for others to receive as well.

## A House of Breakthrough

As Ruth married Boaz, the people of the land and the elders at the gate began to release blessings upon their union. Part of what they proclaimed was, "*May your house be like the house of*

*Perez, whom Tamar bore to Judah"* (Ruth 4:12a NKJV). *Perez* is the Hebrew word for breakthrough! May your house be a house of breakthrough! It comes from a root word which means "to break out, to burst forth, compel, disperse, to grow, increase, to open, to scatter, to press, to urge."[5]

## Praise and Intercession

So who was Perez? We find his story in Genesis 38 when Tamar, a Canaanite woman with broken dreams and a broken heart, is joined with Judah and conceives twins. Remembering that *Judah* means praise, we can see that when we allow our disappointment, discouragement, and disillusionment to come into contact with praise, a double portion anointing is birthed!

As Tamar was giving birth, one of the babies stuck out his arm, and the midwife tied a red cord around it, signifying the firstborn who would receive the father's double portion. But as Tamar travailed, the other child actually came out first instead. And she said, "How did you break through?" (Gen. 38:29 NKJV).

Many people may look at you today and wonder, *How did she break through? It seemed like all odds were against her, and she had no chance of surviving, let alone winning. How did she make it? How did she overcome? How did she break through?* We overcome by the blood of the Lamb, it's true. But sometimes we also overcome by refusing to quit and pressing through the barriers and obstacles that stand in the way of our progress.

God is joining the anointings of passionate praise and worship with those of powerful travail and intercession today in order to birth His divine, double portion purposes in the earth. God desires to change hearts, to win a harvest of souls for His Kingdom, and even to change nations through our prayers. God is looking for intercessors who will go *through and beyond* the enemy's defense lines and begin to reap the spoils of war for the Kingdom.

Webster's Dictionary defines the word *intercede* as "to act or interpose in behalf of someone in difficulty or trouble." This word *interpose* means "to cause to intervene, to put a barrier or obstacle between or in the way of." In other words, as an intercessor, we are to intervene for others and get in the way of the devil's destructive plans! We are called to get in the way!

As previously mentioned, in Second Chronicles 20, when the children of Israel were besieged by all their enemies, they set aside a time to fast and pray and seek the face of God. In the midst of that time, God raised up a prophet with a divine strategy.

> *"Do not be afraid nor dismayed because of this great multitude, for the battle is not yours, but God's. ...Position yourselves, stand still and see the salvation of the Lord...."* ...*[Jehoshaphat] appointed those who should sing to the Lord, and who should praise the beauty of holiness, as they went out before the army and were saying: "Praise the Lord, for His mercy endures forever." Now when they began to sing and to praise, the Lord set ambushes against the people of Ammon, Moab, and Mount Seir, who had come against Judah; and they were defeated* (2 Chronicles 20:15b-17, 21-22 NKJV).

This word "praise" is the Hebrew word *tehillah,*[6] which is a hymn. This is a prayer set to music—a praising prayer before the Lord.[7] God is looking for those who will break through the opposition to stand their ground with boldness and tenacity to see God's Kingdom come, His will be done on earth as it is in Heaven.

## Praise Manifests the King of Glory

Interestingly, both Perez and his sibling Zerah are mentioned in the geneology of Christ in Matthew chapter one. This means that each were important to the lineage God was creating to bring forth His Son. God put an anointing of breakthrough in

the lineage as well as a Zerah anointing. *Zerah* comes from the Hebrew word which means "a rising of light" or "to irradiate like beams, to arise as the sun."[8] This reminds me of the passage about the glory of the Lord in Isaiah 60:1-3:

> *Arise, shine; for your light has come! And the glory of the Lord is risen [Zerah] upon you. For behold, the darkness shall cover the earth, and deep darkness the people; but the Lord will arise [Zerah] over you, and His glory will be seen upon you. The Gentiles shall come to your light, and kings to the brightness of your rising [Zerah]* (Isaiah 60:1-3 NKJV).

So we see that the anointing for breakthrough opens the way for the glory of the Lord to rise upon our lives and for the non-believers (Gentiles) to be drawn to us because of His light that radiates from us.

What is the glory of the Lord? It is more than just a golden glow around a believer's face. It is the tangible manifestation of the presence of the Lord. It is the warmth of His love enfolding us as a blanket when we stand in His presence. It is the demonstration of His power in every miracle, sign, or wonder. It is every expression of who He is manifested in and through His Church.

The glory of the Lord is the direct reflection of who He is. As the moon is a reflection of the light of the sun, it can also be said that the moon is the glory of the sun. It has no light in itself, only what it illuminates from the sun. Likewise, the Church is the glory of the Lord. We are to reflect His image to the earth. We have no light in ourselves, but illuminate only the true Light of the world to all mankind. We are His glory!

Psalm 24 also tells us of this King of glory and describes Him as a warrior!

> *Lift up your heads, O you gates! And be lifted up, you everlasting doors! And the King of glory shall come in. Who is this King of glory? The Lord strong and mighty, the Lord*

*mighty in battle. Lift up your heads, O you gates! Lift up, you everlasting doors! And the King of glory shall come in. Who is this King of glory? The Lord of hosts, He is the King of glory* (Psalm 24:7-10 NKJV).

## Praise Unlocks Miracles!

*Call to Me, and I will answer you, and show you great and mighty things, which you do not know* (Jeremiah 33:3 NKJV).

Praise opens the door to the supernatural. When Paul and Silas praised the Lord, their bonds were supernaturally loosed. The children of Israel saw God's delivering hand when they sent the praisers out first. Paul received supernatural grace from the Lord while he was bound in prison. He wrote these words:

*Rejoice always, pray without ceasing, in everything give thanks; for this is the will of God in Christ Jesus for you. Do not quench the Spirit* (1 Thessalonians 5:16-19 NKJV).

If you are in need of a miracle, praise Him. If you feel pressed on every side by spiritual enemies, declare, "Praise the Lord for His mercy endures forever." If you feel you are on the brink of disaster, remember the children of Israel at the Red Sea. Their brink of disaster ended up being their brink of the miraculous! As we praise Him, it positions our hearts to receive. *"Position yourselves, stand still and see the salvation of the Lord."*

## Endnotes

1. Strong's Concordance, 6942.
2. Strong's Concordance, from root of 6983.
3. Strong's Concordance, 3063, from root of 3034.
4. Chuck D. Pierce, *The Worship Warrior* (Ventura, CA: Regal Books, 2002), 244-245.
5. Strong's Concordance, 6557, from the root 6555.
6. Strong's Concordance, 8416.

7. Brown-Driver-Briggs Hebrew Lexicon.
8. Strong's Concordance, 2224, 2225.

CHAPTER TWENTY

# Stirring Up Passion

Jesus' pathway to the cross is known as the "Passion of Christ." Why is such a term used? Passion means "strong or intense emotion."[1] Jesus displayed an intensity of emotion with His pain and suffering, not for His own promotion or to fulfill His own agenda. He did this to accomplish God the Father's desire to purchase humankind back from the hand of satan. This passion enabled Him to endure much for our sakes. Hebrews 12:2 says of Jesus: "...*who for the joy that was set before Him endured the cross, despising the shame...*" (NKJV).

We were His passion, now He must become our passion. We must cultivate strong, intense emotions for our Bridegroom, our Lord and our King. To do so, we must meditate on His words to us, listen to His voice, and spend intimate time with Him in prayer. Through the depth of our relationship with Him, we can stir up joy, stir up love, stir up excitement, and stir up a desire that will overcome every desire of the flesh.

When we love Him that intensely and that passionately, there will be nothing we will not be willing to do for Him. No price will be too great. Our lives become consumed with Him and His purposes in the earth. This is the place of greatest victory. This is the place of highest worship!

*And I heard a loud voice saying in Heaven, Now is come salvation, and strength, and the kingdom of our God, and the power of His Christ: for the accuser of our brethren is cast down, which accused them before our God day and*

*night. And **they overcame him** by the blood of the Lamb, and by the word of their testimony; **and they loved not their lives unto the death*** (Revelation 12:10-11, emphasis added).

Worship enables us to passionately pursue our Lord, and He in turn, empowers us. Mighty women of God will seek Him with all their hearts, holding nothing back, and stir up passion that leads us to victory!

## Come Away My Beloved

*I am my beloved's, and my beloved is mine...* (Song of Solomon 6:3).

Jesus must become the focus of our heart. All we do for Him in service, all we do for Him in spiritual battle, all we do for Him to change our world must be motivated out of a pursuit of knowing Him more. We must embrace the fact that His greatest desire is that we know Him. We must not be like the servant that stood before the Lord in the day of judgment and said, *"Lord, Lord, haven't we prophesied in Your name, cast out devils in Your name and done many wonders in Your name?"* And the Lord responded back to the servant, *"Depart from me, I never knew you"* (see Matt. 7:22-23).

We must know Him as our Bridegroom who is passionately in love with His Bride. We are the Bride of Christ, individually and corporately, and must return His love, removing all obstacles and hindrances, breaking through to His presence that we might know Him more. He is calling to us to shake off the darkness of the winter months, when nothing grows and nothing blossoms. We must arise and embrace His springtime that we might flourish in His presence.

*My beloved spoke, and said to me: "Rise up, my love, my fair one, and come away. For lo, the winter is past, the rain is over and gone. The flowers appear on the earth; the time of*

*singing has come, and the voice of the turtledove is heard in our land. The fig tree puts forth her green figs, and the vines with the tender grapes give a good smell. Rise up, my love, my fair one, and come away!* (Song of Solomon 2:10-13 NKJV).

## The Demonstration Generation

God is looking for a generation who will not be ashamed of who they are in Christ and of the power that He has freely given to them. He is looking for a "demonstration generation" to boldly demonstrate the heart of God, the message of God, and the power of God to the world. As we are filled with His Spirit, through yielding our lives to Him and through worship, we become equipped to become His ambassadors in the earth.

Women of destiny will not be afraid to boldly declare His message through their worship. They will be creative and expressive, freely painting a picture of God's heart towards His people through song, music, dance, gestures, and demonstration. Deborah Company women will take the limits off and worship with abandonment, freely communicating their love for their Lord.

They will also be equipped to demonstrate every truth from His Word. Healings, miracles, signs, and wonders will flow freely when women of faith arise to demonstrate the Kingdom.

*And I, brethren [or sisters], when I came to you, came not with excellency of speech or of wisdom, declaring unto you the testimony of God. For I determined not to know any thing among you, save Jesus Christ, and Him crucified. And I was with you in weakness, and in fear, and in much trembling. And my speech and my preaching was not with enticing words of man's wisdom,* **but in demonstration of the Spirit and of power:** *that your faith should not stand in the wisdom of men, but* **in the power of God** (1 Corinthians 2:1-5, emphasis added).

## Endnote

1. Webster's Dictionary of the English Language.

# *Women Who Make a Difference Through Compassion*
## MICHAL ANN GOLL

*[Rather] is this not the fast that I have chosen: to loose the bonds of wickedness, to undo the heavy burdens, to let the oppressed go free, and that you break every [enslaving] yoke? Is it not to share your bread with the hungry, and that you bring to your house the poor who are cast out; when you see the naked, that you cover him, and not hide yourself from [the needs of] your own flesh?* (Isaiah 58:6-7 NKJV).

*Yes, there is a fast that goes beyond food and water. It goes beyond all time constraints, for it is a lifestyle of fasting. To engage in this fast, we must carry God's heart for justice and use our spheres of influence to establish true justice and mercy. We need to change the lenses we have been looking through, come out of hiding, and recognize that it is God's heart for everyone to come into the family of God—that's our family. It is time to enlarge our hearts with God's heart. It's time to engage our passion for God—to release His compassion to those who are hurting. I have a conviction within me. I believe that if our hearts have truly been touched by the love of God, we will be moved to give that same love away.*

*There has been much emphasis on the gifts of the Spirit, and many want to know what gifts they have. But, instead of being released to serve, some have used that knowledge to determine what they can't do. It is time for a release for the greatest gift that we all have—the gift of love! It's time to uncomplicate things, and find out what we **can** do! We **can** hold somebody's hand; we **can** give somebody a hug. Why, we **can** even offer a smile to someone who is down and needs some encouragement. It's time for a revival of kindness!*

*I've decided to see what all I can do to help bring about this revival of kindness. Instead of waiting for someone else more qualified than myself to step up to the plate, I have felt the Lord urging me to take my turn at bat. So, I've enrolled myself in God's school of compassion. The first requirement is to admit that we don't have it, and we don't understand it. But, we've got to get it. And the only way I know to get is simply…to jump in! We study the Word to understand God's heart; we then write it on our hearts; and then it is time to move out and do it. Some people have asked me to pray for them for an impartation of compassion, and I have to say that I'm not sure that is possible. Compassion is an outworking of the passion for God that is deep within. If we have true passion for God, then we should also have compassion; and if we have compassion, we will act, because that is what compassion does. Compassion demands action!*

*I believe moving in and through relationships is so near to the heart of God. He believes in relationship! It is essential that the Body of Christ begin acting like a body—we are supposed to be joined together! We want to help connect the body, joint to joint, supply with demand!*

*We have had the wonderful privilege of putting together short-term missions trips whose main objective is to pray, pray, pray! So far, we've gone into Mozambique, Thailand, China, and Burma. Our hearts have been radically touched as we have met these amazing warriors of love. We pray for them. (Oh, how they love and appreciate that!) We pray over the land prophetically, listening for the heart of God concerning that particular area. We pray for and serve the children. We worship God with great abandon, exalting the God of our fathers, the God of Abraham, Isaac, and*

*Jacob, believing that is one of the best deposits to make. Hey,
everyone can do that!*

*We believe you cannot truly carry the heart of the Father if you
do not have some application of helping the fatherless and the poor.
Take a look at Proverbs 29:7: "The [consistently] righteous man
knows and cares for the rights of the poor, but the wicked man has
no interest in such knowledge" (AMP) I used to think I carried the
heart of God, until I saw this Scripture, and I discovered how far I
had been from the truth. We must involve ourselves and educate
ourselves with the needs of the people in difficult circumstances. We
are currently bringing help to the children of Mozambique, looking
for creative ways to raise monies and supplies for their care. We're
also investing in finding solutions for the needs of the people of
Burma, the child soldiers within that country, and in Thailand and
China as well. We're helping to rescue some of these children from
the grip of war, disease, abuse, and poverty.*

*We're developing relationships with compassion ministries,
both locally and internationally. We've got a real heart to help
women who have been trapped in sex trade/prostitution rings, and
see the need for safe houses. These women and children need places
of safety—the safety of God's love. We've got to reach out to the youth
and love them. We've got to see these kids as our kids, because from
God's perspective, that's who they are! We're looking for ways to help
developing countries get water filtration systems in place, and send
medicines and food to areas in need. We are developing rescue teams
in the event natural disasters occur. Some of our team served in the
wake of Katrina, and continue to travel to New Orleans to serve.*

*Another big need we are finding ourselves thrust into is the
arena of health and nutrition. We are in the midst of gathering*

*training materials and self-help tools to educate and train people to prevent disease, rather than have to treat it! Oh, our nation needs this desperately. We have succumbed to the mind-set that says, "If you've got a pain, take a pill," instead of understanding God's ways and heart regarding health and longevity. We are also digging deeply into the wells of healing and applying the healing power of Jesus to many!*

*To carry a Deborah's heart and anointing, we must hold near and dear to our heart the Scripture in Zechariah 7:9-10 (AMP) which says, "Thus has the Lord of hosts said, Dispense true justice and practice kindness and compassion each to his brother; and do not oppress the orphan, the stranger or the poor; and do not devise evil in your hearts against one another." This is the Word of the Lord for everyone who wants to know God's heart. Deborah brought healing and deliverance to her land. She changed the justice system, and brought trade and commerce back to her people. The land pros-pered under her leadership, and all was restored. She and Barak joined together in the infamous battle against Sisera, and won! They won the battle on the ground, but they also won the battle in the spirit, because neither one of them cared who got the glory. They were both jealous for the presence of God; consequently, He received the glory! May we learn how to provide real leadership, like Deborah and Barak! May we be filled with the love of God, to see justice established each in our own individual and corporate realms of authority. May it be so!*

**Michal Ann Goll** is co-founder with her husband, Jim, of Ministry to the Nations. She is the author of several

books and is a conference speaker throughout the nation. She shares her life's experiences and inspires others to a deeper walk with Jesus. They live in Antioch, Tennessee with their four children.

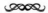

## A Charge to Worshipers

Deborah Company, arise and worship your King! Passionately pursue Him with your whole hearts, giving glory, honor, and praise to Him. Through your worship, receive boldness and courage to enter every battle, expecting victory on every hand. Stir yourselves to powerful times of prayer and intercession. Freely demonstrate and express your love to Him, publicly declaring His lordship over your lives. Worship Him because He is worthy; praise Him because He is powerful; and exalt Him because He is excellent!

## SECTION FIVE

## *Questions for Consideration*

1. What is true worship?

2. How does worship empower you for battle?

3. Are there areas of your life in which you need to employ the principles of warfare and worship? Describe.

4. How can you more affectively demonstrate your worship? What are other aspects of the Kingdom that God would have you to demonstrate?

# SECTION SIX

## Deborahs, Arise!

# Women Who Make a Difference
## Raising Up a Deborah Company
### JULIE ANDERSON

*Deborah must have been an incredible woman of faith in her day. She knew God's timing and nature to deliver His people from oppression, and received God's wisdom and strategy to bring victory to her nation. I believe if she were living today, she would be patiently sitting, worshiping, praying, and listening for God's heart for our nations, but soon she would act!*

*Modern day Deborahs are impacting the world in different spheres of influence and having remarkable supernatural encounters, bringing spiritual victories. The war on terrorism and the continued hostility and oppressive intimidations towards our nations, is being prayed over by a growing army of women who are seeking God— women praying for peace, women with great faith in their God. Today's Deborahs are involved at every level. They are in the marketplace, in art, advertising, banking, education, government, technology, media, medical fields, postal services, stores, and security services. The list is endless of places where women are praying, networking, and seeking God together, and being raised up as voices for God's voice.*

*In 1999, the vision of thousands of women becoming spiritually strong and following the Lord Jesus in a great army prepared for war impregnated me, and I was reminded of Psalm 68:11. I had accompanied my friend Cindy Jacobs to Barcelona, Spain where she was speaking. I had been through a very dry spiritual season preceding this time, and had grown battle weary contending for the land, and discouraged, knowing sinful habits in my heart needed to be broken, which I was not gaining victory over. I needed a break.*

*I wanted to spend time with my dear friend, Cindy, sensing in her prophetic gifting that she would spot my problems, stand in faith in prayer with me to see victory come, and maybe even have the solutions.*

*My husband and I were living in the country in England where he had founded and was leading a Bible training school, offering morning courses there, and evening courses in London. We traveled back and forth, in and out of London several days a week, a two-hour drive often in bumper-to-bumper traffic. Using the curriculum we developed, our one goal was training up warriors who would be confident in God's Word, intimate in worship, and skillful in spiritual warfare. We interceded and sought God for spiritual victory and revival to wake up our nations—my husband's, the USA, and mine, the UK.*

*Teaching and training God's principles to students changed from a daily battle into a long marathon, which God confirmed through Nahum 3:14. It was to be a long continued siege that we had to be prepared for. Life became drudgery, driving through hours of traffic each day, leaving at dawn and arriving home at midnight. Eating poorly and not having enough sleep, rest, and exercise began to break us down.*

*Oppression had increased in London noticeably. There were too many people, with too many views, perspectives, and religions; and they all were begging to mingle together in a mish-mash of cultures and changing society, demanding their own way. The Hare Krishnas were prayer walking Oxford Street; the Muslims were contending at Speakers Corner, Hyde Park; the Jews up in Northern London seemed ever more excluded; while the Christians' voice became quieter. The London I loved began sinking into oblivion,*

*no longer very English. Sunday trading laws had been passed for people who worked all week, which we understood, but now there was no quiet day in the city left free to meditate, pray, read. Everyone bustled around, too busy for God.*

*Deborah knew the timing for Barak to successfully lead the army of Israel to war, and she knew how the glory of God would be manifested through a woman. I preached her story and thought about it, and found myself walking in the country fields on the days I stayed home, outside London. I would listen to God for hours while I took care of domestic work; and, I would pray and intercede for our British Parliament and our political leaders.*

*When I left to travel with Cindy to Spain, I had no idea that God was preparing to impregnate me with fresh vision. Deborah made a difference to her nation's future, and somehow I sensed I would too.*

*Cindy and I were staying in the middle of Barcelona, where she had been invited to speak. The old hotel was clean and peaceful; and, on the second night I awakened about 3:00 a.m. to find Cindy sitting cross-legged on her bed next to me looking startled but quite angelic. Her face was softened and gentle, and the room was filled with the most amazing sense of God's Spirit. Cindy, in a hushed voice, explained it, saying, "Gabriel was here!"*

*God's angel had been there, and she had received a vision of us on horses! Cindy was visibly moved as she detailed what she had seen and heard. She shared that I was on a white horse, and she was on a brown horse; and we were riding across nations with thousands of women following us. It was then I realized an answer had come to bring me victorious strategy, and that it was for more nations than the USA and UK.*

*My husband and I moved into central London soon after this, and began working with training courses there in town. I also began holding more prayer meetings under the banner of "Prayer for the Nations," the registered charity we had founded and led. After a council of reference, meeting with those whose wisdom I trusted, I began a strategic prayer school in Westminster, to pray for our Parliament and political leaders.*

*Three days a week, worshipers, psalmists, intercessors, missionaries, and pastors came to be refreshed spiritually, recharged, and prayed for at the Strategic Prayer School, where believers were sent out to either begin their own prayer schools, or return to their work with fresh faith and vision. All kinds of strategic gatherings came out of that little Prayer School, including yearly International Prayer Summits and "The Call, England," a day where thousands humbled themselves in the Reading Football Stadium and two generations joined to fast and pray. We also organized and led the administration for the National Prayer Breakfast in Parliament four years running.*

*In 2004, it hit me really hard, one day in prayer, that during that night in Spain, 1999, God had intentionally touched my heart for women and for Deborahs to be raised up. It was not by accident that God had sent Gabriel, who had brought a message from Heaven; and though I had no desire to be involved in women's ministry, I knew I had to pray for the vision of thousands of women uniting. I loved to pray and talk to God and be around prayer and healing meetings, but to be around many women was not so appealing. God would have to work through my insecurities, fears of criticisms, and petty jealousies that could be very strong amongst women.*

*As I began to pray and understand that God does not send angels, and in particular Gabriel, for earthly visitations unless it is*

*very important, I knew I had been given an assignment from Heaven to earth that I needed to flow with. I began to pray for all women longing for purity and strength, who are not afraid to go to war. (Although women did not go to war in Deborah's day, still she rose up and was not afraid to accompany Barak to the battlefield.)*

*At that same time, Cindy came to London to speak at one of our AWAKEN conferences, and I realized I needed to invite and gather women of influence to hear her. We organized a luncheon, in a pizza restaurant, in Pimlico, in central London and packed out the down-stairs room. Subsequently, an explosion of spiritual vision shot into the hearts of the hungry, desperate women to see victory and destiny fulfilled in their lives.*

*A few months later, I gathered a founding group of women leaders together for another lunch, this time in a nice hotel in Victoria. Twelve of us met to discuss how to encourage women and gather a praying army. During the next year, as different leaders met, I continued to pray. And the more I prayed, the more I sensed that July 7, 2005 was an incredibly important date to God, which would be the day we should actually launch the Deborah Company, U.K.*

*When Jane Hamon came to London to speak at our AWAKEN conference, none of us knew that would be the day the terrorist bombs would explode in different locations all across London, where innocent men, women, and young people would be killed. The morning of July 7, I had gotten up early to pray, and then had gone to get my hair washed and blown dry before the three- day conference began with Tom and Jane Hamon, Dutch Sheets, and Chuck Pierce. The Lord had clearly said we were to open the prophetic gate wide from London and invite the prophets in; the spirit of prophecy would flow out into the nation, and into other nations from London. When my mobile*

phone sounded at 9:10 am, it was a young Deborah calling me to inform me about the bombings, and I immediately felt enraged.

Deborah was not afraid of war though, and we should not be afraid either as women of God. I felt no fear, just anger that this had happened on this particular morning. We are called to rule and reign from heavenly places of intimacy with and in Christ, and to walk on the earth in close relationship with God. On that historic day, many of the women were blocked from attending the luncheon because the British Police had immediately switched off mobile phone networks and barricaded the city. The date 07-07-05 is the day London remembers the tragedy of terrorism. God chose that day to launch the Deborahs through a prophetic gate in order to be used to bring His voice.

The previous Sunday afternoon, my husband had taken me to visit the Imperial War Museum, quite close to our home. My husband is very sensitive to the timings of God and leads and protects me many times in the heat of spiritual battles. It was very moving to walk around with him through the history of World War I, World War II, and end that afternoon in the D-Day room.

In 1944, women officially "in the know" on D-Day were among those who worked in the various establishments of the Royal Navy and Royal Air Force Headquarters, helping win the war in World War II. The war effort was supported greatly by women who were wives, girlfriends, and mothers, who unofficially knew of the immediate imminence of the generally known launching, some-where presumably in France, of the long-awaited Second Front. The women were known as Wrens. My mother was a Wren, and I remember as a little girl wondering how women went to war.

*As I paused to look at history, it was interesting to see that when men despaired, there were times that women arose and saved their nation. I saw that victory had come out of the strategy that God have given to the generals, using everyday people to form an army who went across the English Channel and rose up against Nazi domination. Britain, of course, joined with the USA in a united force. I realized God was talking. I heard Him say, "Begin to hold D-Days in London, and bring victory to my women! I want women to rise up! I want every one of them to hear My voice and know they are called to pray in such a time as this!"*

*We have held four D-Days to date, and each one has been historic. When Jane Hamon came to London in June 2006, it so happened that we held D-Day on the same date the original D-Day occurred. That day in Westminster, as we prayed for women with influence and especially those involved in politics, there was a tangible outpouring of God's Spirit.*

*Today there are many women who are present-day Deborahs praying with the fresh wind of God's Spirit. They are modern day Deborahs, women making a huge difference working with Prayer for Parliament, and serving governments through prayer and intercessory intelligence!*

*Rise up, women of God! You are a Deborah in your field, and can make a difference as you obey whatever He has fashioned you to do. Just as everyone worked together on D-Day with whatever they had, making a difference and bringing victory in World War II, likewise there is today a joint or individual victory that must be obtained through you.*

*Deborah knew intimacy with God was her highest purpose.*

*Deborah didn't allow herself to be lulled to sleep, or deluded by worldly gods, or goods.*

*Deborah waited with uncompromising faith and dedication, and received God's heart.*

*Deborah was being prepared for war in that secret place where true victory is received.*

*Deborah remained in that intimate place with God to receive victorious strategy that defeated and outwitted the enemies of her nation.*

*Rise up, women of God! There is a Deborah anointing being released among women today, and if you are reading this book, then it's certain the Holy Spirit is stirring up that anointing within you to fight in prayer for your children, families, and nation.*

CHAPTER TWENTY-ONE

# Deborah Company, Arise in the Double Portion

God is calling forth a new breed of women in the earth today. This company of women will share many of the aspects and attributes of Deborah. These women are not one dimensional in nature, but have many facets of giftings, talents, and abilities. God will take them, like a priceless gem mined from the mountain, through the process of cutting and polishing until each facet shines with brilliance and clarity.

## Claiming Our Inheritance

We have entered a season of change in the Church and in the earth. God is restoring women to their rightful place of function and authority. We see through the Scriptures that this has always been His heart towards women, and we are entering the greatest season of dominion and release that the earth has seen since before the fall. We have previously been a part of limited breakthrough, but now is coming a season of double portion.

In Numbers 27:4-7, we read the story of the daughters of Zelophehad and how they stood against culture and custom to demand a place of inheritance among their brothers. Zelophehad, a righteous man serving under Moses, died with no sons to inherit his possessions. Instead, he had five strong daughters who pleaded their cause of inheritance before Moses. *Zelophehad* means "shadow of fear." God is delivering women from the shadow of fear that has immobilized them and cut off their ability to make a difference in the earth.

*"Why should the name of our father be removed from among his family because he had no son? Give us a possession among our father's brothers." So Moses brought their case before the Lord. And the Lord spoke to Moses saying, "The daughters of Zelophehad speak what is right; you shall surely give them a possession of inheritance among their father's brothers, and cause the inheritance of their father to pass to them"* (Numbers 27:4-7 NKJV).

This positioning describes how this movement to restore women to a place of full function and full inheritance began. Women rose up and asked for a place of inheritance among their brothers. Male leaders who sought the Lord, as Moses had done, declared that the women's request was good and right—that they should be given a possession of inheritance as able ministers in Christ's Body. As a result, women began to step into places of speaking, preaching, and leading. This was only a limited breakthrough, however, because many arenas of Christian leadership continued to fail to acknowledge God's call upon women.

Galatians 3:26-29 reminds us that there is neither male nor female in the Body of Christ but that we have all been made heirs according to the promise. Colossians 1:12 tells us that the Father has qualified every one of us to be partakers of the inheritance of the saints. This inheritance is more than mere salvation of soul and forgiveness of sin. It is the ability to step into God's destined path for our lives.

## Receiving the Double Portion

A principle in the Word of God declares that when God restores something to His original intent of operation, there is a double portion release. Zechariah 9:11-12:

*As for you also, because of the blood of your covenant, I will set your prisoners free from the waterless pit. Return to the stronghold, you prisoners of hope. **Even today I declare that***

*I will restore double to you* (Zechariah 9:11-12 NKJV, emphasis added).

In Isaiah, we are also encouraged that God will restore double honor in places where shame and confusion have reigned. God is a God of justice, and His desire is to see the Genesis 1:28 mandate of male and female take dominion in the earth. This occurs when the double portion is released.

> *Instead of your shame **you shall have double honor,** and instead of confusion they shall rejoice in their portion. Therefore **in their land they shall possess double;** everlasting joy shall be theirs. For I, the Lord, love justice; I hate robbery for burnt offering; I will direct their work in truth, and will make with them an everlasting covenant* (Isaiah 61:7-8 NKJV, emphasis added).

This double portion that God is releasing throughout the Body of Christ is the impartation of the apostolic and prophetic mantle, which destroys demonic structures that have held individuals and cultures in bondage. It is the release of the spirit of wisdom and revelation mentioned in Ephesians 1:17-18, which equips the saints to walk in personal breakthrough as well as bring breakthrough into their spheres of authority. This double portion is men and women, young and old, black and white, rich and poor all working together as one to accomplish Kingdom purposes.

The double portion releases wholeness to individuals as they shake off the shackles of history that have bound them in false identity, fear, and shame. As the Church arises in this freedom, look out world! It's time to bring a Kingdom shift throughout the earth and to infiltrate the kingdoms of this world with the Gospel of the Kingdom of God.

The double portion is also an anointing for abundance. It is one portion for me to meet all my needs—physical, emotional, relational, financial, and spiritual—and another portion to meet

the needs of others. There is one portion for me to walk in divine health and another portion to release the healing anointing of the Lord to others with physical needs. There is one portion to have all my financial needs met and my vision financed and another portion to sow into the lives of others' needs and others' visions. There is one portion for me to fulfill my destiny and another portion to help others in fulfilling their destinies. Our God is a God of abundance, a God of more than enough. He is the Lord of the double portion!

Though women began this movement of restoration through rising up and asking for the right to take their place in the Body of Christ, now, God, the Father, is releasing this inheritance to His daughters.

When Job went through all his losses, pain, and grief yet remained faithful to his Lord, God brought him to a place of restoring all that had been taken from him. But God didn't just restore equal to what was lost, He restored a double portion. In this double portion release, Job gave his daughters an inheritance among their brothers, and God made them the most beautiful women in the land.

> *And the Lord restored Job's losses when he prayed for his friends. Indeed the Lord gave Job twice as much as he had before. ... Now the Lord blessed the latter days of Job more than his beginning.... He also had seven sons and three daughters. And he called the name of the first Jemimah, the name of the second Keziah, and the name of the third Keren-Happuch. In all the land were found no women so beautiful as the daughters of Job; and their father gave them an inheritance among their brothers* (Job 42:10,12-15 NKJV, emphasis added).

## Deborah Company, Arise!

The Deborah Company of women will move with both the spirit of wisdom and the spirit of revelation. They will be wives,

mothers, and businesswomen. They all will have a vision of their calling as ministers and a confidence in their ability to hear the voice of their Lord.

The Deborah Company will be bold and courageous, confronting sin and darkness, fighting forces of evil, and tearing down strongholds. These women will deal ruthlessly with their own fears and insecurities, and will give no place to the devil.

The Deborah Company will not be ruled or dictated to by the world's philosophy towards women. They will not be held back from fulfilling destiny because of their gender, nor will they adopt the godless philosophies of feminism and humanism. These women will be ladies, embracing their femininity and their strengths as women.

The Deborah Company of women will have hearts of worship towards their Lord and King. Knowing, loving, and serving Jesus will be their passion, and they will be challenged and stirred to demonstrate His Kingdom everywhere they go.

They will walk with the Baraks in the Body of Christ, in the double portion anointing of the Lord to impact the earth. These women will be apostolic and prophetic in all they do. They will walk with and work with other women without jealousy or competition. They will embrace the mandate to walk in dominion and bring transformation throughout the earth. They will be women who make a difference!

*The Lord gives the Word [of power]; **the women** who bear and publish [the news] are a great host* (Psalm 68:11 AMP, emphasis added).

# About the Author

Dr. Jane Hamon has been co-pastor of Christian International Family Church with her husband, Tom, for over 20 years. She travels nationally and internationally, imparting prophetic revelation and apostolic authority to strengthen the Church to rise up and breakthrough into destiny and purpose in the earth. Her ministry activates saints to hear the voice of the Lord and releases strategies to win spiritual battles, as well as releases a fresh dynamic of God's miraculous power to the Church. She has written three books, *Dreams and Visions*, *The Deborah Company* and *The Cyrus Decree*. Dr. Jane lives with her husband of 25 years and has raised three children, all who work with them in ministry.

For further information or to contact Jane, please visit the website at www.cifamilychurch.org. If you would prefer to email Jane, please send it to cifc@cifamilychurch.org or call at 850-231-2660.

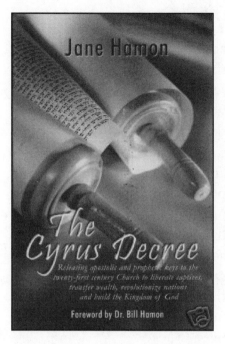

**The Cyrus Decree** releases apostolic and prophetic insight regarding the role of the Church in confronting the kingdoms of this world with the Kingdom of God. We have been given the power to make decrees that shift things in the realm of the spirit and open up the earth for the harvest. Learn keys that will liberate captives, bring about a transfer of wealth, and revolutionize nations.

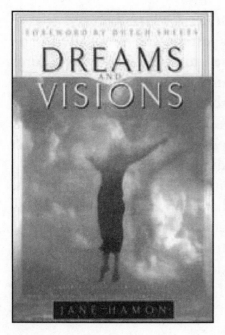

*Dreams and Visions* will activate you to hear the voice of the Lord in a new way. Acts 2 tells us that in the last days God will pour out His Spirit on all flesh. As a result, we will begin to prophesy and have dreams and visions. This book brings practical and inspiring insight on how to hear God's voice in dreams and visions, how to accurately interpret what He is saying through understanding the language of symbolism, and how to apply His message to our lives.

# Available CDs

### 1) Women of Destiny (6 CD Series) $30.00

Deborah, Esther, and Abigail were women in the Bible whom God used to bring tremendous change in the earth. Today God is equipping women to rise above personal obstacles and limitations and the religious restrictions of the past, and step into their God-ordained destinies in the church, in business, and in government. Are you a woman of destiny?

### 2) Discerning of Spirits (3 CD Series) $15.00

Have you ever had an unexplainable, uneasy feeling about a person, place, or situation? Perhaps the Holy Spirit is causing you to discern activity in the unseen realm of angels and demons. Learn to walk in spiritual discernment with wisdom, balance, and accuracy, and reap the benefits of freedom in your life.

### 3) Dreams and Visions (5 CD Series) $25.00

Acts 2 tells us that in the last days God will pour out His Spirit on all flesh. As a result, we will begin to prophesy and have dreams and visions. This is a practical and inspiring teaching on how to hear God's voice in dreams and visions, how to accurately interpret what He is saying through understanding the language of symbolism, and how to apply His message to our lives.

### 4) The Cyrus Anointing (3 CD Series) $15.00

Cyrus was an example to the apostolic/prophetic Church today of bringing transformation to nations, transferring wealth for God's purposes, and setting the captives free. Learn how the

demonic spirits of Gad and Meni may be locking up your wealth and destiny and how the power of decrees can bring a Kingdom shift in your life.

## 5) The Roots of Jezebel (2 CD Series) $10.00

Many people use the term "Jezebel" without a full understanding of what this spirit is and how it truly operates. It is rooted in what the Bible calls the Queen of Heaven spirit and attempts to control the lives of believers. Discover how to break the power of this spirit and walk in victory.

## 6) Conquering the Ites (4 CD Series) $20.00

When Israel went in to possess their promised land, they were told to drive out all the enemy nations—Canaanites, Hittites, Hivites, Jebusites, etc. These "Ites" of that day each represent barriers and strongholds we must drive out of our lives today in order to possess our land of promise.

## 7) Understanding Serpent Spirits (2 CD Series) $10.00

Demonic forces have specific assignments and personalities. Scripture speaks of Leviathan as the "king of the children of pride" and is said to be difficult to defeat. Python is otherwise known as a spirit of divination and chokes out faith, life, and resources. Learn how to recognize the operation of these spirits and how to gain victory over them.

## 8) Favor of the Lord (2 CD Series) $10.00

The Church has entered an incredible season of favor. Learn how to fully receive the favor of the Lord in your life, as well as what the Bible has to say about specific areas favor is to impact us. These are not only teachings, but include specific prayers of release so that you might begin to experience the power of favor.

## 9) The Spirits of Absalom, Behemoth, and Antichrist (3 CD Series) $15.00

Demonic forces have specific assignments and personalities. These three spirits can control individuals, families, businesses,

and even nations. Learn how to identify these spirits at work and how to break their controlling powers.

## 10) Releasing the Miraculous (3 CD Series) $15.00

Acts 1:8 tells us we shall receive power when the Holy Ghost comes upon us. This word "power" is the Greek word *dunamis*, which literally means "miracle-working power." It is time for the Church to learn to operate in this power by releasing healings and miracles, signs and wonders.

## 11) The Breaker Anointing (3 CD Series) $15.00

God is our Master of breakthrough, and we must recognize that we are His ambassadors of breakthrough in the earth. Learn how to move into a breaker anointing to open the heavens and birth God's purposes. It's time we break through to the next level!

## 12) Receiving the Double Portion (4 CD Series) $20.00

Elisha asked Elijah for a "double portion" of his mantle. It was a mantle of supernatural power and miracles. But the mantle of Elisha is nothing in comparison to the mantle of the Holy Spirit power that we can receive today. Learn the principles we must practice to enter into our double portion.

**To Order These Products:**
**www.cifamilybookstore.com**
**or call 850-231-3348**

Additional copies of this book and other
book titles from DESTINY IMAGE are
available at your local bookstore.

Call toll-free: 1-800-722-6774.

Send a request for a catalog to:

**Destiny Image® Publishers, Inc.**
P.O. Box 310
Shippensburg, PA 17257-0310

*"Speaking to the Purposes of God for This
Generation and for the Generations to Come"*

**For a complete list of our titles,
visit us at www.destinyimage.com**